This book is to be returned on or before
the last date stamped below.

EYEWITNESSES TO ART

SERIES EDITED BY MINA GREGORI

GIORGIO GUGLIELMINO

HOW TO LOOK AT
CONTEMPORARY ART
(...and like it)

66 WORKS FROM 1970 TO 2008

EVERYTHING YOU ALWAYS
WANTED TO KNOW
ABOUT CONTEMPORARY ART
BUT WERE TOO AFRAID TO ASK

UMBERTO ALLEMANDI & C.
TURIN ~ LONDON ~ VENICE ~ NEW YORK

Nothing, perhaps, is more important than just this:
that to enjoy these works we must have a fresh mind,
one which is ready to catch every hint and to respond to every
hidden harmony: a mind, most of all, not cluttered up with long
high-sounding words and ready-made phrases. It is infinitely
better not to know anything about art than to have the kind
of half-knowledge which makes for snobbishness.
E. H. Gombrich

English translation by Jude Webber

ACKNOWLEDGEMENTS

I would sincerely like to thank the gallery owners, their assistants, the staff
of the contemporary art departments of auction houses and the museum
directors whom I have met over many years of passion for contemporary art.
Over the course of these years I have frequently pestered them
with my requests for information, details, prices and photographs,
and have appreciated their patience and willingness to help.
However, I would like to extend particular thanks to:
Anne Blümel (Galerie Lelong, Zurich);
Alessandra Bonomo (Galleria Alessandra Bonomo, Rome);
Marilena Bonomo (Galleria Bonomo, Bari);
Valentina Bonomo (Valentina Bonomo Arte Contemporanea, Rome);
Laura Chiari (Galleria Lorcan O'Neill, Rome);
Tamara Corm (Phillips, London and Paris);
Bernd, Verena and Julia Klüser (Galerie Klüser, Munich);
Beatrice Merz (Fondazione Merz, Turin);
Massimo Minini (Galleria Minini, Brescia);
Tobias Mueller (Galerie Bischofberger, Zurich);
Lorcan O'Neill (Galleria Lorcan O'Neill, Rome);
Angelica Pediconi (Art & Ethics, London);
Adriana Rosenberg (Fundación PROA, Buenos Aires);
Mimmo Scognamiglio (Mimmo Scognamiglio Arte Contemporanea,
Milan-Naples);
Timothy Taylor (Timothy Taylor Gallery, London);
Cheyenne Westphal (Sotheby's, London).

Thanks also to my son Federico and to my daughter Alessandra.

Contents

Neither critical nor cryptic: a book to read

FRANCO FANELLI

Art has always been disagreeable ⁄ just being contemporary
is enough for that. Michelangelo was a contemporary artist
in his day and, in 1541, Cardinal Gonzaga received an in⁄
dignant letter about the "nudes" in the Sistine Chapel. His
contemporary, Caravaggio, was a great dissident because of
the explicit realism of his Virgin on her deathbed, which
was censored 200 years before the Impressionists were turned
away from the Salons of Paris. And before the negative con⁄
notations of the suffix "⁄ism" applied to the vanguard of
20th⁄century art, plenty of criticism was doled out to illus⁄
trious artists of the past by their contemporaries. But aside
from the quills of the critics (Michelangelo was branded a
braggart, and Caravaggio had to wait for a great art histor⁄
ian like Roberto Longhi to be "rehabilitated"), how many
times has it fallen to ordinary people (now we would say the
"non⁄experts") to condemn and jeer at artistic novelty?
Nowadays the critics lay off everyone, but popular intoler⁄
ance of contemporary things still finds expression in the same
tones as in the past, when satire and mockery were the norm.
We can watch the classic Italian film comedies with Totò
desecrating an "expert" or Alberto Sordi and his "wife"
dressed as two Roman, or rather Romanesque, grocers grap⁄
pling with a problematic visit to the Venice Biennale. There
are innumerable comic sketches in magazines that laugh at
modern art: Alighiero e Boetti, one of the most refined Italian
contemporary artists, collected them, half in jest, half ser⁄
iously. But Boetti was also a champion of irony and self⁄dep⁄
recation, a quality in short supply among other artists and

their supporters. Let's be frank: the contemporary art world, which comes across as serious and as taking itself seriously, does little or nothing to make itself nicer. Hundreds of thousands of people visit commercial art fairs but very few ordinary people can overcome that subtle inferiority complex which prevents them from entering a gallery where they will have to deal with staff who are snobbish and a bit standoffish, and works that are often "difficult" and frequently even lack signs with the artist's name on them. "Ordinary people", maybe, but passionate ones, who, in order to "learn", have had to consult specialised publications written in language no less cryptic than the works they describe. They are passionate, it is true, and thus they find themselves in a very uncomfortable position, caught between a small elite which rejects them, and Alberto Sordi who derides them. But they are passionate. They visit exhibitions (even if statistics show that those former dissidents, the Impressionists, now more attractive and now less shocking, beat all the box-office records), and they frequent museums, and not just the packed Uffizi Gallery. They are guaranteeing the success of the outreach departments of public institutions dedicated to contemporary trends which have finally also started up in Italy.

They are passionate and happy, to use an adjective chosen by Giorgio Guglielmino as the subtitle for the Italian version of this book ("How to look at contemporary art... and live happily"), and the book is above all aimed at them, because the author is one of them too. These *aficionados* won't find in these pages what, because of a professional vice, seems to have become part of the literature on contemporary art: they won't find linguistic acrobatics in critic-ese, or circumlocutions. It has been proven that the most common word

in the criticism of contemporary art is "about". But this book goes right to the heart of the works of art, because these are not pages of criticism but pages to read. By focusing on 66 works, Guglielmino proposes a journey into the most inaccessible sector of art, because it is the most contemporary, from the 1970s to the present day, with a novel itinerary taking account of the impact of trends and new vanguards without the usual, rather stale and not very clarifying chronological descriptions. His journey builds an idea of the work as the output of an individual in a dialogue with our times and our languages. And speaking of language, Guglielmino keeps it simple: he uses our own language to explain and make us understand. Talking simply of very complex "things", "explaining" tough issues succinctly but unequivocally, is almost as hard as producing a work of art itself. The artists themselves have taught us this ∕ like Kazimir Malevich, the father of so much contemporary art, who said "less is more". But the synthesis of the artists cannot be expressed by the same means by someone who is called upon to write about them. This book, where each work of art is considered a living organism and as such is "deconstructed" to show all the elements and the way it functions, talks about very rich "content", but also about "forms", demonstrating that this second branch of the problem of art, contrary to what one might think, continues to be an issue for its present protagonists. The reader will also see how, in the emphasis on "doing" in our era, which is strongly connoted by our thoughts, concepts and in certain periods also by the immaterialness of the work, the job of the artist continues to be that of harmonising the "physicality" of the product with its (what a surprise!) aestheticism.

There is more: the issue of whether, beyond the fact that contemporary art is often the bearer of anguish and problems, it owes its scant popularity to market prices and the mysterious dynamics of art dealing. Here too, Guglielmino takes the reader by the hand without being condescending, indicating to him or her works that have been "sanctioned" (maybe temporarily, maybe permanently), by art markets. Guglielmino does not directly analyse the way prices behave but to some extent explains them through his examination of the pieces: the work becomes "art" and thus a vehicle for culture. In this way, art assumes a value that is not exactly synonymous with price. These are the simplified equations of the author, who collects because of his passion and not vice versa.

This "book to read" won't please the Jacobins and the vestal virgins of contemporary art, or those who turn it into a status-symbol, or those who go to exhibitions not to see but to be seen. Know-it-alls will leaf through the book and decry its "banality". They will read it but will not quote it to their friends who already know everything, just like they do, though something tells us that thanks to this book, they won't lose face with them.

This is a book that you obviously won't have on the coffee table in your living room because, in some unconscious way, something tells us that these far from irreverent pages are nonetheless, by virtue of their elementary and unheard-of simplicity, at least as scandalous as the works they refer to. People who don't have anything to do with such cliques or complexes will understand, without frustration and even gladly, that most of the time the bluff in contemporary art isn't the works but the people who talk and write about them without knowing how to read them.

Preface

Is contemporary art hard to understand? Can it be explained in simple words? The answer to the first question is "no", and to the second, a resounding "yes". Contemporary art should be perfectly easy to understand and more accessible considering that today's artists are living and working in the same historical and social context as us, the spectators of their works. Thus we share information, references, characters and details that are an integral part of the modern mindset. It's a very different story with ancient art, where it is far harder to grasp the whole range of meanings contained within individual works of art without the right cultural baggage, including knowledge of specific allusions from philosophy, history, religion and classical mythology. It's far easier to read a contemporary novel than a Greek tragedy written 2000 years ago. Why can't it be the same for art? The basis of this book is that contemporary art can indeed be explained simply, through discussion, drawing out of the pieces themselves, rather than an analysis of the artist, the personal and social references we all find in newspapers, television, cinema and daily life and that often form the basis of many artworks. It's an approach that is diametrically opposed to the majority of books on the history of contemporary art which, especially in Italy, are written in deliberately complex and hostile jargon as if intended for members of a sect that no one else can join.

It was while wading through some of these particularly cryptic texts that the idea for this book was born. To name but a few of the examples I found in books and art magazines: "The artist's intention is not to produce images but to ques-

tion images, shall we say, in his categorical entreaty"; or, "If in the imperfection of a technical reproduction one can glimpse the possibility of a paralogic state, of reality reconstructed as fable, or romance, or invention, then the manual imperfections with which the pictorial text is studded give rise to a pulsing and thus different entity which resists the regime of homologous information technology". Here is another one: "In the case of this artist, the pictorial contextuality is richest, encapsulating notions of the presence of indeterminate images, both vaguely objectified and venerated, a certain density of memory immersed in such a context". And finally, try to make sense of this one: "The mark of our artist is, by contrast, a lineary syncope which produces a polyrhythmic dissonance. Thus his convulsion is both a lucid conscience of a state and of a status of being."

Sentences like these will definitely not appear in this book and anyone who wants to approach art with healthy curiosity and passion is warmly invited to ignore critics and curators who try to intimidate them with incomprehensible jargon.

So what do we mean by contemporary art? In January 1998, Christie's auction house announced that, in its auctions and catalogues, it was changing the parameters defining contemporary art from the rest of the art produced in the 20th century. The new start for contemporary art was 1970.

After a couple of seasons, Christie's backtracked and again included artists from the 1950s and 1960s in its contemporary art auctions. But it nevertheless remains true that there is a whole generational and artistic leap separating a slash in a canvas by Lucio Fontana and an installation by Santiago Sierra. Works produced in the decades immediately after World War Two seem like "classics" compared to today's pieces.

Even art ages and this has direct repercussions on collectors and in museums. The 19th-century notion of a museum containing the entire history of art is dying out and museums are gradually becoming more specialised. A contemporary art museum can only be a museum in the process of transformation. While stopping short of the radicalism of Christie's decision, this trend was illustrated by the fact that, in December 1998, the Museum of Modern Art of New York (known as MOMA) gave the Metropolitan Museum of New York works by Van Gogh and Seurat because the MOMA and the donor of the works, Abby Aldrich Rockefeller, no longer considered them appropriate for the collection of a modern art museum.

As far as the art market is concerned, the new division puts auction houses in a leading position, and a position of force, compared with other players in the sector (galleries, critics, art fairs, museums). The brochures Christie's sent to collectors and institutions around the world to present its new method of dating contemporary art included a list of about a hundred artists considered by its experts to be the worldwide elite of contemporary art. It is certainly not an exhaustive list, but it is definitely significant, and more influential than other attempts at categorisation. In Christie's list, there were seven Italians: Alighiero e Boetti, Jannis Kounellis (Greek by birth, but Italian by adoption), Mario Merz, Sandro Chia, Francesco Clemente, Enzo Cucchi and Mimmo Paladino. These artists belong to the two art movements to have emerged in Italy created by Italy's two most internationally respected art critics: Germano Celant's Arte Povera (Boetti, Kounellis and Merz) and Achille Bonito Oliva's Transavanguardia (Chia, Clemente, Cucchi and Paladino). If Europeans and U.S. artists are excluded,

only two of the artists cited by the auction house come from the rest of the world: the Indian Anish Kapoor (though he is de facto English and represented Great Britain at the Venice Biennale in 1990) and the Korean, Nam June Paik. The typically Western nature of contemporary art only began to disintegrate in the final years of the 20th century and one of the essential characteristics of art in the 21st century is this very internationalisation of art. We will see artists emerging in ever greater numbers especially from Africa, Asia (Chinese artists have literally invaded auctions in recent seasons) and Latin America, together with critics from the same countries.

HOW TO LOOK AT CONTEMPORARY ART
(...and like it)

The 1970s

At an auction of contemporary art in May 1999 in New York, Christie's offered a work by Felix Gonzalez-Torres from 1988, consisting of a black background on which the following words and dates were written in white at the bottom: "Patty Hearst 1975 Jaws 1975 Vietnam 1975 Watergate 1973 Bruce Lee 1973 Munich 1972 Waterbeds 1971 Jackie 1968". It is a portrait of the decade sketched by someone who grew up in the 1970s (Gonzalez-Torres was born in 1957) and later cast his mind back, flattening memories and mixing together in one big cauldron both defining political events, such as the Vietnam War and the Munich Olympics that are sadly remembered for the murder of Israeli athletes, with other more frivolous, but perhaps just as significant, events, such Steven Spielberg's film "Jaws" or the commercial launch of water beds. This piece, like others by Gonzalez-Torres, seeks to be the flattest and most anonymous snapshot of a past era: today's culture retains scraps of information and references of it, but is unable to distinguish the important from the inconsequential. It's no coincidence that the words in white look like subtitles on a television screen which renders every piece of information uniform and endorses everything.

The spirit of the art world at the start of the 1970s can be summed up by three apparently defining factors. After the political events of 1968 in Europe, and the response by students on U.S. campuses, art also tried to free itself from rules and constrictions. The provocation and novelty of the preceding years, from the monochrome paintings of Yves Klein to Lucio Fontana's slashes in his canvases, were not considered sufficiently radical because they were still confined to the surface of the painting. Now, artists had to get beyond the surface, as Kounellis would have said, to exit the restricted spaces of galleries

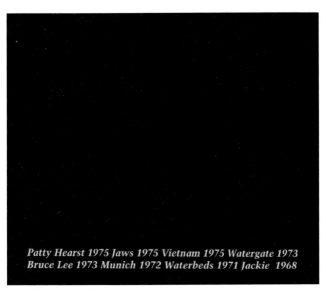

Patty Hearst 1975 Jaws 1975 Vietnam 1975 Watergate 1973
Bruce Lee 1973 Munich 1972 Waterbeds 1971 Jackie 1968

FELIX GONZALEZ-TORRES, "UNTITLED", 1988

*and bring art outside (Richard Long) at a time when ecology was
catching on. It was time to seek different places to put on perform-
ances (Rebecca Horn) or, by contrast, to bring the outside world
with all its day-to-day reality, unfiltered by artistic artifice, inside
galleries by exhibiting live horses, parrots and fires gushing from
gas canisters (Jannis Kounellis). The idea was to annul completely
the distance between the internal world of art and the external world
of reality.*

*A second important factor was that in this search for reality, a whole
series of instruments, materials and techniques that had not previous-
ly been used were adopted: Mario Merz glued dried leaves onto his
canvases; Richard Long picked up stones and scraps of slate;
Giuseppe Penone rediscovered the pleasure of carving beams and
polishing stones picked up from rivers; Jenny Holzer used neon bill-
boards. There were no longer any restrictions on what could be used*

to create works of art and the 1970s would, in fact, turn out to be a decade of very little "painted" art.

The third trend which flourished in this decade was the expansion of "conceptual art", that is, art accentuating the concept, idea or "discovery" at the root of a piece, compared with the moment when it is actually executed. That became a secondary phase which could also be delegated to the artist's assistants or to specialist workers.

Conceptual art is the great overriding idea to emerge from the end of the 1960s and the start of the 1970s and it proved so significant that it conditioned a large part of the art produced in the last 30 years of the century.

"Images should never express anything. Painting is not a means to an end"
Georg Baselitz

It's 1969 and German artist Georg Baselitz, who is just over 30, is at the centre of a storm over his "scandalous" images of heroes with muscular bodies, small heads and their trousers undone. He has just finished painting a canvas and then proceeds to turn it upside down, putting the sky at the bottom and the ground at the top. After literally turning the canvas on its head, he signs it in the bottom right, so there can be no doubt that the image turned through 180 degrees has to be seen this way. Thus he created his first "inverted canvas".

Baselitz himself gives us a very clear indication of what moved him to do so: "Images should never express anything. Painting is not a means to an end. On the contrary, painting is autonomous. And so I said to myself, if that is really true, I should take all the traditional images of painting ⁓ landscapes, portraits or nudes, for example ⁓ and paint them upside down. This is the best way to free the images from their meaning." Thus we see the beauty of the painting for the painting's own sake, the work stripped of any content, remaining simply as pure forms and colours.

"Birch" ("Birke") from 1970 is one of Baselitz's first inverted works and uses an image deliberately devoid of any par⁓

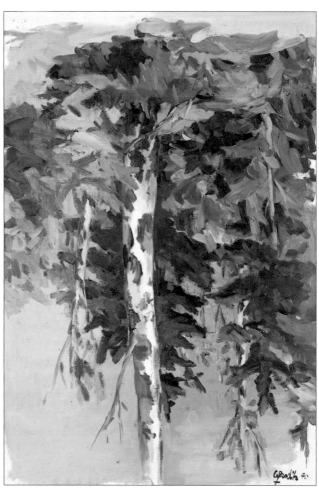

Georg Baselitz, "Birch", 1970

ticular attractiveness or any political or social connotation to underline the supremacy of the painting itself and of the colour over the choice of subject. The upside down image of the tree, and in particular its branches and leaves, are rendered with broad brushstrokes that accentuate the abstract character of the representation. In Baselitz's works, the paint starts out as pure energy at the centre of the canvas and spreads to the edges which often, as in the case of "Birch", keep some small areas unpainted as if the force of the colour had run out before reaching the edge of the painting. But this is also a trick to remind us that the canvas is a real object and the image conveyed upon it is just an image.

Inverting a painting is a contrivance to concentrate the observer's attention on the abstract part of reality, on how the colours interact with each other or how the paint is dripped. From a theoretical point of view, it is also an important contribution to the elimination of barriers between the figurative and the abstract. Baselitz demonstrates that the artist can make these two natures, which are apparently so far apart, coexist.

Baselitz's works are not about understanding the significance of the inverted images. Instead, he seeks to immerse the observer in the innate abstraction of every figure, in the elements conveying the pure essence of the painting which are also contained in the depiction of the most banal of landscapes. In "Birch" this is true especially on the right and the upper parts of the image. If we cover the trunk of the lighter coloured tree, all that remains in the painting is absolute abstraction.

Lucio Fontana tackled the problem, and the desire, as Kounellis puts it, to get beyond the surface, in dramatic and decisive fashion in the 1960s with his famous slashes in the

canvas. Starting from the same artistic concern, Baselitz asks himself: "For me, the question is: how to continue painting?" The German artist's gesture, just like that of Fontana 10 years before, is not designed to negate the painting. On the contrary, it seeks to reaffirm its lasting power. Baselitz demonstrates that there is still immense room for the artist to use canvas and colours, especially at a time (bridging the 1960s and 1970s) when many artists were distancing themselves from traditional artistic instruments and techniques amid the challenge of new materials. We see this in the works of Jannis Kounellis, Richard Long and Rebecca Horn. Georg Baselitz, on the other hand, wants to carry on painting and this is what makes him appear a "classical" artist. His talent, greatness and importance stem from the fact that, by remaining faithful to the traditional tools of his trade, he nonetheless manages to reinvent how they are used with strong expressive power and to enormous effect.

Imagine the sound of a workman soldering something with a blowtorch. Now imagine that inside four walls and multiply it by 20!

Jannis Kounellis

Jannis Kounellis is one of the leading exponents of the Arte Povera (Poor Art) movement, as the critic Germano Celant termed the movement which emerged in Italy at the end of the 1960s and the start of the 1970s. What stands out in Arte Povera is the use of low-grade materials like coal, jute sacks, iron, glass, cardboard and so on, instead of art's "noble" materials like marble and bronze. But the term "poor" also has a political and social connotation in that this movement also sought to be "proletarian" in contrast to the tastes of the bourgeoisie. It is no coincidence that the movement took off immediately after 1968 in Genoa and Turin, two industrial cities with large working-class populations.

From 1967, Kounellis began using fire in his pictures, either in the form of lighted blocks of metaldehyde or, more commonly, by using blowtorches connected to gas canisters. Before him, other artists, especially Yves Klein and Alberto Burri, had made use of fire, but essentially as a tool

to obtain particular effects and not as a direct element of artis‑
tic composition. Kounellis, on the other hand, uses fire as
the subject of many of his works. Kounellis himself says of
fire that "the elements of sound and heat achieve this exter‑
nal movement, from the wall towards the spectator, while
in the case of a painting it's up to the spectator to read the
wall. So it's a trip in another direction." "Untitled" (all of
Kounellis' works are deliberately devoid of titles) from 1971
comprises more than 20 burning blowtorches laid out on
the floor, all pointing in the same direction. In this way the
space in the gallery is charged with energy and rendered al‑
most magical by the presence of a living material which in‑
spires both fascination and fear. Furthermore, fire is an ele‑
ment which invokes not only religion and the sacredness of
ancient rites and altars, but also the modern industrial era,
with labour in factories and steelworks and the working
class.

In this work, the acoustic dimension cannot be stressed
enough. Photographs of it annul the element of sound,
which is almost deafening when experienced in a gallery.
Imagine the sound of a workman in the street soldering
something with a blowtorch. Now imagine it inside four
walls and multiply it by 20! Not to mention the heat! All
this creates a real, almost infernal, landscape of its own in
which not only our sight but all our senses are involved (the
smell of gas is also important). It's a scene that attracts but
at the same time repels us because it strikes an instinctive,
and completely justified, fear of being burned if we venture
inside the intricate route marked out by gas canisters, hoses
and flames. So we remain on the edge of a wood, barred
from entering by our own fear. Despite the "poor" references
conferred by the materials used, it is a scene with the char‑

Jannis Kounellis, "Untitled", 1971

acteristics of a grand formal structure since Kounellis' installations are carefully studied and executed within a precise framework.

Works by Kounellis such as "Untitled" from 1971 are important in that they manage to combine the force of the materials, which convey an undeniable fascination and a considerable charge of energy, with an attempt to provide an answer to what Kounellis defined as "the problem of understanding what pushed us to move beyond the surface" and what could today be "the critical dialogue between the concepts of structure and sensitivity". The switching of the roles of observer and artwork is also fundamental. Witnessing Kounellis' work, the spectator is both brought down to earth and overwhelmed by the presence of uncontrollable elements (in this case, fire, or the presence of live, bucking horses as in the case of one of his most famous exhibitions in Rome at the Galleria L'Attico, then repeated at the Venice Biennale) which render the spectator totally passive and give the work a life of its own. These are pieces in which it is futile to resist and it is far better for spectators to allow themselves to be drawn in by the vitality of the work in which they are immersing themselves.

Richard Long's **lines, crosses and circles refer to the shamanistic and religious traditions of ancient civilisations**

Richard Long, the best-known exponent of a group of British artists known as the "Nature Boys", has set out to turn his rapport with nature into a single, global work of art. The group's other leading light, Hamish Fulton, often joined him on his adventures and strolls.

Why "strolls"? Because every work by Richard Long is based on a journey he made, a walk (lasting anything from an hour to 10 days), immersed in nature. Walking for him has become a kind of personal artistic technique; steps are for Long what watercolours or acrylic paints are for others: a means and not an end by which to express the concrete nature of a relation between man and nature.

But if his art springs from an action with a beginning and an end, what is left to document its existence? Essentially three types of "traces": simple descriptions of the walk, to which he often adds the transcription of the atmospheric phenomena (rain, wind, snow) which he encountered on his trip; photographs of things he did on it and the landscapes he passed; and the reassembly in a neutral environment (like the rooms of an art gallery or a museum) of natural elements he picked up on his walk: bits of wood or stones as is the case of "Three Circles of Stones". This last

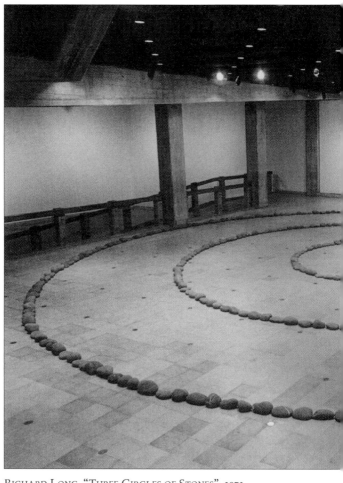

RICHARD LONG, "THREE CIRCLES OF STONES", 1972

type of "traces" are the basis for Richard Long's sculptures, which are always reconstructed in a simple and primitive form using strictly natural materials from a particular environ, onment. Lines, spirals, crosses and especially circles constitute the essential catalogue of images which he uses, varying

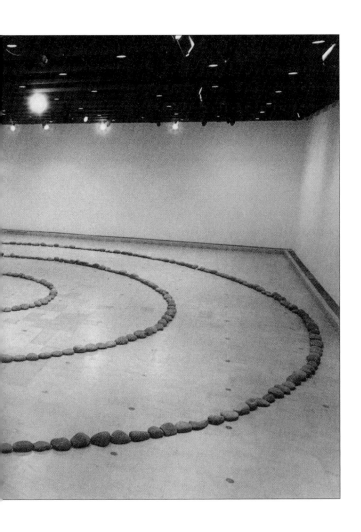

the dimensions and the materials, to produce very different works. But what is there to attract us in a series of completely ordinary stones laid out in concentric circles, as in the case of "Three Circles of Stones"?

The simple shapes which Long uses have nothing to do with

the contemporary art movement called "Minimalism" which also uses simple structures reduced to their essence but in a rather different way, linking them to serial industrial production. Long's lines, crosses and circles refer instead to the shamanistic and religious traditions of various ancient civilisations. They take symbols and signs present in antiquity in every part of the world, from the circles of monolithic stones at Stonehenge (not far from Richard Long's native Bristol), to the crosses carved on the stones of catacombs. The use of these primordial shapes immediately brings us into contact with a quasi animistic nature charged with spiritual meaning. They are forms that we don't need to analyse logically for them to draw us in. They interact with our minds in what we might call a pre-rational way. The idea that the artist walked on the paths running beside a mountain patiently picking up a certain number of stones, and brought them back down in order to rearrange them according to a precise scheme inside a room in a gallery, has something of ritual about it and, at the same time, something unique. It is the fact that it is only "these" stones and not any others that may have caught the attention of the artist, and only "that" particular arrangement and no other, which encapsulates the secret of the rapport built up between Long and the landscape at that precise instant and in that precise place.

His sculptures can by their very nature be dismantled and set up again (though always according to precise instructions contained in a certificate provided by the artist), and the artists sees the slight "imperfections" that result every time that the stones or branches are laid out beside each other as a way of bringing him closer to the continuing and mutating imperfections of the human condition. It is interesting to note how the natural elements which make up his

works ⁄ even when installed in an environment which is to⁄ tally different from their original location, like the room in a museum ⁄ maintain and indeed seem to amplify their force and impose their presence with authority.

Even if, at first sight, it might seem a provocative remark, Richard Long is de facto a landscape artist and the poetry of his works has been compared with the great romantic English tradition from Constable to Wordsworth, in which, as for Long, the direct, unfiltered experience of na⁄ ture was of primary importance for the artist.

Just as in the case of "Three Circles of Stones", the titles of the works are always self⁄referential, adding nothing more than the description of what the eye of the observer can see. This extreme reduction to the qualities of the piece which can immediately be perceived ⁄ a circle of stones is a circle of stones, a line made up of dry branches is nothing more than a line of dry branches ⁄ renders his work at the same time both simple to the point of banality and mystically evocative. It is their very simplicity which sets off in the ob⁄ server a series of unconscious questions which immediately establish a link between the work and the deepest part of our minds, rather than with our rational intellect.

"But I could do that too!" That's the typical comment many people make when faced with the apparent simplicity and the lack of crafts⁄ manship of much modern and contemporary art. Who couldn't slash canvases like Lucio Fontana or line up a few stones like Richard Long? "Well, why don't you then? Considering that one of Fontana's "cuts" costs as much as a manager's annual salary, it could be a brilliant alternative to winning the lottery.

But in fact there's a world of difference between "creating" and "re⁄

producing". The fact that I know how to play a Schubert sonata on the piano does not put me on a par with the composer, even if my technique is impeccable. Even the simplest of melodies can be marvellous and the fact that there are thousands of musicians in the world capable of playing it (sometimes far better, technically, than the composers themselves) does not diminish the importance of the idea, the invention, the creation of the piece. So the moment of creation predominates over the moment of execution and as far as execution is concerned, the problem essentially lies in the distinction between manual skill and art. Not all good craftsmen are artists and technical skill, even if impressive at first sight, is really just one of many elements - and not even the most important one at that - in the complex mixture which creates a work of art. That is why a cut by Fontana, which is easy to carry out, is a work of art of great importance and value. Before him it was unthinkable to "smash" through the canvas, but anyone can do it today: to do so does not diminish but rather gives greater value to Fontana's idea.

Is it unthinkable to consider that technique does not matter anymore? An example from another sector of human genius can help to clarify the terms of the question. Let's take literature. We all share the conviction that our century has produced some great poets: Eugenio Montale and T. S. Eliot, for example, both of them Nobel laureates. Neither of them wrote in rhyme and yet rhyming constructions were the essential technique at the basis of poetry until the revolution of free verse. In the Middle Ages it would have been inconceivable to write poetry that did not rhyme and throughout the 1800s verse had to follow iron rules, at least regarding metre. A poet's skill lay in how best he managed to express himself within the confines that the laws of harmony (the stress, the precise number of syllables in every verse, the rhymes, the length of the composition, etc.) imposed on him. None of this exists nowadays and anyone writing in verse or in rhyme is considered to be engaging in a literary game rather than poetry. Poetic tech-

nique, therefore, has totally lost importance, but the value of poetry is more alive than ever. Similarly, in figurative art, especially since the advent of photography at the end of the 1800s removed any need for art to represent reality, the pictorial skill of an artist began to lose importance until it disappeared entirely in the 1960s and 1970s, leaving the field clear to conceptual art in which what counts is what the idea expresses, the concept, rather than how it is executed. It's obvious that figurative painters will still exist, but the real revolution brought about by photography has been fundamentally to highlight the importance of some factors to the detriment of others. The fact that so many artists in the 1990s have used photography was not in order to provide a short-cut to a picture but rather as a way of eliminating the bother of having to reproduce something by hand, thus giving the artist more room, time and clarity to concentrate on a variety of other aspects (mental and conceptual) innate in the choice of the reproduction of a specific object. In the 1980s there was a partial revival of the importance of technique (Spanish artist Miquel Barceló is, for example, technically excellent). It took on different connotations in the 1990s, when technique itself evolved with the use of different and sophisticated means of expression, notably video, which need often huge material and human resources to be fully exploited (the cast of people taking part in the "production" of Japanese artist Mariko Mori's photography or video is astonishing, and looks more like the closing credits on a film).

But if technique is only one of the elements of a work, why do Fontana's "cuts" cost 200,000 to 400,000 pounds if in fact they can be copied so easily? The answer is precisely because they are original, and as such unique and impossible to reproduce. They are the expression of an artist at a point in history. They are part of the history of art. They have "lived" their reality like a tattered flag from a war museum which has a whole lot more worth than a brand new flag just out of the factory.

An artist's body is transformed into a machine which alters the body's sensory, expressive and communicative capacities
Rebecca Horn

In the early 1970s, Rebecca Horn was one of the artists us‐ing "performance" as a working technique with the great‐est force and to greatest effect. Performance is an "action" exe‐cuted by the artist with movements, words or sounds in front of a public witnessing the representation (either outdoors or inside a gallery) while it is documented in photographs or on film or video. Documentation relating to the perform‐ance is not considered a work of art in itself, because the piece is only the work of the artist at the moment it is performed (even if, in fact, it is this documentation which galleries sell to collectors).

The dichotomy between the desire to communicate with the outside world and the impossibility of doing so is at the ba‐sis of many of Rebecca Horn's performances. The sense of solitude and removal from external reality comes from her own experience. While at art school, she began creating sculptures from polyester and other synthetic materials, but no one told her that they could give off toxic fumes. She was taken to hospital with lung poisoning and was sent to a sana‐

torium where she spent nearly a year of her youth. Horn herself recounts that "at that time I was so completely isolated from the outside world that I began to develop ideas for communicating with other people through my work. All of my early performances were born out of my experiences at that time". The artist's body, therefore, is transformed into a machine which alters the body's sensory, expressive and communicative capacities, almost always diminishing them or rendering them more difficult.

Sometimes Horn has fixed long prostheses made of birds' feathers to her fingers. On other occasions she has worn or made actors wear complex systems of tubes recalling the circulation of blood around the body. In the performance "Mask of Pencils", which is documented on film, Rebecca Horn wears a leather structure on her face with a number of pencils sticking out, pointing outwards, like the rays of a sun. The artist moves her head from left to right and right to left, continuously until the pencil needs sharpening, cre-

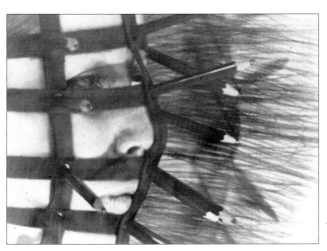

REBECCA HORN, "MASK OF PENCILS", 1972

ating a mass of horizontal pencil lines on a sheet of paper placed in front of her. The sense you get, watching the film, is one of desperation. The film shows neither her arms nor her hands which ought to be the natural conduits of writ-ing. The artist's mouth, furrowed by a vertical leather strap, makes no sound. Her body, restrained by the mask that ap-pears anything but a reassuring means of expression, is seek-ing to transmit a message. But the result is a series of grey lines like a television set tuned into the wrong frequency showing no images. The attempt to communicate and the physical effort expended in such efforts are completely out of propor-tion to the result obtained, which is practically nil. The pol-itical climate at the start of the 1970s provides additional so-cial overtones that underline the need to keep trying to com-municate at any cost, to keep trying to change, to keep try-ing to react to the cage imprisoning her head.

It's as if the work of art were a building which the artist, like an architect, designs
Sol LeWitt

At the end of the 1960s and early 1970s, artists began creating non-permanent works painted directly on walls and not on a background that can be moved (like paper or canvas).

Paintings on walls have obviously always existed and the figures of animals traced inside caves are the first documented evidence of human art. But it is the "temporary" nature, the fact that they can be erased and then redrawn, that makes these non-permanent works absolutely unique.

It is precisely because of their temporary nature that such works are generally accompanied by "certificates" written and signed by artists containing indications and instructions for their correct installation, proving at the same time property and reproduction rights. These are artworks that need to be accompanied, justified, by a certificate which attests to their existence. The particular nature of the works defined by certificates of authenticity in this way is the fact that they are unstable but can be reproduced infinitely and each reproduction will to all intents and purposes be authentic and original, while the document which attests to its existence appears almost like a legal document with no pretence of being considered a work of art in its own right.

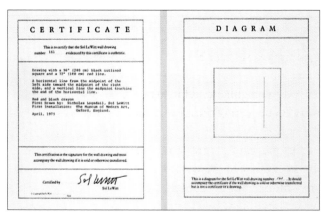

SOL LEWITT, "WALL DRAWING # 161", 1973

In 1968, Sol LeWitt invented the "Wall Drawings": paintings done directly onto the walls of galleries, museums or the collector's home which, unlike murals, can be moved despite their having been executed on a fixed surface simply by erasing them from one place and recreating them in another. Their originality lies not in the fact of executing the work directly on the walls ⁄ think of the frescoes of Pompeii ⁄ but rather in the fact that they can be destroyed and recreated an infinite number of times.

"Wall Drawing # 161" was conceived and installed (that is, designed and subsequently removed) for the first time in 1973 in the Museum of Modern Art in Oxford. The design is simple in the extreme, being composed only of a large square drawn in black pastel in which two red lines are placed. LeWitt deliberately intends to reduce the elements at his disposal to the bare minimum in order to arrive at the purity and essence of the work obtained not by the addition but by the subtraction of elements. The vast majority of his works in the1970s in fact comprises just four

types of lines (horizontal, vertical, diagonal, 45 degrees from right to left and 45 degrees from left to right) and four colours (yellow, red, blue, black) and their multiple combinations.

In order to highlight his bid to raze any emotional involvement on the part of the artist in the execution of the work, the wall drawings (just like the sculptures from the Minimalist movement which emerged in the United States in the second half of the 1960s) are often executed not by the artist himself but by his assistants. It is as if the work of art were a building which the artist, like an architect, designs, oversees and in which he supervises the work of technicians and workers, but does not necessarily build himself. For this reason, the certificate which "proves" the original and authentic status of the work takes on increasing importance.

A Sol LeWitt "wall drawing" produced in an edition of 10 numbered copies in 1992 in collaboration with the Galerie Schellmann in Munich is the extreme case of the prevalence of the certificate over the work. Whoever acquired the rights of the work was free to write the two words "wall drawing" on the walls of his or her house using any method and any format. A photograph of the writing had subsequently to be sent to the artist who would then authenticate it and send it back to the owner. In this way, not only does the artist not intervene directly in fabricating the original work, but he can also give no indications of the size, type of paint or characters to be used to write the two words. In this case, therefore, the certificate is a pure exemplification of an idea. After Sol LeWitt, many other artists have created wall drawings and some, like English artist David Tremlett, have made it their favourite technique.

An interesting corollary is the question of how these works can be transported from one country to another without falling foul of national export authorisation legislation, which can at times be very severe. What can in effect be taken materially from one country to another is the "certificate" which, like any other certificate authenticating an artwork, is a document that is not subject to restrictions regarding free circulation of artworks. The piece itself is not moved from one country to another, even though it de-materialises in one place in order to be recreated in another, maybe 2000 miles away.

It is likely that in future an increasing number of artists will also create works across the vast range of their production whose uniqueness and originality will be backed up solely by a certificate (such as in the case of Felix Gonzalez-Torres), while the temporary material reality of the works will be the product of instructions and technical details that can be reproduced and recreated infinitely. Therefore we could one day imagine a show travelling from London to New York and to Tokyo that would happen only on the basis of "reproduction rights" without a single work being transported from one place to another. The works will be produced in a museum, scrubbed out and then reproduced in new exhibition sites.

Robert Ryman
eliminates colour from his works, choosing to use the most neutral of tones: white

The problem of standing in front of a canvas and having to decide "what" to paint (a flower, a landscape, a portrait) isn't the main problem of contemporary painting. Subject matter is just one of the aspects of the work and often it is relegated to secondary importance by questions about "how" to paint (in abstract art) or "why" to paint (in conceptual art). In the abstract art of the 1950s, prominence was given to the purely visual aspect of a work linked to the use and appli‑cation of particular tones and to the way in which the colours were applied to the canvas: sometimes by dripping (Jackson Pollock), sometimes with large and violent brushstrokes (Franz Kline), and other times by letting the colour run from one side to another by tilting the painted surface (Morris Louis).

Robert Ryman has an even more radical approach. He not only totally eliminates from his work any figurative reference, but he also abolishes colour, choosing to use only the most neu‑tral of tones: white. Other artists before him had painted mono‑chrome works, comprising the application of a single colour. The most famous is Yves Klein who painted many works at

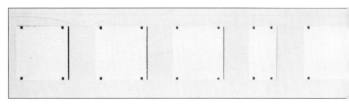

ROBERT RYMAN, "UNTITLED (STUDY FOR BRUSSELS)", 1974

the end of the 1950s and start of the 1960s in a particular very intense shade of blue that he named, and which came to be known as, IKB (International Klein Blue). But while Klein chose the colour blue to represent feelings and emotions linked to the realm of spirituality and asceticism, Ryman wants to eliminate any involvement of an emotional kind. And indeed white is a colour which does not distract the eye and can high-light aspects of the painting that the presence even of minimal nuances of colour would relegate to a secondary plane.

Ryman has also chosen to limit the format of his works solely to square surfaces because they represent, as he says, "the per-fect space". The equal length of the sides, marking the outer edge of the canvas, accentuates the artist's and in turn the spec-tator's concentration on what happens inside the edges.

So what remains of a painting if we take out both the con-tent, whether figurative or abstract, and the form? For Ryman, what is left is paint, understood as the physical ges-ture of painting, at its most pure.

If, on the one hand, Ryman's painting appears as a continu-ation and a radicalisation of works by artists such as Malevich or Mondrian, the difference is that his canvases seek neither to spark nor back up theoretical assertions. His works are the sublimation of the pleasure of spreading a colour on a surface. In practice, he paints the paint.

An additional important aspect of his pieces is what they

are painted on and how they are fixed to the wall. In "Untitled (Study for Brussels)" from 1974, a work comprising 10 identical panels to be mounted one beside the other on a single wall, the colour has been spread on a vinyl surface applied in turn onto fibreglass. The presence of the four metal brackets arranged in pairs on the two horizontal sides of each panel becomes fundamental. It was in the mid 1970s that Ryman began using different ways of hanging his paintings on the wall, especially metal brackets of various types and sizes which have the function not only of fixing but also of distancing the painting from the wall. Through the use of brackets, Ryman wants to define the space of the work, which could lose force and autonomy since it lacks a frame and is fixed to a wall which is equally white. At the same time, he wants to hang the work and make it an indissoluble part of the wall, of the room and thus of the architectural space which surrounds it.

It is incredible how, by limiting himself to one colour (white), and to one format (the square), Ryman's works manage to be different from one another. And it is equally strange that some works seem "better" than others and "more beautiful". Why does one white square canvas appeal to us more than another? It is not possible to reply without a genuine faith in art and its capacity to connect with our unconscious in an almost subliminal way.

The beams conceal indelible traces of the tree and the artist rediscovers the soul of the wood, reconstructing the lines of its past

Giuseppe Penone

Throughout the history of art, nature and human figures have always been artists' favourite subjects.

By the end of the 1960s and the early 1970s, various "schools" of artists emerged, looking at nature and producing works based on natural elements. There was the so-called Land Art group, which used nature essentially to construct works of enormous dimensions inserted into, and interacting with, the landscape. The American artist Walter De Maria, for example, created one of the most spectacular works of art ever conceived. It is called "Lightning Field" (1971-1977) and is made up of hundreds of lightning rods scattered across a semi-desert terrain in New Mexico where storm clouds concentrate with unusual frequency and thus where dozens of electrical charges are discharged. Then there was the group of English "Nature Boys" mentioned earlier: Richard Long, Hamish Fulton and, later, Andy Goldsworthy.

Separate from these two trends is the work of Giuseppe Penone which, having developed within the Arte Povera movement, insists on trying to redefine the relationship between the natural world and man. Instead of considering the landscape as an object in his works, the Italian artist appropriates its elements (trees, leaves, stones, etc.) and uses them as instruments of his artistic work in place of paintbrushes, colours, paper and chisels.

"Four-Metre Tree" is part of a group of similar sculptures which Penone began in 1969. He takes as his starting point a wooden beam (whose length is always indicated in the title of the piece) and after having identified both the direction of growth (where the base and where the top of the tree were) and a particular ring inside the trunk (which indicates the circumference of the trunk at a given moment in its life), he begins to "peel" back the beam following the rings and the knots in the wood so as to reveal again the exact features of the tree which existed years before and which grew to give life to the timber now making up the beam itself. Through careful chiselling, incisions and excavation work in his studio, Penone restores form and life to a natural object that has been transformed by the actions of man - by cutting down the trees, chopping off branches, squaring up the beams - into an object destined for industrial production. The beams conceal indelible traces of the memory of the tree (just as an old man wears how he looked as a boy or a baby imprinted beneath his skin): the artist rediscovers the soul of the wood, reconstructing in this way the lines of its past.

Once the ring inside the tree to be used as a reference is chosen, it is interesting to note how the artist is bound to what he is doing by the natural shape of the original tree and cannot proceed autonomously according to his own stylistic

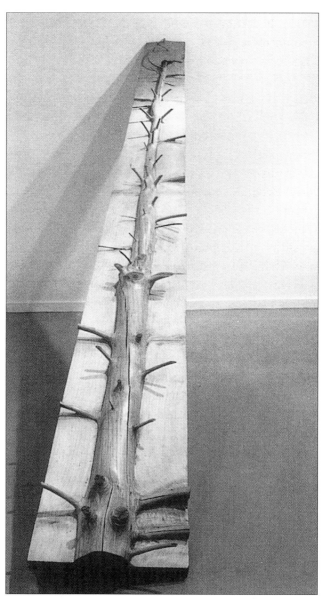

GIUSEPPE PENONE, "FOUR-METRE TREE", 1974

choices. It is a kind of conditioning that we find in another exponent of the Arte Povera group, Alighiero e Boetti, who, albeit in an entirely different fashion, experiences the same characteristics of constriction and limitation of artistic individuality, as we shall see later in "Map of the World" from 1984. Penone is forced to shape his artwork by the natural forces he chooses to deal with.

Penone has also presented some installations comprising trees of varying shapes and sizes laid one next to another, entitled "Repeating the Wood", in an attempt to recreate a genuine habitat.

Why are Penone's sculptures beautiful? Because they imbue us with a notion of mutual respect between man and nature in which the artist is cast in the role of mediator. Penone's sensitivity and his ease with nature (he was born and brought up in the northern Italian countryside) are immediately perceptible. Furthermore, his sculptures succeed in integrating and amalgamating elements that are perfectly natural (the material used) with conceptual elements (the desire to bring back to life a tree that no longer exists and has been lost in time). In the same way that Baselitz unites figures with abstraction, Penone reconciles man with nature.

Gerhard Richter
has remained constantly faithful to painting: this gives him the status of an almost "classical" artist

In a decade which saw the growth and differentiation of artistic materials and techniques, Gerhard Richter has remained constantly faithful to the traditional discipline of painting and has never deviated from that: this gives him the status of an almost "classical" artist. His extremely vast output, ranging from portraits to landscapes to abstract works, invariably starts, as a tool for representation, with the use of colour and its layout on the canvas.

While Robert Ryman's squares tackle the spirit of reduction and purity which is made explicit through the exclusive use of the colour white, Richter takes the opposite approach in that he uses an excess of colours to achieve the delicate balance of his work. To borrow a philosophical simile, we could say that Ryman searches for the infinitely great in the infinitely small (the rigid confines dictated by a highly limited spectrum) while Richter seeks the infinitely small (namely the rule on which the principles of painting are based) in the infinitely great (the infinite range of possibilities conveyed by colour). Richter himself explains the principle on which he based his painting "1024 Colours" in a book aptly entitled *The Daily Practice of Painting*. He states: "In order to represent all the existing graduations of colour in a single painting I devised a

GERHARD RICHTER, "1024 COLOURS", 1974

system which ⁄ taking its starting point from three primary colours [red, yellow and blue] with the addition of grey ⁄ enabled a continuous subdivision based on equal graduations: 4 x 4=16 x 4 = 64 x 4 = 256 x 4 = 1024. The use of multiples of four was necessary in that I wanted to maintain the square shape of the painting and the number of squares in constant proportions. To have used more than 1024 shades, for example 4096, seemed pointless to me since the difference between the final graduations would not have been perceptible to the naked eye. The colours were arranged randomly on the surface so as to obtain the generalised effect of a lack of differentiation, while at the same time having some zones that prove more stimulating than others."

Thus the painting is presented as a complete range of the colours available to the artist randomly arranged on the canvas. Each square is in a different shade to the other 1023 and this constant differentiation is unsettling and creates an effect which was to be specifically exploited 15 years later by the English artist Damien Hirst with his so-called "pharmaceutical paintings".

Richter's work obviously has conceptual properties by dint of the fact that, just as traditional techniques were being relegated to a secondary plane, he sought to highlight the importance of painting itself. By concentrating not on the figurative aspects but on the essence of painting, he divests the work of any concern for subject matter. It is as if the artist wanted to distance himself from the creative process by avoiding taking decisions about what to paint in his pictures.

That is also evident in his most famous figurative works, which are in fact reproductions in black and white of photographs often taken from newspapers. They are characterised by the fact that they represent banal scenes from daily life and are thus "ordinary" pictures.

Eliminating the concern about the subject gives Richter enormous freedom of expression, forcing him to concentrate on the pure colour or, as in "1024 Colours", on all colours that can be seen by the observer and which contain within them any possibility for creation. His attempt to penetrate the mechanisms of painting beyond representation and the object depicted makes Richter comparable in some ways to an artist like Giulio Paolini, who at first sight appears totally different to him, but who has also put the quest for "seeing" and meditation on the nature of art at the heart of his work.

"Art about art" where the pleasure is not in the eye but in the mind
Giulio Paolini

"Mimesis" is the Greek word for "imitation" and it is gen‐ erally used to refer to the artistic theory initially conceived by Plato according to which art is a pale imitation of reality, in contrast to later theories elaborated by Kant and Hegel which see art not as imitation, but as free individual creation. "Mimesis", just like other works by Giulio Paolini, is a re‐ flection upon art, on space, on the concept of original and copy, and on the role of the artist. Paolini's works are con‐ ceptual meditations on particular aspects of art and make no concessions to the romantic side of art or the attempt to trans‐ mit feelings. His art has been described as "art about art", where the pleasure is not in the eye but in the mind. The writer Italo Calvino highlighted this aspect of Paolini's works, affirming that "all Giulio Paolini's oeuvre starts from the assumption that painting is finished and definitive, a building to which he has nothing to add. He stands out [...] by the determination with which he creates new works on the very narrow margin left from the creative activity reduced to an analysis of itself."

The sculpture "Mimesis" comprises two identical casts of the "Venus dei Medici" arranged in such a way as to appear that the two women are looking each other in the eyes. It is

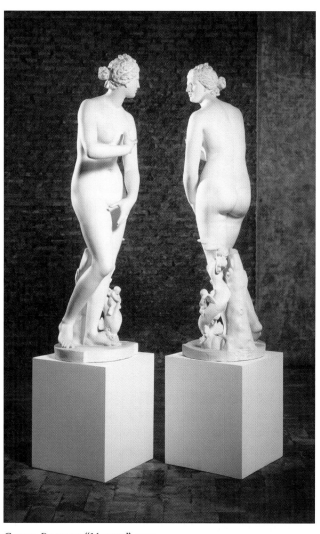

Giulio Paolini, "Mimesis", 1975

thus an image which is duplicated, which sees itself and is reflected in itself. Art thus becomes an imitation of art and the spectator risks losing him- or herself in a game of infinite repetition of the work, always identical, but, at the same time, always different.

The two identical copies looking at each other appear to be debating the very meaning of "original" and "copy"; whether a copy can become less of a copy; and the need, beyond the way the work mirrors itself, for it to have an audience. But the statue staring at itself also seems to allude to man's unavoidable need to compare himself with his peers. The glance of the two Venuses also seems to create a magical space in which time is suspended and estranged from reality. The very fact that it combines intellectual reflection with an aura of indefinable attraction turns "Mimesis" into a wonderful work. The artist himself has talked about this strange, evanescent territory created between the two figures: "When I put two identical copies of the same ancient sculpture facing each other, I do not seek to be the person who created or rediscovered them, but the observer who grasps the distance which separates them and in so doing comprehends all of the possibilities of a relationship or lack of relationship between them, and between that image and ourselves. What interests me is conveying the distance separating them." It is interesting to note how Giulio Paolini, who has practically never painted or sculpted in the traditional sense of the word, defines himself as an "observer" and not the "author" or "artist", thus confirming the meditative quality of his work.

For the first time in the history of art Carl Andre has given importance, and even predominance, to the "flatness" of sculpture

"This sculpture can be walked upon," said the sign in London's Tate Gallery, where I first saw a sculpture by Andre, an artist who made his name when in 1968 he started making essentially flat sculptures that could be laid down on the floor like the one I was standing in front of.

Andre apparently conceived his "floor sculptures" after being inspired by the flat water of a lake and trying to recreate the intensity and sensation it conveyed. The work put me in mind of a short story by German writer Helmut Heissenbüttel in which he talks about a "painter of water" who painted his works on the surface of lakes and of the sea and then let the colour dissipate in the ripples of the water.

Whatever the genesis of his sculptures, Andre must certainly be credited with giving importance and even predominance, for the first time in the history of art, to the "flatness" of sculpture, which previously had generally been characterised according to height and depth. Furthermore, they are sculptures which lie directly on the floor and do not need pedestals: their direct contact with the earth on

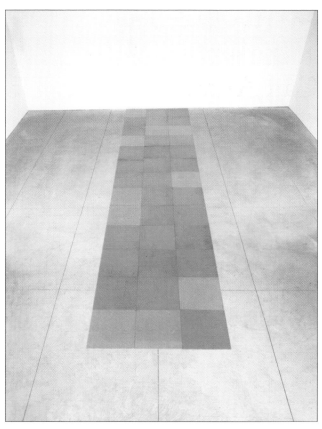

CARL ANDRE, "THIRTY-NINTH COPPER CARDINAL", 1975

which they rest makes them appear "immediate" elements in an urban landscape, that is, elements which frame our daily reality without the intermediary of art.

Can you say Andre's sculptures are beautiful? Certainly their simplicity, which neither intends to mean anything nor to convey any message, has a particular attraction which is hard to resist. Simplicity and novelty are two characteristics which always intrigue.

Carl Andre's sculptures vary enormously in size. There are some minute ones, conceived to be placed on a table and made up of little quadrants measuring just over a centimetre on each side, as well as very large ones.

Andre has used numerous materials but he has a predilection for plates, almost always square, of copper, zinc or iron which he lays beside one another, forming squares or lines as in "Thirty-Ninth Copper Cardinal". This sculpture is composed of 39 square copper slabs that form a single large rectangle.

Like Mario Merz, Andre also draws inspiration from a subject as apparently dry and abstract as mathematics, following a logic tending to reduce to zero any aesthetic or poetic aspect inherent in the work in order to focus attention on its most logical aspect. Andre began his "Copper Cardinal" series in Turin and these pieces, exhibited between 1972 and 1977, consisted of a progressive number of square copper plates. If the number of plates was an indivisible primary number (1, 3, 5, 7, etc.), the slabs were laid in a line one beside the other. If, on the other hand, the number was divisible (when there were 2, 6, 9 slabs, and so on), they were set out in a square or, as in the case of "Thirty-Ninth Copper Cardinal", in a rectangle.

The day I saw Carl Andre's piece at the Tate Gallery, I didn't walk on the sculpture. I was afraid that a lady standing nearby, rapt in contemplation of Rodin, hadn't spotted the sign, and would call the guards at the sight of this man stomping all over a work of art.

Contemporary art is the sum of previous artistic experiences and is intimately linked to them by a linear development
Mario Merz

Mario Merz, one of the outstanding exponents of Arte Povera, is, essentially, a painter of landscapes who, like Penone, finds the perfect subject of his works within nature. But forests, paths or mountains cannot be discerned in his work. What Merz has chosen to represent is not the external features of nature but instead its vital internal energy in a bid to penetrate the secrets of natural development without being drawn into the charm or strength of its external features.

Merz bases his attempt to understand the process of growth of every living organism on a numerical series devised by Fibonacci, an Italian mathematician who lived in the second half of the 12th and first half of the 13th centuries. In Fibonacci's famous progression, every number is the sum of the two preceding numbers: 1, 1, 2, 3, 5, 8, 13, 21, 34, etc. The resulting proliferation, which in nature is effectively at the root of the growth of various organisms, thus appears as the golden rule driving the development of life.

In "Fill-In Leaves" the first numbers in Fibonacci's series,

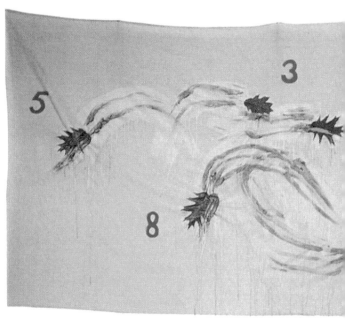

MARIO MERZ, "FILL-IN LEAVES", 1976

up to 55, are highlighted despite their being arranged casu-
ally on the canvas (other works by Metz include all the num-
bers of the series until reaching figures in the thousands).
The other elements on the canvas are some real leaves that
have been stuck on, and coloured brushstrokes linking the
leaves and conferring the impression of a kind of windmill.
Looking at the work, what we see is a wood which contains
nothing of the stillness and silence of a romantic scene: it is
pure energy of the elements in continuous motion.

Another important element in this piece is the fact that the
canvas was not originally fixed onto a frame, but left loose
like a stretched-out sheet. Freed from the rigidity of a support,
the canvas is subject to movements and vibrations, as if it were
moved by the same wind that moves the leaves. Thus the
dynamism and vitality of the piece itself is accentuated.

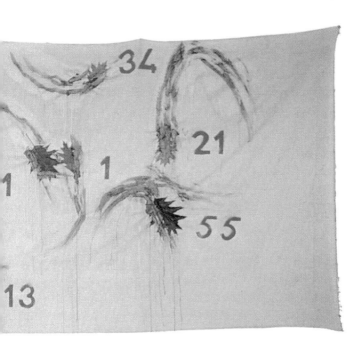

Fibonacci's progression can also be applied metaphorically to the history of art. Thus contemporary art, regardless of the diverse and apparently novel forms which it can assume, is the sum of previous artistic experiences and is intimately linked to them by an intrinsic linear development.

The importance of Merz, just as that of Penone, lies in the fact that he knew the conceptualism of the 1960s and 1970s, but tempered its intellectual coldness with the use of images and objects taken directly from nature.

If you arrive in Zurich by train you see a large sculpture inside the train station: an installation by Mario Merz which represents an enormous reptile climbing up a glass wall overlooking the tracks. It is a very compelling sculpture which brightens up the often unhappy

atmosphere of a train station. I had gone to Switzerland to see "Art Basel", the Basle art show which takes place every year in the first half of June and is the world's most important contemporary art fair. There are also other excellent international fairs: Bologna's "Arte Fiera" in the second half of January, "Arco" in Madrid (in February), New York's "Armory Show" (March), London's "Frieze" and Paris' "Fiac" (in October), and Art Miami (in December).

Wandering between the stands at these fairs is a visual treat and art lovers, even if they have no intention of buying anything, should visit a few fairs because they are often more at the cutting edge of contemporary art than many museums. You could object that fairs are increasingly focused more on commerce than on critical importance. But it's not easy to see works by the world's most important contemporary artists all in one place, as for example is the case in Basle. Thus a visit can be made in exactly the same spirit as a visit to the Tate Modern in London or the Guggenheim in Bilbao.

In recent years, there has been an explosion in the number of fairs devoted to contemporary art. Large and small cities appear to have discovered a vocation for holding them, but galleries generally take part in no more than three or four fairs a year and so the gallery owners who count the most tend to focus on the traditional dates, such as Basle, London, Miami and New York.

Jenny Holzer
aims to stimulate people to share and identify with statements that are banal in their truthfulness

It's unnatural to imagine the work of Jenny Holzer on dis⁄
play inside an art gallery or inside a museum. Her slogans,
which over the years have been printed on flyers, T⁄shirts,
stickers, caps, put in neon displays or carved into stone
benches, were born to be shown in public spaces not assigned
to art so as to be seen and read by ordinary passers⁄by.

The so⁄called "Truisms" are a series of brief, snappy, spe⁄
cific phrases which adopt the style and directness of the ad⁄
vertising world to provide a commentary on consumer so⁄
ciety, its rules, and its conditioning on our way of life that is
by turns ironic and pitiless. Some of the most famous of these
phrases are: "Protect me from what I want"; "Abuse of
power comes as no surprise"; "Money creates taste"; "The
beginning of the war will be secret"; "Stupid people shouldn't
breed" and "Expiring for love is beautiful but stupid".

These phrases were collected between 1977 and 1979 and
were the theme of installations and shows during the whole
of the following decade, interacting in a different way ac⁄
cording to the context in which the works were presented.
The photograph printed here was taken in Las Vegas in

1986 when a series of "Truisms" was run on an enormous neon billboard, about six by 12 metres, set up on top of Caesar's Palace, one of the city's most famous hotels.

By using methods that put her works in direct contact with an enormous public, Jenny Holzer intends to stimulate people to share and identify with assertions that are banal in their truthfulness. Whoever reads these slogans while walking down the street, heading out to the casino to gamble (as in the case of Las Vegas), or driving home from work, feels detached from them, but then reflects on them later. Someone faced for the first time with one of these phrases in an a generally anonymous context that has nothing to do with art (they have appeared for example on the neon signs above luggage reclaim belts at airports, or on stickers stuck to parking meters) has no idea, and can have no idea, of what it's all about and could indeed mistake them for public announcements or advertising. Contributing to this is the com-

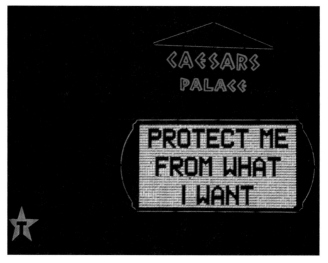

Jenny Holzer, Selection from "Truisms" series, 1977-1979

plete separation of the artist from the formal creation of the work. Jenny Holzer does not paint or write her phrases by hand, but always uses industrial processes (typography, printing, LED) which do not require the direct participation of the artist in the execution of the work.

It would be wrong to consider the "Truisms" on the same level as poetry. While Holzer does approach a more poetic and creative language in subsequent works ("Under a Rock" from 1986 and "Laments" from 1988-1989), the "Truisms" deliberately flee any linguistic lyricism in a bid to present themselves in the most anonymous and laconic way possible. What defines and characterises these works is the very fact that they are unrecognisable. Thus we cannot relate what we are seeing to pre-existing concepts, although the content of what we are reading is, by contrast, a stereotype of the way we think within our mass culture.

"With you inside me comes the knowledge of my death." The phrase, by Jenny Holzer, is engraved on a silver ring, produced in an edition of 75 numbered copies. It is a multiple, a work of which a certain number of identical copies have been produced which are numbered progressively to form an edition.

Multiples and prints when they are made on paper have a market of their own, specialised auctions and specific collectors. Some collectors hold editions in the highest regard, valuing how certain artists have thoroughly studied the process of reproduction and have successfully executed it using techniques such as aquatint, etching, lithography or woodcut. Other artists, whose work already uses materials and objects that are easy to reproduce from a technical standpoint, have almost been forced into multiple works by the lack of manual craftsmanship innate in their pieces (Jenny Holzer's neon signs are a typical example).

Other collectors consider multiples and prints nothing more than glossy reproductions which conceal the desire for individual works that is all too often beyond reach: an inferred "I'd love to, but I can't afford it". Very few people can spend several thousand pounds on a canvas by Andy Warhol, but there are infinitely more collectors able to spend a few thousand pounds on a Warhol lithograph of which 200 signed and numbered copies have been made.

The market for editions will grow significantly in the next few years by virtue of the fact that many contemporary pieces are in fact industrially created. Furthermore, new trends set to become widespread in the next few years are video and photography: the finished product of a video or a photograph (of which three or 100 copies have been made) is in every way identical.

The first multiple I bought was a piece by Douglas Gordon. It comprises a sheet of white paper which the artist has folded in half, bitten and reopened, leaving the mark of his teeth. The impression you have is of a mouth wide open, in the process of yelling. The multiple by Douglas Gordon, like Jenny Holzer's aforementioned ring, was produced by the Swiss contemporary art magazine Parkett in collaboration with the artist. Parkett dedicates each issue to two or three artists so that the volume appears like a small monograph of each selected artist and offers readers the chance to buy a multiple produced for the occasion at utterly affordable prices, thus giving them the chance, as Parkett itself says, to create your own contemporary art "museum in your apartment". The majority of such editions of the magazine (with collaborations from the best contemporary artists, from Kounellis to Baselitz, from Rebecca Horn to Rachel Whiteread) sold out immediately and are now impossible to find.

Wolfgang Laib
sees art as a veritable spiritual medicine with magical and therapeutic powers

If, in today's globalised world, there is a way of conceiving a work of art as a means of attaining spiritual heights on a par with crucifixes in the Middle Ages which mystics contem‑ plated to enter a trance, then its disciple is Wolfgang Laib. He sees art as a veritable spiritual medicine with magical and therapeutic powers conferring the ability to modify our rap‑ port with the external world through a series of "rituals" or actions characterised by a quest for natural purity as a metaphor for purity of spirit. Laib contends that his works should be considered less as objects belonging to a conven‑ tional system of artistic questing and rather as instruments of a therapeutic liturgy intended for the mind. Given this prem‑ ise, it seems obvious that he feels himself apart from Western art (Wolfgang Laib only recognises affinity with the works of Joseph Beuys, who considered the artist as the "shaman" of the modern world) while he seeks to insert his modus operandi into an oriental‑style sense of religion.

Aside from any philosophical or spiritual consideration, viewers cannot fail to be moved in the presence of his works. They are characterised by the use of natural materials and apparent simplicity of execution that convey a sense of peace and serenity.

Wolfgang Laib, "Milkstone", 1978

Laib has made works which can essentially be divided into four different categories: piles of pollen spread into impalpable yellow and orange carpets on the floor; small constructions in the form of little houses made up of rice and wax; rooms and tunnelled walls covered completely in beeswax; and "milkstones" consisting of slightly concave slabs of marble onto which a thin stream of milk is poured.

This "Milkstone" composed in 1978 is a square block of Greek marble on which three-quarters of a litre (the artist indicates the quantity precisely) of milk are to be poured. The opaque white liquid which veils the polished surface of the marble has the power to convey an enormous sense of calm arising from the perfect equilibrium of two substances which look so different. The heaviness of the stone and the fluidity of the milk are two opposites which balance each other out.

Given the perishable nature of one of the two elements which make it up, the work is extremely unstable. Indeed, it only takes a few days for the milk to evaporate, leaving a yellowish film of grease on the marble.

The importance of the work, beyond the sense of peace which looking at it imparts, does not come from its aesthetic appearance. It is, in fact, the function which derives from it which permeates it with meaning, giving it an almost mystical quality. The owner of the "sculpture" is forced every few days to conduct the "ritual" of filling the convex surface of the marble with milk. The final meaning of the work lies in the benefit which the patient-collector will get out of following the instructions, thus being forced to carry out a repeated action that could help meditation.

Laib's pollen carpets spread onto the floor of galleries or museums, in which he filters the almost imperceptible material through a sieve and often takes hours to distribute it in a uniform fashion, are also highly evocative. In these works too, the lightness and delicacy of the pollen counterbalance the solidness of the floor on which the pollen is laid. This special ritual begins for the artist many months before the work is installed. Following the rhythm of the seasons, Laib personally goes from flower to flower collecting pollen by hand and sealing it in little glass jars that constitute his inexhaustible supply of work material (the pollen is gathered up and put away again after each installation).

Purity of art is a measure of man's sense of harmony with the world and with himself. Healing is a measure of the artist's identification with nature. It is not by chance that Laib did not study fine arts or classics; in fact he has a degree in medicine and wrote a thesis on the purity of drinking water.

Buying a work by Wolfgang Laib does not mean having to

share his philosophy, nor should the purchaser of one of his "milkstones" necessarily feel obliged to conduct this sort of daily purification rite for life. The simple beauty of his compositions can transcend any other consideration. Furthermore, as Lucio Amelio, Italy's most important post-war gallery owner, put it in 1994: "All contemporary art contains something magical." And it is the crisis of figurative art that has increased the importance of the element of wonder and magic innate in so many contemporary works.

"Untitled Film Still # 48" intends to represent reality as a fictional scene, as seen through the evocative and distortive eye of the media
Cindy Sherman

The most famous series of photographs by American Cindy Sherman is made up of about 80 black-and-white images tak-en between 1977 and 1980, all identically named "Untitled Film Still". They seek to evoke an image taken from a film, without giving any other references. The work takes the form of a standard 18 by 23 centimetre black-and-white photo-graph, of which a total of 10 copies were printed, each one signed and numbered on the back by the artist.

In "Untitled Film Still # 48" we know neither who the pro-tagonist of the scene is (in reality, it is Cindy Sherman herself who appears in all of her photographs), nor where she is go-ing (is she escaping or waiting for someone to pick her up?), nor can we tell the time (is it dawn or dusk?). We can only imagine some details of her life and her past from a few specifics like her long skirt, tennis shoes and her hairstyle. Looking at the picture, we are thrust into the role of the driver of a car whose headlights pick out the white shirt of the girl who has

CINDY SHERMAN, "UNTITLED FILM STILL # 48", 1979

perhaps not even realised the car is coming and is still looking the other way. We wonder who she is. For a moment, we enter into the life of a woman we will have forgotten as soon as we have gone round the bend. She has entered and will exit our life with the same speed as scenes in a film.

"Untitled Film Still # 48", like other works by Sherman, intends to represent reality as a fictional scene as seen through the evocative and distortive eye of the media in the era of cinema and television.

Sherman has composed the image very elegantly, presenting it as a triangle with the girl at the tip and two sides formed by the white lines in the middle of the road and the profile of the mountains.

From a technical point of view, it is interesting to know that the photograph was not taken by Sherman (in this case, it was her father who took the picture). It is not important for her who took the picture, but how and why the whole scene has been created. Photography, therefore, is just a technique

among the many different possibilities at the artist's disposal. In 1996, the Museum of Modern Art of New York bought the entire series of "Untitled Film Stills" directly from the artist for $1 million. Not a bad deal when you think that one of the 10 existing copies of "Untitled Film Still # 48" was sold at Sotheby's in New York on May 19, 1999, for $250,500 (an auction record for the artist).

The 1980s

The 1980s, particularly the first half of the decade, essentially marked a return to "painted" art. This can be seen in the renewed importance given to traditional techniques (extensive use of canvas, oil colours, acrylics, watercolours, sketches etc.) and a full-scale revival of figurative painting. Increasingly recognisable figures and fewer abstract images.

This return to tradition took place mainly in the United States through the work of a small group of artists whose styles were actually rather diverse (including Julian Schnabel, David Salle, Eric Fischl), and in Italy in what the critic Achille Bonito Oliva dubbed the Transavanguardia movement, whose leading members are Sandro Chia, Francesco Clemente, Enzo Cucchi, Nicola De Maria and Mimmo Paladino.

The 1980s were a decade of great wealth, and the prices achieved by some artists (such as David Salle) in these years fell drastically over the following decade, not necessarily because such pieces lost artistic value, but simply because the enormous sums of money that invaded the art market between 1980 and 1989 dried up in the 1990s. By 2004 money was back: cash had flooded into circulation once more and the May 2008 contemporary art auction in New York (the aggregate results of auctions by Christie's, Phillips de Pury and Sotheby's) netted half a billion pounds.

Some critics see the 1980s as a lighter, more frivolous and less creative period compared with the preceding and succeeding decades. But, from an artistic point of view, they were nonetheless important years because they decreased the overwhelming presence of conceptual art compared with more traditional methods of painting, and because they gave rise to individual approaches by artists who still continued to

work on canvas but introduced exciting new elements. Schnabel sticking plates on the canvas or Barceló taking his starting point from the marks left by termites which ate through his paper demonstrated how innovation and invention are always possible.

A typical feature of these years which was to have a major influence on the art world was the growing importance of contemporary art museums and the parallel and associated increase in the size of pieces which were conceived and produced not for small apartment spaces, but for the enormous walls of a museum.

Museums played an important role, not so much in establishing artists who were already critically and commercially acclaimed, as in launching young artists. Picasso enjoyed widespread early recognition for the importance of his works, but had his first retrospective in a museum in his old age. By contrast, in the 1980s, museums, and in particular the German and Swiss "Kunstverein" (institutions without permanent collections but with enterprising curators and vast funds donated by their members), began mounting exhibitions of artists in their thirties who found an alternative space in this type of museum compared with the small spaces available to them in private galleries. This has had a profound impact on today's art world, making it inconceivable for young artists not to have exhibitions in the most prestigious museums among their list of solo shows. This meant that the number of exhibitions in museums by far outnumbered those in private galleries.

As noted earlier, museums usually require large-scale pieces and artists adapted themselves easily to this new demand, creating huge canvases (Schnabel has painted works measuring four by six metres), or sculptures, that would be difficult to show in small private spaces (Tony Cragg and his works made up of hundreds of industrial fragments is a case in point).

But precisely as a backlash to the wealth, consumerism and ostentatiousness of those years, towards the end of the decade some artists

began a renewed inquiry into the sacred and the spiritual (Mimmo Paladino, James Brown, Chrisian Boltanski), or an investigation into the mechanisms and dysfunctions of society in the relationships between groups of people and between the sexes (Rosemarie Trockel). Taking as a whole the period between 1970 and 2008, the 1980s was certainly the time in which the most attractive and immediately comprehensible works were produced. That, as well as the economic prosperity of those years, was an important factor in many artists' commercial success. But success did not necessarily come by pandering to public tastes. Instead, these "easier" works responded to a feeling shared by artists and collectors about a world shaped by greater affluence and a lack of war which reached its height with the fall of the Berlin Wall, before the economic turmoil and crises in political and social values that would characterise the following decade appeared on the horizon.

Standing before the works of David Salle and looking for answers is just the kind of trick he wants us to fall for

David Salle is a mystery to me: it seems impossible that an artist who at the start of the 1980s painted some of the most interesting and intriguing pictures of the whole decade should later have gone on to produce works of far inferior quality, without ever managing to recover the same expressive force as in his early canvases. Before he was 30, David Salle had created works of extreme beauty that earned him immediate fame, critical acclaim and success (with pieces sold at auction for nearly £200,000). But then his talent seems to have evaporated. After a period of near oblivion, from 1998–1999 several major exhibitions led to a re-evaluation of Salle, but the fundamental core of his work belongs to the beginning of the 1980s. A similar fate befell Italian artist Sandro Chia, whose images of big fat men from the 1980s have decidedly more force and artistic value than his later paintings.

We don't know what prompted Salle to change his style or why he lost some of his talent, but it is true that contemporary artists face the significant extra managerial burden of having to be agents for their own work (choosing the right

DAVID SALLE, "UNEXPECTEDLY, I MISSED MY COUSIN JASPER", 1980

galleries, not putting too many works on the market, etc.) and knowing how to remain grounded in the face of the acclaim, and especially the financial success, which led to the emergence of new artists in the 1980s. One could say, cynically, that had some of these artists died at the same age as Amedeo Modigliani (36), Egon Schiele (28) or Umberto Boccioni (33), the impression they would have left would have been that they would have continued to produce great works, even if that is not necessarily true.

That said, works like "Unexpectedly, I Missed My Cousin Jasper" are and will remain pieces with great expressive force with an importance and significance for their times.

"Unexpectedly, I Missed My Cousin Jasper": such a strange title, isn't it? The painting looks extremely odd, composed of two adjacent panels in yellow and blue, with a woman in the middle barely outlined in red with her eyes looking into the distance almost misting up, lost in thought while she smokes a cigarette. In the background are two dogs and some images

of women (one dancing, one talking on the telephone, another playing the violin). The background fading away interacts with the superimposed images in brighter, almost violent red, creating an image of transparency and simultaneousness.

The image of the woman smoking is at the centre of about a dozen works of David Salle from this period. "I painted the image of a woman smoking a cigarette on a background full of other images so as to show such images through her eyes, to see them through her," he said. It is as if the canvas allows us to enter the brain of the protagonist of the work and lets us see her overlapping thoughts, where memories are jumbled and interspersed with images that have just been dreamed. We find ourselves navigating a sea of memories, projections and situations of déjà vu that are not ours.

But what do they mean? What logical thread binds them? We don't know, and maybe the woman doesn't either. Almost nothing is explained in David Salle's works. The whole picture provides a representation of the reality in which the frenetic and rampant protagonists of the 1980s lived: the constant sense of waiting and depression as an existential state of mind. The real protagonist of the painting is therefore this generation's sense of confusion.

The figures remain fundamentally enigmatic and this quality is also achieved by the way the technique reflects the content. Two different canvases are basically put together (David Salle often makes diptychs or triptychs, puts smaller works inside bigger ones and sticks the most unusual things to his canvases, from chair legs to hair to little plastic armchairs). He also uses different styles: the two figures of the woman dancing look like they were drawn in charcoal and have light and shadow but the other images are extremely simple, al-

most sketched, and lacking in any depth or perspective. Even the title contributes to the mystery: is the woman referring to the loss of a relative? Or is it possible to infer a reference by the artist to American artist Jasper Johns?

But standing before the works of David Salle and expecting answers is just the kind of trick he wants us to fall for. No questions, therefore, and no answers, so as to represent the emptiness of the decade that was beginning as this work was painted.

Indian miniatures have often depicted scenes dear to the popular imagination; what could be more popular for a westerner than football?
Francesco Clemente

Very few Italian artists have travelled widely and there are even fewer who, correctly assuming that the international art market is almost impossible to penetrate by staying at home, have actually moved abroad. Francesco Clemente and Sandro Chia opened their studios in New York at the start of the 1980s and this decision proved highly significant, both in putting them on the map and also in getting recognition for other Italian artists who were little known at the time. This paved the way for the huge international success of the artists linked to the Transavanguardia movement, who made their names faster and on a bigger international scale than any other Italian artists in the whole of the 20th century, in-cluding the futurists, Giorgio De Chirico or Alberto Burri. Relocating to New York was essential for Clemente in terms of critical recognition. But in terms of artistic development, his innumerable trips to India and long stays there from 1973 onwards were just as important. In India, Clemente stud-

ied and was influenced not only by eastern spirituality but also by painting techniques, the use of natural colours and the beautiful imperfection of handmade paper.

Between 1980 and 1981, Clemente composed a series of 24 small works called "The 24 Indian Miniatures", painted in gouache on pages of an old book. Clemente left unpainted the original margins, inside which he put his modern miniatures in the Moghul style, one of the classical Indian schools of painting which reached its height at the end of the 16th century.

The air of antiquity is enhanced by the wide border of the paper, discoloured with age, which here takes on a gorgeous ivory hue. Reusing antique paper to repaint historical scenes is a technique still in use in India and there is nothing odd or sacrilegious about it (unless the idea is to pass off and sell modern paintings as ancient ones). In the print shops of Delhi or Calcutta, it is common to find modern copies, on ancient paper, of original Moghul miniatures.

Another element of the original paper used by Clemente, comes from the two words in Farsi written in the middle at the bottom which, to guarantee the correct pagination of the book, indicated the last word on the page and the first word on the next. Since the original point of this has been lost, the signs add another element of mystery (they could be indecipherable captions to the image) and break up the geometric balance of the composition.

But the work's real insight comes from the fact that, while sticking to the narrow technical confines dictated by the miniature style, Clemente unleashes on paper such imagination in composition and conveys such originality that he has assembled a series of small and amusing jewels. At first sight, there seems to be nothing strange about the scenes he has

Francesco Clemente, from the series "The 24 Indian Miniatures", 1980-1981

painted. The natural colours, the clear outlines and the perspective of miniatures are faithfully reproduced. But within the imitations of the technique we unexpectedly discover ⁃ to our astonishment and amusement ⁃ a telephone or a pair of sunglasses, objects which are obviously completely out of place and out of time in the Moghul miniatures.

The miniature shown here, which closes the series, is divided into two parts crammed full of geometric patterns. The pattern in the large rectangle at the top is repeated in a semicircle in the bottom part and vice versa, as if to recall the oriental symbols of Yin and Yang, the integrated opposites which each contain a small part of the other. We can certainly see this miniature as an intricate mosaic of patterns but how could we not be struck by the fact that, actually, the miniature depicts... a football pitch! There are the two halves of the pitch, the goalmouths, the corners, the half-way line that looks like a snake, the nets. We are suspended in the sky looking down on an imaginary stadium.

Indian miniatures often portray scenes that are dear to the popular imagination, and what could be more popular for a westerner than football? Ernesto Tatafiore, another artist linked to the Transavanguardia, devoted a series of paintings to football, in which he even painted Maradona. The combination of traditional Indian techniques and western content, which has often produced meaningless hybrids, is blended in Francesco Clemente's 24 miniatures with such delicacy and irony that they prove likeable and intriguing and represent a peek inside a different culture free from prejudices and inhibitions.

Clemente has returned several times to the idea of composing a series with Indian references. In 1997, he had an ex-

hibition at the Anthony d'Offay Gallery in London of 51 splendid watercolours, entitled *51 Days on Mount Abu*, in memory of a trip to one of India's classic meditation sites, where he painted a watercolour every day to mark the passage of time.

His large works on canvas often appear heavier and less spontaneous, but in miniatures as well as watercolours (which are technically more demanding because watercolours cannot be retouched), Clemente has always been more at ease coming back to a size of composition with which he is more in tune.

Francesco Clemente is one of the artists who helped revive the portrait, which in preceding decades had been neglected by many artists (with the exception of the great Andy Warhol). I found an initiative by the Bruno Bischofberger gallery in Zurich in March 2000 very interesting: it put on an exhibition called Portraits *with pieces by Schnabel, Salle and Clemente, among others. The most stimulating part of the show was the fact that such artists, as well as showing some already finished works, were available to accept commissions for portraits. If this partly served to satisfy the vanity of some collectors, it nonetheless revived interest in what has been a "classic" par excellence of western painting of all time.*

Clemente has made portraits a constant theme of his work. People depicted in his watercolours - from photographer Robert Mapplethorpe to actress Gwyneth Paltrow, to fellow artist Keith Haring, to his wife Alba - make up a sort of hall of fame of VIPs from the 1960s to the 1990s.

"I don't want to do anything incredible, I just want to do something serious"
Enzo Cucchi

The first work of art I ever bought was a sketch by the Futurist painter Fortunato Depero from the Il Vicolo gallery in Genoa. It was a pencil and ink study for the label of a can of soup sold by the "Zucca Restaurant" in New York. In the middle of the little sketch were the words "Zucca's soup" surrounded by squiggles, lines and curves. Depero had already designed packaging for some of their other products as well as some furnishings.

It gave me a magical feeling to think that Depero himself had held that very sheet of paper, had pressed his own pencil on it and at the end had initialled it "F.D." as if he were stamping "O.K." on the idea which had taken shape on the paper. The fact that this work, small though it was, was unique, electrified me and made me feel as if it were the microscopic repository of the artist's creative genius.

Depero's small sketch instilled in me a passion and respect for drawings that are all too often - mistakenly - considered minor works compared with canvases. Drawings allow the artist to reveal a more intimate and private side and convey a more affectionate and closer link between the artist and the work.

For collectors, drawings are an excellent way of approaching already established artists whose large scale (though not necessarily better) works are much costlier. It would be wrong to think of buying a drawing as just something to fall back on. It's always better to have a beautiful drawing, which costs less, than an ugly oil painting that costs five or ten times more.

ENZO CUCCHI, "HOLY BREAD", 1981

There is no other contemporary artist for whom drawing has become as important as Enzo Cucchi. His drawings, as he himself says, represent the soul and the foundations of his artistic activity. The act of drawing for Cucchi has to do with a sort of spiritual and existential discipline, something important, grandiose and complete. "Doing a drawing is like travelling round the world," he once said.

"Holy Bread" is a small work, made up of a few scant elements: two houses on the sides of the sheet and a large oval shape which appears suspended in the air and which the title of the drawing makes us see as an oblong loaf of bread. This very simple drawing brings together two of the elements which Cucchi uses most frequently: the house and the oval shape (which here is a loaf of bread but which could, as in other works, be a stone or a cloud). Cucchi's houses always give off a sort of mysterious attraction with their unfinished look, the result of an odd number of windows and the lack of doors. But despite that, they never have the sad or anonymous air that is of typical of buildings on the city outskirts that filled the works of an artist like Mario Sironi 50 years before. Cucchi says: "Those long houses that are factories for Sironi are like Noah's Arks for me; for me they are much more archaic and elementary." Even the oval shape, which recalls feminine symbolism, has something mysterious about it, something unexpected and threatening, heightened by the fact that, as in this drawing, the shape appears magically suspended in the air. It is an object which isn't flying but seems trapped in a force field.

Interpretations of Cucchi's drawings are never unequivocal. It's true that the bread that the title calls "holy" is a religious reference and can be understood as a nutrient for the soul, like the uprightness of the houses is often associated with man's

possible spiritual ascent. But the force and the beauty of this drawing lie in the fact that we cannot completely penetrate the meaning of this enormous shape lying between the houses in a composition in which the proportions of the houses and the bread are completely distorted (as happens at times in works by writer and painter Dino Buzzati, which, too, are pervaded by an aura of magic). The images in the picture invite us to read between the lines and to immerse ourselves in the undefinable quality emanating from the sheet, allowing "wonder" to be one of the guidelines in looking at and interpreting drawings like "Holy Bread".

Some people could object that larger and technically more complex works are more carefully thought out and therefore more significant precisely because their composition requires more effort. Cucchi has produced some large oil paintings, numerous frescoes and a considerable number of large-scale sculptures. But even a small drawing, if blessed by talent and inspiration, can give full rein to the artist's expressive force. And nothing seems to me more beautiful in this regard than Cucchi's own words when he says: "I don't want to make anything incredible, I just want to make something serious."

The protagonists can't hurt each other but perhaps they can't love each other either: it is proof of their inability to adapt to the real world
Sandro Chia

"The Scandalous Face" is one of Chia's most important and beautiful paintings and, indeed, one of the most interesting works of the vast output of the Transavanguardia movement in Italy in the 1980s.

The painting shows a man and a woman engaged in a fight. The man has a small knife in his right hand and is threatening the woman with it. We don't know why he wants to hurt her, but the term "scandalous" in the title, referring to the woman's strange face, makes us think of jealousy.

Looking more closely at the scene, we realise that the knife is too small to kill her and her arm seems to be resting on his chest in an attitude of boredom or annoyance rather than imminent danger. Tension is also dissipated by the physical appearance of the protagonists. Their enormous and out-of-proportion bodies, the woman's large thighs, the man's

SANDRO CHIA, "THE SCANDALOUS FACE", 1981

child-like face, in profile but with no features, the roundness
of the shapes and the lack of straight or broken lines, all help
imbue the scene more with a sense of mockery, satire and
playfulness than violence and evil.

Chia's figures - the couple in "The Scandalous Face", fish-
ermen, shipwrecked people, hunters in other works - are all
physically similar. While Botero, another artist known for
painting corpulent people, has subjects who always seem a

bit clumsy and awkward, Chia's move at ease in their over-flowing physical appearance. Unselfconscious and relaxed, they indicate their *joie de vivre* and, paradoxically even in apparently violent situations, a lack of bad intentions that make them seem fundamentally good. The painting also imparts a sense of melancholy, accentuated by the empty darkness of the background balancing the scene. The protagonists can't hurt each other but perhaps they can't love each other either and the lack of expression on their faces is proof of their inability to adapt to the real world. One critic correctly high-lighted that Chia's works "describe not so much reality but the loss of reality in which our lives unfold". Chia's works, therefore, show us in our desire to conduct heroic gestures with neither the means nor the will to do so, in our game of living as lions for a day fighting the banality and repetitive-ness of daily life.

The painting's originality, in terms of composition, comes from the use of the wicker basket (a real one, not a painted one) on which the woman's features are painted. The bas-ket, which captures our gaze, makes us think of a mask, thus increasing the theatrical and non-violent nature of the scene. It is not the only time that he has used this idea. On other oc-casions in the early 1980s, Chia added objects like toys, cut-lery, ladles, as a mechanism to attract the viewer's attention. There is another work by Chia painted in the same year, called "Hand Game", featuring exactly the same image, as if it were another version of "The Scandalous Face". But in this second painting, the basket on the woman's face is just painted not real, the lines of the man's face are well marked, the background of the picture is coloured and the tones of the whole piece are much more strident.

Many artists frequently paint different versions of the same

work. That does not necessarily imply repetitiveness or a lack of invention but, instead, a particular attention and even affection for a subject that they are seeking to reinterpret, highlighting different aspects every time. When Christie's put up for auction the collection of Victor and Sally Ganz in November 1997, they offered four different versions (out of the 15 or so in existence) of Picasso's "Women of Algiers", which was in turn based on a painting by Eugène Delacroix (Delacroix painted two versions of his painting, the first in 1834 and the second 15 years later). And "The Scandalous Face" itself is based on Titian's "Tarquinio and Lucrezia", which was painted more than 400 years before.

Anselm Kiefer
depicts Germany with such a dramatic sense of history that some of his works can be compared with Picasso's "Guernica"

There is always something grandiose, exultant and in some ways "teutonic" in the monumental works of Anselm Kiefer. With their moments of triumph and tragedy, his paintings bring back to life the history of Germany which the artist tries to reconstruct through images, people, mythical and literary references.

"The Master Singers" takes its inspiration from a Richard Wagner opera "The Master Singers of Nuremberg". Wagner's opera, set in medieval times, focuses on a song competition in which the young Walther von Stolzing takes part. If he wants to marry Eva, the woman he loves, he must win the competition. Walther has an innovative musical style and must battle the prejudices of a traditionally-minded jury as well as the cunning of his competitors. In the end his love for Eva and his love for innovation win over enemies and traditions.

At the bottom of the work is the stage on which the 13 singers, depicted by strings or bits of straw stuck directly onto the canvas, intone their melodies. The upper ends of the pieces of straw appear to be lit by a white flame - representing the voice of the singers - which fills the top part of the piece with smoke. The

scene stands out against a black background like a theatre with no scenery. The scene seems gloomy like, metaphorically, the history of Germany. Indeed, the reference to Wagner evokes Nuremberg, where Nazi leaders were tried in 1946 in one of the darkest chapters in Germany's history.

Through metaphors and references, every element on the canvas recalls some aspect of the overall sentiment of laceration, between glorifying the goodness of the traditional feelings of the "old Germany" and the degeneration to which the sense of duty and the respect for the values of the fatherland can lead. We must, therefore, tread the path of change and purification (through the fire of the straw which burns the past, for example), but the smoke that this gives off will still be black and suffocating.

The use of straw is an extremely original and evocative method often used by Kiefer from the beginning of the 1980s to achieve different effects. In one series of works, for example, straw is

ANSELM KIEFER, "THE MASTER SINGERS", 1982

used to evoke the blonde hair of Margarethe (one of the two protagonists of a poem by Paul Celan written in 1945 in a concentration camp) which Kiefer uses as the starting point for his reconstruction of the Holocaust: the German blonde, Margarethe, contrasting with the dark-haired Jew Shulamith, a woman depicted as a shadow of ash and smoke. On another occasion, straw in flames has been associated with the image of the Nazis' funeral pyres.

Kiefer has often added anomalous materials to the canvas. We can find twigs, fern leaves, wires, nails, pieces of broken glasses. But straw, with its apparent weakness and fragility, perfectly balances the compactness and monumental nature of the whole of the composition.

Faced with Anselm Kiefer's large canvases we realise almost instinctively that we have to look at works that are neither simple nor reassuring. "The Master Singers" is a work which can hardly fail to move the spectator. The work can please our sense of aesthetics, but at the same time it pushes us to reflect. The German artist does not intend to amuse or entertain. In 1974 Kiefer, not yet 30, painted a work called "How to Paint for Fun". On it, in a style halfway between figurative and impressionist, was a typical Alpine landscape with inns, little churches with bell towers, and snow-capped mountains in the distance. The title of the work was ironically written in large letters across the landscape. As if to say: you want a picture of a beautiful landscape to look nice on the wall of your living room at home? Here it is. But this is just fun. Serious art is something else. Kiefer's more mature works came a few years later, in the 1980s, when he began to paint Germany in such a dramatic and historically charged way that some of his paintings can be compared with works displaying strong civil commitment, like Picasso's "Guernica".

Works of art are not inanimate objects but living elements in a world in perpetual motion
Giovanni Anselmo

The sculptures of Giovanni Anselmo, another exponent of the Arte Povera movement, succeed in the difficult task of combining the physical heaviness of the materials used (often blocks or slabs of granite) with the ideas of movement and energy that are innate in the material but not immediately easy to spot.

Anselmo focuses, among other things, on the concept of balance, movement and gravity, all of which are tangibly and visibly united in a work with such strong visual impact as "Greys Lighten Towards Overseas". This was part of a series made in the 1980s comprising various works all with the same title and the same basic structure: pairs of granite blocks joined by steel cables and hung from a nail so the weight of the two blocks appears balanced. At the same time, a dab of "aquamarine" blue recalling the title is painted directly on the wall.

The tension of the work comes from two separate factors. On the one hand, the two heavy blocks appear precariously balanced and we almost instinctively wonder if the cable or indeed the nail can hold their weight and prevent them

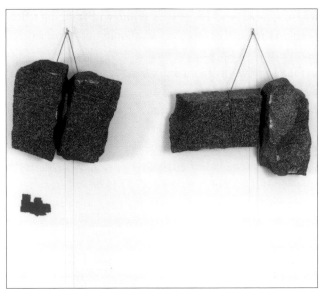

GIOVANNI ANSELMO, "GREYS LIGHTEN TOWARDS OVERSEAS", 1982

from falling. On the other hand, the blue paint on the wall – which appears an ethereal, unrelated element – acts as a counterpoint to the heaviness of the stone and inserts a con‑ ceptual and therefore "mental" dimension into the work. The blue sea that the paint and the title evoke is a horizon towards which everything disappears, a direction towards which even the heaviness of the material is diluted and, as the title suggests, lightened.

In Anselmo's sculptures, it is fundamental to consider the element of instability and movement that they contain. The possibility that they could change, transform, move or "fall" is in fact a fundamental aspect of the work. The artist him‑ self says: "I, the world, objects, life, are situations of energy and the important thing is not to crystallise these situations but to keep them alive and open in our lives." It is a very in‑

teresting concept which pushes us into wide-ranging reflec-
tions on the fact that works of art should not be considered
inanimate objects to be preserved with the greatest care with-
in the austere walls of a museum, but living elements in a so-
ciety in perpetual motion and transformation. It is precisely
because of their highly unstable nature that some of
Anselmo's sculptures made out of materials that decay have
presented conservation and restoration problems, making
the replacement of some parts a frequent need. One of his
most famous sculptures is entitled "Structure Eating Salad".
The salad to which the title refers is a real lettuce which, of
course, goes rotten within a few days and continually has to
be replaced.

Through the use of non-conventional materials, Anselmo
builds structures that are visually captivating and which,
once they have attracted us and sparked our curiosity with
their physical nature, prompt us to reflect on the role of art
and the function of works of art and their continually evolv-
ing relationship with the viewer and with society.

Manhattan's Van Gogh
Jean‑Michel Basquiat

Just as Van Gogh was the epitome of the brilliant but mis‑
understood 19th‑century impoverished artistic genius driv‑
en to suicide whose works later fetched tens of millions of
pounds, so Jean‑Michel Basquiat embodies the instantly
successful contemporary artist who, barely 20, was catapult‑
ed from a life of hardship to international fame but burned
out and died of a heroin overdose at 27 at the height of his
career, rich and courted by top international art galleries.

His brief but prolific life makes a good story and it is no coincidence that another New York artist, Julian Schnabel, made a film about him ("Basquiat" in 1996).

"Portrait of the Artist as a Young Derelict" is a large work measuring about two by two metres with many of Basquiat's typical features. Firstly it is not painted on canvas but on three hinged rough panels shaped like doors or shutters. The shape is irregular with a bigger panel in the middle. It suggests something picked up off the street. In this way the artist wants to remind us that before he had exhibitions in art galleries, he painted on walls, doors and any available surface found in the streets. The images painted by Basquiat on these pieces of wood could be taken from the infinite repertoire of signs and figures appearing on walls around the city: words, figures, abbreviations, blotches of paint, signatures, scribbles. But for Basquiat, this bizarre ensemble is a genuine new artistic language which he claims to have spawned (the letter "c" with a circle around it in the middle panel is the sign for the word "copyright") and for which he believes he deserves recognition and fame. Fame - which can prove so elusive, especially for black people in American society and culture (Basquiat had Afro-Caribbean origins) - is symbolised by the crown, which is repeated twice, in the centre and at the bottom of the middle panel.

The painting's strongest image is the self-portrait-mask on the right-hand panel surrounded by an orange halo, the head pierced by thorns. Basquiat more than once revealed a kind of obsession with fear and death: in this work the word "morte" (death in Italian) appears on a cross.

Among the tangle of signs and colours in "Portrait", anatomical shapes are recognisable in the central panel with the word "ankle" above them, typical of Basquiat's manic

desire to dissect the human body and include bones, internal organs and arteries into his works. We should also note the tall, narrow building, with no front door, but five windows fitted with bars which suggest a prison (a completely different image from Enzo Cucchi's equally tall, narrow houses) and which may also recall the mental hospital where Basquiat's mother was interned for a time.

His works are often a vortex of images and words (Basquiat often said he used words as if they were felt pens), highlighting his feeling of not fully being part of society and his consequent anxiety, which he expressed with violence and anguish at the same time.

Would Basquiat's fame have continued had he not died so young? It's difficult to say. In the space of a few years, Basquiat produced hundreds of pictures and an even larger number of works on paper. Had he continued to paint at the same rate, his market would probably have become saturated and it would have been hard to see the frenetic climb in his prices which led Sotheby's in New York in May 2008 to sell a single work entitled "Untitled (Prophet I)" for nearly £5 million.

Comics - the Last Judgment
Keith Haring

KEITH HARING, "UNTITLED", 1983

Hailed by the American critic René Ricard as one of the two most original artists of the decade along with Jean-Michel Basquiat, Keith Haring is above all a playful and amusing artist. And he remained true to his childish and funny nature right to the end, even after being diagnosed with AIDS, from which he would die in 1990. His figures make you smile and even his devils, like those represented in

"Untitled" from 1983, inspire no fear. Growing up, as he often remarked, with television cartoons and animated Walt Disney films as his essential cultural references, Keith Haring created a universe made of asexual figures, barking dogs, children radiating light, monsters, snakes, televisions and computers, sexual signs and symbols which he reproduced everywhere. After starting his career mainly painting in the New York subway ⁄ not only on parked trains, but also on the black paper rectangles (which looked like blackboards) stuck over out⁄of⁄date advertising posters ⁄ Haring was soon using any surface he could lay his hands on. We find works painted on metal, clay, wood, mannequins, caps, slippers, t⁄shirts, human bodies, stickers and more besides. Furthermore, he began to use very bright colours like red, green, black and yellow, often spray painting them without mixing or shading.

"Untitled" from 1983 is an enormous piece measuring nearly four metres square. If you are reading this book at home, imagine that it is probably at least a metre higher than the ceiling of the room you are in and nearly as long as the walls. The work is part of a series called "Tarp paintings", short for tarpaulin. At the four corners of the waxed canvas riveted holes make the work look like an enormous tarpaulin ready to be slung up with straps and ropes.

The canvas represents a sort of Last Judgment. In the middle we find a devil which looks a bit like a robot with two mechanical arms trying to grasp an angel in each arm. In front of the large devil stands a human figure (probably a saviour or saved soul because of the Catholic cross on his chest) emerging from an inert body laid horizontally, thus indicating a spiritual renewal which is probably infuriating the great demon of the painting.

In the lower edges of the canvas we see two men with their arms up as if they were tied, with two large crosses like Xs on their chests. This is a symbol that Keith Haring often used to indicate ignorance (in some works dedicated to AIDS, men shooting up wore crosses) and ignorance is probably the cause of their damnation. The canvas is dense with signs; no element acts as background and no space is left empty. The paint drips come from the incredible speed with which Haring worked (on this occasion he used industrial-type vinyl paint), and are not meant to recall earlier styles like American Abstract Expressionism or the works of Jackson Pollock. The completely accidental drops of colour in this devilish scene may remind us of drops of blood.

In "Untitled" we also see a trait common to the composition of almost all of Haring's work: the image is framed by a broad black line bordering the work which recalls the outline of a comic strip. This is exactly what Keith Haring wanted to be: a great illustrator of popular images and a creator of characters and patterns recognisable not only to the art elite, but also to ordinary people who read comics and watch television.

To reach paradise lost, all you have to do is lie down on the grass and lose yourself in the colours and scents around you, just like the artist when he paints

Nicola De Maria

The titles of works of art provide precise and sometimes essential indications about their content. For some artists, they are the key to unlocking their oeuvre. So, reading titles is always an essential starting point. Probably the best-known work by the Italian artist Giulio Paolini is a simple photograph of the face of a young man taken from a painting from the early 16th century. Without the title "Young Man Looking at Lorenzo Lotto" to help us, we would not be able to understand or appreciate anything about the work. It is only the title that provides the explanation: the image refers to a young man who was indeed painted by Lorenzo Lotto in 1505; the title, putting the accent on the person in the portrait who is looking at the painter, rather than on the painter looking at and painting his subject, turns the whole optic of the picture upside down. The work is not significant for being the artist's perception of reality but because it puts us on the side of the boy watching the artist paint him. We seem to enter his mind and see through his eyes a painter at work on the very spot where we are now standing to look at the painting. In this way, the work exists only in the eye of the spectator. The photograph is a reflection, like a mirror, that inverts the portrait's perspective.

GIULIO PAOLINI, "YOUNG MAN LOOKING AT LORENZO LOTTO", 1967

Other contemporary artists like Jannis Kounellis, or Sean Scully in the case of his works on paper, have deliberately chosen not to give titles to their works so as not to distract attention from the act of observation. The American David Salle, on the other hand, uses titles that are deliberately confusing and deceptive with regard to the images represented so as to underline the apparent casual nature, chaos and contradiction of society represented on the canvas.

Another American artist, Julian Schnabel, composed a series of works generally referred to as the "Fox farm paintings" in which he writes "There is nothing more horrible on this planet than a fox farm during pelting season" all over the picture in large letters. The sentence, which Schnabel found by accident scribbled anonymously on a banknote has become a kind of trademark.

One of the artists who has always paid the most attention to the titles of his works, turning them into a veritable poetic language, is Nicola de Maria. His titles, often long and almost always inspired by the natural world (flowers, sky, the sea, snow, etc.) appear like verses of a never-ending great autobiographical song, almost like a poem describing the affectionate relationship between the artist and the world around him represented essentially by a mythical "Kingdom of Flowers" to which De Maria frequently refers. Here are some titles of his works: "The Kingdom of Flowers Sings: Nicolaa Nicola Nicolaa aa"; "Many Years to Finish a Star-Studded Drawing"; "Be a Chinese Painter, Become an African Artist, Nicola Is in Tune with the Kingdom of Flowers"; "Head of a Happy Blue Poet"; "Good Christian Angels"; "Every Night at Work to Build the Kingdom of Flowers".

Besides the inherent poetry in their titles, there are two striking things about the works of Nicola De Maria. Many of his canvases indicate the date they were painted with a string of years. "Polychrome Head. Friendship", for example, carries the following date "1986-87-91-92-93-95". Another work, "Romantic Head of Love-Struck Maiden" indicates "1991-92-95". This means that his works undergo a very slow evolution and stratification over the course of time. The canvas is begun and then put away to rest. Works are painted and put away to be brought out in order to be completed maybe a year or two later. We could associate the slow

NICOLA DE MARIA, "UNIVERSE WITHOUT BOMBS", 1983

pace in executing works to a kind of affection of the artist with his creatures, almost a reluctance to rush, and putting off the moment when the last brushstroke will be made, marking completion of the work and thus its eventual sale. The other characteristic of De Maria is that he paints a large number of his works not inside his studio but in the open air, on the grass, in a meadow or in the middle of a field of flowers. He seems to be taking up the tradition of landscape artists of the past who immersed themselves in nature with their easel, canvas and paints in order to grasp its laws and connections in the world before reproducing the details. The happiness and "naturalness" of the trees, flowers and the sky fill De Maria's works and convey to the spectator, in paintings which are not strictly figurative, the intrinsic qualities rather than the detail of what is being painted. His paintings are "happy" even if some titles (as is the case of "Universe Without Bombs") allude to possible threats contrasting with the hopes for peace.

In his work on paper "Universe Without Bombs", it is interesting to note how the artist's standpoint, and thus the reflection for whoever is looking at the work ⁄ is not separate or distant from the flowers he paints. Whoever looks at the picture finds himself "inside" a field of flowers and thus sees things not as a human being walking through a field would see (flowers from above), but through the eyes of a small animal sneaking through the grass. The eye of the observer is at the same height as the calyx and the petals painted on the paper. A person would only be able to see things from this angle by lying down on the grass.

De Maria's pictorial language is apparently simple, almost infantile, and for that reason he has been compared with one of the great protagonists of art in the first half of the century: Paul Klee. De Maria's infantile style is synonymous with freshness and an utter freedom from any conditioning derived from pictorial convention. That allows the artist to go straight to the heart of the matter and to the purity of nature. There is a kind of search for essence which is very different from the realism of figurative works; an attempt more like that of Cézanne, who, by painting fruit, wanted to render what he called an apple's "appleness".

The colours in "Universe Without Bombs" are bold, clear, unmixed. The flowers are often monochrome ⁄ stem, petals and stamens are all red or all blue ⁄ but that doesn't make us see De Maria's flowers as any less natural because it is the combination of all these colours and brushstrokes which envelop and immerse us in the meadow, in the same way that the sound of an orchestra forms a single whole even though it is comprised of a number of individual instruments.

The use of colours and the simple approach is sometimes uncertain and reminds us of childhood paintings, which the

title also seems to evoke. The universe without bombs is thus that of the ideal world which existed when we were children. Though the title recalls innocence now lost, it puts the accent not on nostalgia or sadness but on joy and happiness. De Maria paints a fantastic and happy world, not with the melancholy of someone lamenting a paradise lost but in the conviction that such a world is still within reach. To get there, all you have to do is lie down on the grass and lose yourself in the colours and scents around you, just like the artist when he paints.

Some time ago I tried to buy a work by Nicola De Maria from a famous gallery in Milan. Since I lived in a different city, I asked the gallery to send me colour photocopies or photographs of the works available, stressing my particular interest for works on paper. The swift faxed reply informed me that to replace "the onerous and difficult (?) task of managing colour photocopies" the gallery would put all available works on the Internet within a few days. A great idea, I thought, and I called the gallery owner for details of the website.

But on the telephone I discovered that the website was not going to include works on paper and would only show those on canvas. So I asked if I could have photocopies. I was told that it was a complex, time-consuming operation, that sending colour photocopies was not easy and that the gallery owner was working on a large De Maria retrospective planned for 2000 (this was in 1998) and so, while they would certainly keep my request in mind, it would take some time.

A few days later I sent a similar request to the Galerie Lelong in Zurich. Within a few days, courteously and professionally, the gallery posted me a full series of photographs of works on paper, with the prices and every possible detail for me to make my choice.

I proceeded to hang a splendid little drawing by De Maria in my study. Bought in Milan or Zurich?

A personal interpretation of Caravaggio's "Narcissus"
Miquel Barceló

Barceló's works, when you see them in the flesh, are stunning. Obviously the same can be said of any painting, but in the case of the Spanish artist, photographs remove much of the emotion of being able to see the squishy texture of the surface of the canvas. This is one of the reasons why there are virtually no Barceló multiples (lithographs, etchings, etc.), since they fail to transmit the works' physical nature.

I can vividly remember the impression that Barceló made on me the first time I saw a major exhibition of his work. It was at the Whitechapel Gallery in London in 1994. Huge canvases depicting still lives in which seeds, pieces of paper, strings and colours had been combined to create a single mixture from which images of heads of lettuces, carrots, pumpkins and onions emerged. I remember works painted on sheets of paper that had been eaten by termites: figures of nomads and shepherds could be seen as if emerging from the holes left by the termites.

Barceló is a typical artist of the 1980s, a painter who goes back to using images and figures to tell stories, just like Sandro Chia, Enzo Cucchi, Mimmo Paladino and other exponents of the Transavanguardia in Italy, Julian Schnabel and David Salle in the United States and so-called New Savages in Germany like Rainer Fetting.

In the work "Painter with a Blue Paintbrush", Barceló paints himself kneeling on the canvas drawing a dog with

MIQUEL BARCELÓ, "PAINTER WITH A BLUE PAINTBRUSH", 1983

large brushstrokes. The picture is a personal interpretation of the myth of Narcissus and a direct reworking of Caravaggio's "Narcissus" in which a young man looks at his reflection in the water. But here, the image which the canvas reflects is not that of the artist but that of a dog (re-calling the poet Dylan Thomas who wrote *Portrait of the*

Artist as a Young Dog, which was in turn a play on the title of the book by James Joyce, *Portrait of the Artist as a Young Man*; all these titles also have a connection with Jean-Michel Basquiat's work, "Portrait of the Artist as a Young Derelict" mentioned earlier. The image of the dog seems to be an allegorical picture of the spirit and conscience of the artist who, as he looks at his reflection in the painting, sees his soul instead of his face. In the bottom right, another man and another dog appear painted on the canvas, thus mirroring the entire image of the painting.

"Painter with a Blue Paintbrush" also contains an erotic reference: the artist is naked and the brush dripping blue paint is held between his legs as the colour drips directly onto the dog's penis. Rather than a sexual reference, however, this is proof that the man and dog share the same nature.

Barceló has homes in Paris and Majorca but mostly lives in Africa and it is the time he spends in Mali that keeps the tactile quality of his work alive. The painting is not just lines and colours but also earth, dust, smells, organic matter. Barceló has at times been compared to Italian artists of the Transavanguardia (some have spoken of a Spanish Transavanguardia), but despite some similarities, he follows his own path. There have always been artists who are so original and charged with such expressive force and talent that they defy categorisation (in this very narrow and elite circle we should include two of the greatest painters of the 20th century, Balthus and Francis Bacon). Their works could have been painted 100 years earlier or conceived in 200 years' time and nothing would change. A portrait by Francis Bacon or a landscape by Miquel Barceló have a life of their own. They don't represent the reality of the moment: they are themselves reality.

From Gaudí to the brushstrokes of broken plates
Julian Schnabel

I first got to know Schnabel's work at an exhibition in the 1980s in the Museo Pecci in Prato and later bought a drawing and collage on paper from 1980 called "Golgotha" - a small work, rare because of its size. I bought it from the Bruno Bischofberger gallery in Zurich (one of the world's most important contemporary art galleries). I contacted the gallery almost reverentially thinking that Bischofberger, the European dealer for artists like Warhol, Clemente, Basquiat and Barceló, capable of influencing the art world decisively with his acquisitions and market strategies, would have precious little time to spend on a small-scale collector like me who wanted to buy a piece by Schnabel for less than £5000. But I found the Bischofberger gallery in Zurich to be both so professional and cordial that I was inclined from then on to deal with the most influential gallery owners in Europe rather than with small galleries (unfortunately some influential U.S. galleries are a different story...).

There are essentially three advantages to dealing with big, top-notch, international galleries. They have a "right of first refusal" over the production of many artists, sometimes sanctioned by written agreements. That means the artists gives to other galleries only the works that were not previously bought by the large galleries.

The second reason is that when the collector decides to sell the painting, the fact that it was bought from a first-rate gallery is a sort of quality guarantee for the future purchaser; thus, putting such a work on the market in an auction with Christie's or Sotheby's and mentioning its provenance improves its prospects of a successful sale.

JULIAN SCHNABEL, "PORTRAIT OF JACQUELINE", 1984

The third reason is really psychological, but just as important. Maybe my personal experience was unique and shouldn't be taken as a general rule but I have never been treated with such courtesy, been so respected as a collector and "spoiled" as I have been by the top galleries in Europe, despite having made clear the financial limitations of my purchases. Bruno Bischofberger in Zurich, Berndt Klüser in Munich, Daniel Lelong in Paris, Timothy Taylor in London, to name but a few of the world's major contemporary art gallery owners: none of

them skimped on time or patience; all responded promptly to my let-
ters; none ever sought to make me feel ill at ease; and, with consum-
mate skill, they made me feel at that moment like their favourite cus-
tomer, telling me anecdotes and confidences. All that sounds obvious,
doesn't it? However, for many galleries it isn't at all, and some, which
I won't name but have vowed never to set foot in again, treat you as if
you want to steal the family silver and are impossibly gauche if you
ask the price of a work without previously having been properly intro-
duced by a long-time client.

There are some artists who have such enormous talent that
whatever they draw on a sheet of paper or on canvas man-
ages to convey such expressive force and such a perfect sense
of harmony and beauty as to satisfy the spectator. Schnabel
is a hugely skilful artist who has produced works of intense
emotional impact, even if at times his shortcoming is to lim-
it himself to this sense of "correctness" in the colour and the
strokes on the canvas without enriching or charging the
work with formal or conceptual structures.

In Julian Schnabel's work, everything is big, exaggerated -
starting with the size of the works, many of which are almost
monumental and could certainly not be hung on the walls
of a house (what do you do with a painted sailcloth meas-
uring more than five metres square?) but have to be hung in
museums.

Even the titles of some pieces reveal the larger-than-life per-
sonality of their author. One example is the beautiful
"Portrait of God" from 1981 where the very lack of modesty
in the title renders almost figurative what at first looks like a
completely abstract piece (blotches and splashes of blue on
a white canvas).

Even if in many other cases, Schnabel has painted on high-ly original and innovative surfaces (velvet and sailcloth), his real invention was "plate painting" in which he stuck broken plates and bits of earthenware usually onto wood, and then painted them. The surface of the work thus almost becomes a battleground and takes on a three-dimensional aspect as if the images wanted to emerge, even in pieces, from a broken landscape.

Schnabel himself tells how he got the idea of plate paintings. In the late 1970s he travelled to Europe. In Spain, he went first to Barcelona and then to Madrid, and was forced to spend a few extra days there after losing his passport. In Madrid he thought back to the architecture of Gaudí he had seen in Barcelona and about the idea of creating mosaics like those he had seen in many Spanish restaurants. In bed in his hotel the word *mosaic* went round and round in his head un-til he began associating it with the structure of the large wardrobe which took up all of one wall of the room. He thus decided to make some three-dimensional sketches similar to wardrobes, covered with handles, stones and pots; they are the first studies for his personal idea of a mosaic. Once he got back to New York, he built a wooden base and stuck bits of broken plates on before he began to paint it. Schnabel recalls how during the night he heard the bits of plates keep on falling off and smashing on the floor because the glue wasn't strong enough to hold their weight. The following morning he stuck the pieces back on and carried on paint-ing. That was in 1978 and his first "plate painting" entitled "The Patients and the Doctors" was born.

For Schnabel, the fragments of ceramic stuck on the painting recall both the concreteness of the real world and other artists who have based part of their work on the reconstruction of

more physical and material aspects of reality: the fragments of floor in the works of the Boyle family of British sculptors; the walls eroded by time in the canvases of Spanish artist Antoni Tàpies or the graffiti-like signs by the American Cy Twombly. For Schnabel, though, the material nature of the work is not the scope of the piece but a means to make the figures depicted more real, as well as capturing the curiosity and the attention of the viewer. The images which fill Schnabel's plate paintings are for the most part portraits of relatives, friends, colleagues or dealers - people Schnablel knows and to whom he is close. Their portraits emerge from a surface entirely made up of fragments with curved lines creating a sequence of concave and convex angles and thus of light and shade. The work's chiaroscuro effects are therefore not painted but real, created by the material sticking out from the surface. We would probably imagine the portrait of Dorian Gray to be like this: real but at the same time unsettling.

"Portrait of Jacqueline" features Schnabel's Belgian ex-wife, Jacqueline Beaurang, in an expression of almost reverie with her eyes closed and her head tilted up. Her face seems to emerge from the night illuminated by its own light and irradiating brightness as if it were bathed in the bluish light crowning her hair. The picture is painted with large, intense brushstrokes which seek to express the energy, including the physical energy, which Schnabel pours into his works. The broken plates which surround the woman are painted in sombre colours - black, ochre and blue - that seem to charge the night sky with an imposing force. We can almost feel the roughness of the broken edges of the plates and cups with our fingers giving such a physical sense to the portrait that you think it could be a picture of a saint or a martyr in a moment of intense pathos.

Schnabel was often included among the swiftly rising young artists of the 1980s but he never reached the heights touched by some of his colleagues (such as David Salle). However, this made him less vulnerable to the swift fall in prices at the start of the following decade. "Portrait of Jacqueline" was sold at auction by Christie's in New York in 1993 (a time of serious crisis in art prices) at nearly twice the reserve price.

A note on the enormous size of the works of Schnabel and several other artists: interestingly the two factors which had a direct influence on the size of the works in the 1970s and 1980s were the beginning of a wave of major purchases by contemporary art by museums (especially in the United States, Germany and, to a lesser extent, Britain) and the rise in the number of private contemporary art collectors in America where houses are generally bigger than in Europe. It could seem to be a frivolous and not very "artistic" consideration, but to decorate houses with big walls, you need big pictures. Furthermore, we shouldn't underestimate how important consultants as well as architects and interior designers became, especially at a time when new collectors were flush with cash but had too little time to organise and evaluate their own purchases. London gallery owner Timothy Taylor once told me that an American client was about to buy a piece by Sean Scully which he had fallen in love with at first sight. But the sale fell through because the collector's interior decorator said the picture was... the wrong size.

Breaking the rules in search of a different order
Richard Tuttle

Standing in front of pieces by Richard Tuttle is the kind of place you might hear people say: "I just don't get it" and "What does it mean?". His works disconcert us not only because of their apparent simplicity but also because of the lack of links between the various elements that make them up. It is hard to know if we're looking at a sculpture hung on a wall or a picture with undefined edges, because the reassuring border of the frame is missing.

With an evocative and intense work like "Two or More IX" the missing frame is just the right place to start. Two vertical light-coloured wooden rods and the slightly darker horizontal wooden border a bit lower, almost in the centre of the work, give the impression that some kind of structure once contained the work. But what we're looking at is a landscape after a tornado or an expanding mass after the initial big bang. It is as if the structure was under pressure and exploded, the frame gave way under the force of material and colour. The work therefore lost its initial unity and has been reassembled in an apparently random way. But every sign, every detail, every fold in the paper in Tuttle's works is thought out and executed with obsessive, millimetric precision.

The lack of precise confines in the work certainly greatly blurs the line between painting and sculpture since three-dimensional elements are as essential for Tuttle as the choice

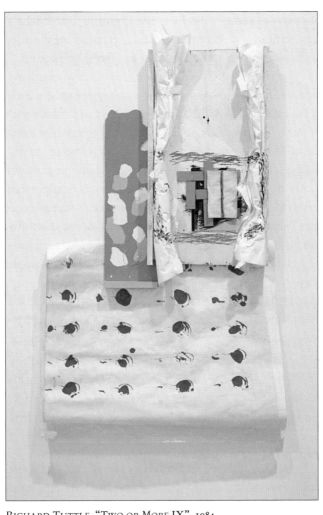

RICHARD TUTTLE, "TWO OR MORE IX", 1984

of colour or surface. But he is also venturing into unchar-
tered territory with everything to discover. Breaking the rules
and the search for a different order are Tuttle's objectives.

In "Two or More IX" we already have one non-clarifying
element in the title itself. Are there two elements to which
the title refers (maybe the upper and lower parts of the work)
or more than two? And if the artist himself seems to be look-
ing at an unknown object, how can we be expected to un-
derstand it? But it is this very choice not to nail things down
that is important, just as the nature of the work (sculpture or
painting?) is imprecise. If at first sight it seems like a sculp-
ture because of being three-dimensional, some other ele-
ments, like the use of paper (Tuttle's favourite medium)
brings the work firmly back into the realm of paintings and
drawings.

Fragility is an important feature of the work (Tuttle himself
mounts the pieces carefully at his own exhibitions). It is a phys-
ical fragility that unites with a delicacy of signs and sensations.
The way colours and materials are put together creates an
affinity between different elements in the composition. The
paper enters into symbiosis with the wood, the wood with
the colours, the colours with the wire and so on. The unity
of the work seems destined to evolve, to change. Despite the
rigid nature of materials like wire and wood, it is as if "Two
or More IX" mutates when our backs are turned and a very
careful second look could spot imperceptible changes in the
creases of the paper. Evolution continues. We discover that
if the initial frame has exploded and almost completely dis-
appeared, it reappears in the form of colours: indeed, in the
top right, blue lines on the wood and fabric frame a small
cardboard structure. The regeneration of the painting has
therefore begun.

"The biggest pleasure in the world consists of inventing the world as it is, without inventing anything"
Alighiero e Boetti

Lots of people fall into the trap of believing that the word "e" ("and" in Italian) between Alighiero and Boetti indi-cates two artists working together (like Gilbert & George or McDermott & McGough). This is just one of the innumer-able amusements with which Boetti has restored the pleas-ure of play, joking, wonder and marvel to the world of con-temporary art.

Boetti is a completely unique and unmistakable artist. He has produced a range of very different works which are all, however, marked by a childish and playful poetic spirit which makes his works delightfully light and clear. Like when in 1966 he built a sculpture called "Yearly Lamp" which lights up once a year at random for 10 seconds.

Boetti's most famous works are probably his tapestries, and maps are one of his best and most widely-known subjects. He sketched his first map of the world in 1969, finished his debut embroidered version in 1973 and continued to pro-duce maps until the year before his death. Indeed his last map is dated 1992-1993.

Every map is different, not only because of the words includ-ed on the border, but also because each one is a faithful

record of the evolution of the world's political geography with changes of regime and flags, schisms, the creation of new states, redrawn borders, etc. (just think of the changes brought about by the break-up of the Soviet Union). In every map the border contains some specific indications: often the signature, date and place of execution and sometimes some narrative elements. The writing is sometimes even in Farsi, a language spoken in Afghanistan where Boetti, who had run a small hostel in Kabul as a young man, often had his tapestries made until he had to stop because of war.

This map of the world from 1984 contains the following text which starts from the top left and goes in two directions: from left to right "Alighiero e Boetti thinking of Afghanistan, of Mazar Sharif and Heratband Amir"; and from top to bottom "Alighiero e Boetti in Rome in the first days of nineteeneightyfour".

A map of the world invents nothing and this is one of the fundamental aspects of many of Boetti's works. He has often limited himself to observing, transcribing and rendering

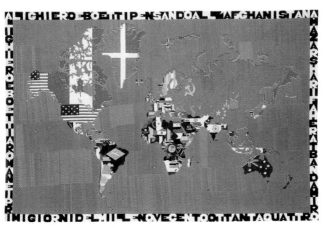

ALIGHIERO E BOETTI, "MAP", 1984

in poetic forms images that already exist and are largely ignored. As Boetti himself said: "The biggest pleasure in the world consists in inventing the world as it is, without inventing anything".

Referring to his maps he also said: "For me, embroidered maps of the world represent the height of beauty. In these pieces I haven't produced anything, I haven't chosen anything – the world is how it is and I didn't design it; the flags really exist, I haven't designed them. At the end of the day I did absolutely nothing. Once the fundamental idea, the concept, is formulated, all the rest is a consequence and no longer a matter of choice."

The other important feature of Boetti's tapestries is that they are made by unidentified artisans and the artist isn't personally involved – a method of working he has also used in other projects. The artist's contribution, therefore, is essentially to have had the initial thought. "There are five senses," says Boetti, "and the sixth sense is that of thought, the most extraordinary thing man possesses and it has nothing to do with nature." Boetti is, therefore, someone who discovers connections which he brings to life and transfers onto fabric or paper (Boetti never painted on canvas).

In his maps he demonstrates what has correctly been defined as his "childlike spirit of adventure" which unites the seriousness of the world and the international balance of power with the manual dexterity of the artisan who did the embroidery, the bright colours of children's pictures and the artist's perception of the idea.

Polke, Polek, Pollock: dripping vs pop
Sigmar Polke

Sigmar Polke doesn't delight at first sight; he doesn't have Barceló's immediate draw or the amusing irony and childishness of Boetti. His works are often multifaceted, containing different elements which the artist subtly seeks to link together, creating pieces that have a strong visual impact but are not easy to decipher.

His work "Untitled" from 1985 has a background divided by two lines: one horizontal (the big white band) and one vertical (where the two fabrics join) which divide the canvas into four parts. On this background he has painted figures that are reminiscent of characters in comics and added splashes of white, either in the form of crossed lines or abstract signs.

Sigmar Polke has often used patterned fabric with a geometric print as the starting point for his works. It serves as a decorative and ornamental base on which to add other elements more properly pictorial. In the case of "Untitled" from 1985, the fabric on the left has white dots (a favourite of Polke's), recalling Benday dots, the tiny dots that make up photographs in newspapers, visible only if the image is enlarged excessively. In addition, the term "polka dots" is a clear reminder of the artist's surname. The fabric on the right, on the other hand, recalls the wallpaper of a child's bedroom and that, together with the figure of a man with the newspaper in his hand and the funny daisy talking on the telephone, complete the image.

The different painting styles allude to an apparent row be-tween two major artistic movements to have emerged from the United States in the 20th century: the Abstract Ex-pressionism of the 1950s and the Pop Art of the 1960s. Abstract Expressionism is represented by the colour white. The big swathe of paint in the middle recalls Franz Kline and the paint squiggles recall Jackson Pollock, the American artist linked to the technique of dripping in which paint was dropped from a brush onto a canvas laid

horizontally on the ground instead of applied vertically to a canvas on an easel. A further ironic allusion to Jackson Pollock comes from the way in which the work is signed on the back. The artist deliberately spells his surname wrong, writing "S. Polek" instead of "S. Polke". Thus changed, the surname sounds very close to "Pollock".

Pop Art is recalled with the comic-style characters, although they are used here more as funny vignettes than as the heroes of love and war in Roy Lichtenstein's paintings.

Everything is mixed and superimposed just as all contemporary art is a combination of a thousand references rather than a single trend line. Just as the man in the picture looks amazed at the daisy talking on the telephone, the public is disorientated when faced with art. But it is the kind of disorientation that inclines us to smile rather than to engage in serious debate.

The lack of a single and immediately recognisable style and the use of highly different techniques are Sigmar Polke's main features. Often he first conceived new ideas (such as fabric used as a background) but others have consciously or unconsciously taken them over and deepened them. But Polke is a real trailblazer and continual experimenter who never wanted to remain linked to a single style, preferring to make changes like a chameleon and to take risks by overturning conceived ideas.

Why do works of art cost so much? "Untitled" from 1985 by Sigmar Polke was sold at auction in June 1997 for nearly $650,000. A year after "A portrait of Marilyn Monroe" by Andy Warhol was sold at Sotheby's in New York for $17 million. Ten years have passed and prices which sounded crazy at that time are relatively "cheap" now.

In Part I auctions (Part I is the evening auction where the most expensive lots are offered, followed the next day by Part II) in 2007 and 2008 at Christie's, Phillips and Sotheby's, there were at least a few lots that broke the barrier of £10 million.

Market laws, depending on supply and demand, drive the prices of contemporary art. But there are often other factors such as fashion, the availability of large sums of money for investment (paintings are undeclared works which are not subject to property tax), as well as speculation by dealers and individual large-scale collectors.

But this doesn't mean that only multimillionaires can collect contemporary art. Some of the pieces illustrated in this volume cost around £10,000 and for that price you can buy beautiful works on paper by Richard Tuttle or Enzo Cucchi or canvases by James Brown or even a small Julião Sarmento. Sandro Chia's watercolours or Rosemarie Trockel's multiples and small works cost about the same. If £10,000 seems too much, consider that it is the price of a small car and that, unlike art, a car is worth a bit less every day. One can certainly look for emerging artists and aim for low-cost works. A collector friend of mine bought a piece by the very young Douglas Gordon for £2400 and sold it six months later for £18,000. But things like that don't happen every day.

What should prompt us to buy is primarily whether we like the piece and it gives us pleasure, the genuine feeling of falling in love with it, and the small contribution it can make to improving our quality of life.

Lessons from the world of darkness
Christian Boltanski

Boltanski is an artist who favours dim and gloomy sur-
roundings, and dark and silent places in which his works
take on an aura of mystery and seduction which is essential
to the whole experience. His works are often exhibited in
out-of-the-way places, in hidden corners of museums or in
churches.

One of his great shows in Rome, in the Villa Medici in the
mid 1990s, perfectly combined the lights and shadows from
his works with the magnificence of the French Academy.
The steps, the nooks and crannies, the niches of the Villa
Medici were an absolutely integral part and not merely back-
ground scenery for Boltanski's unsettling works.

"Candles", of which several versions exist, is made up of
seven tin figurines a few centimetres high fixed to a little
copper bracket with a candle at the end. In a stylised and al-
most archaic fashion, the figures represent images of death
(skeletons, death with a scythe), or terror (winged monsters,
devils). The little brackets holding the miniature statues
have to be fixed to the wall and the candles must be lit. Thus
the dim room is only illuminated by the light of the candles
which cast the shadow of the images onto the wall. The
flickering of their flames makes the shadows move, creating
the illusion that the creatures of the night have come to life
and are moving freely on the wall. The impression is accen-
tuated when a visitor leans in for a closer look: the move-
ment of air triggered by the viewer's movement makes the

CHRISTIAN BOLTANSKI, "CANDLES" FROM THE SERIES
"LESSONS OF DARKNESS", 1986

flames flicker more, as if a human presence has excited the
demonic figures, who are lying in wait for their next victim.
The "Candles" series, together with two others called
"Shadows" and "Monuments", belongs to a body of work
called "Lessons from Darkness". The word lesson recalls

both the scholastic significance of learning and, in the case of black magic, is a metaphor for life's lessons and the concept that evil is innate in life. The "Lessons from Darkness" are decidedly spiritual works and, from the standpoint of composition, are partly ephemeral, composed of non-existent parts (shadows) and parts which are tangible but which run out and have to be changed frequently (candles). Candles are also an integral part of the religious symbolism of Christianity (the flame as man's soul, the use of the candle in administering the sacrament of baptism) and thus this work by Christian Boltanski depicts man and his relationship with religion and God (the lighted candle), as well as evil and the devil (the tin figurines and their shadows on the wall). God and the devil appear therefore to be indissolubly linked, like light and shadow.

The first version of "Candles" (they differ in terms of the number of miniatures and their images) was exhibited in 1986 in the Chapelle de la Pitié-Salpêtrière in Paris, and Boltanski's views on churches and their relationship with today's museums are interesting: "I am not religious but I am convinced that the first contact we have with art comes when we go to church when we are little. Not because of the presence of paintings, but because of the presence of the priests whose words and actions in an abstract way seek to communicate something important. We are, therefore, on a symbolic level, inside a mysterious realm. The same thing happens with painting. In the Middle Ages, relics of saints were conserved in cathedrals in the same way that museums today conserve art works. People made pilgrimages to the cathedrals and the influx of pilgrims brought economic benefits to the city. Today's princes build museums rather than cathedrals. Museums are today's new churches."

Paintings as books
divided into chapters
Julião Sarmento

"My work is closely connected with literature," says Sarmento, and it is true that knowing what gave him his inspiration can help us appreciate many of the nuances in a work like "David and Devil", where the devil is very different from the cartoon-like one seen previously on Keith Haring's canvas.

The title refers to a love story between the writer David Bourne and his wife Catherine, nicknamed "Devil", the protagonists of the Hemingway short story *The Garden of Eden*, which was published posthumously in 1986 (the same year the painting

JULIÃO SARMENTO, "DAVID AND DEVIL", 1986

was executed). Hemingway tells how, soon after the couple are married, Catherine begins to exhibit lesbian tendencies and starts an affair with a girl called Marita with whom David Bourne himself has an affair. In parallel, the story also narrates an episode which deeply marked Bourne's childhood: David's father, a passionate big-game hunter, took his son on an elephant hunt. After injuring the animal, and before re-moving its tusks, his father went up to it with his gun and fin-ished it off with a shot to the head, a few steps from David's horrified gaze. The story goes on to relate how the marriage of David and the "Devil", Catherine, falls apart.

"David and Devil" tells the short story in images, and is con-structed by assembling five different-sized canvases that at first sight appear to be completely unrelated. Sarmento con-structs many of his works like books divided into chapters or films split into sequences (cinema is another of Sarmento's passions). By using different canvases and images, he con-veys the sense of progression of a story rather than the impres-sion of overlapping thoughts or feelings (as we saw earlier in David Salle's painting). The canvas at the top left shows a steam ship and a series of sheets of paper flying in the wind; immediately below, the second canvas depicts a fatally wounded elephant; the canvas on the bottom left shows three people, a man and two women in the depths of a sort of cave; the main image in the centre, which captures most of the spectator's attention, consists of two headless figures, half human and half animal, having sex; and the last canvas on the right, which closes the piece, shows the image of the head of a man in a reflexive pose, and at the bottom, a jug.

The figure of the protagonist, David, is repeated three times (an almost magical number which often recurs in Sarmento's paintings: three figures, three houses, three trees, etc.). At the

bottom left he is divided between two women, in the centre clutching the "Devil" and in the top right, he looks more serious, though in fact he appears to contemplating the jug which, in the language of psychoanalysis, is often associ⁄ated with female genitalia.

The visual impression is one of rigorous order in the way the picture is structured and the various panels are assembled. Even if a few references are lost (without knowing the Hemingway story, everything would appear mysterious and hard to fathom), we sense very clearly that nothing in the painting is accidental. The head of David at the top right, for example, is based on a Portuguese advertising poster from the 1930s and the story of "David and Devil" takes place in the 1930s. We could continue to seek triggers for Sarmento's inspiration, but at some point it is wise to pause the pleasur⁄able intellectual pursuit of his references and allow ourselves to be moved by the overall impression of the piece. Just like many other works by the same artist, "David and Devil" is an exploration in the territory of desire. Desire, solitude, memory, obsession, sexuality: these are the recurring themes in Sarmento. As a Portuguese artist, he cannot fail to recall the concern and solitude expressed in the books by the great⁄est Portuguese author of the 20th century, Fernando Pessoa. Passion, therefore, emerges as a key to reading Sarmento's work. Sarmento leads us into the domain of the imagination through stories and objects from our daily life and he does so through thought not action, with images that are not vio⁄lent but instead prompt reflection. His paintings render in images the conviction that the key to reading our behaviours and our passions lies in a deep analysis of the desires hidden in our minds. And for Sarmento art itself has to be passion.

Symbols? Decipher them, but above all let yourself be captivated
Mimmo Paladino

The great protagonist in Paladino's works is silence ⁄ the absence of noises, sounds and voices. No one shouts, noth⁄ing falls on the floor, no dog barks. It is as if everything were wrapped in cotton⁄wool, helping provide the sense of mystery that is the most immediately recognisable trait of Paladino's work. Even "Baal" has its dose of mystery. The term *baal*, Hebrew in origin, means "gentleman, pat⁄ron" and for Semitic peoples, it was the name of the div⁄inity (whose centre of worship is the town of Baalbek in today's Lebanon), who was a lord and protector of a spe⁄cific site. The central image of the painting, which towers over the viewer since it measures more than two metres, is thus that of the divinity, one which does not speak but manifests itself through signs and dark symbols that are dif⁄ficult to interpret. Baal's eyes, like those of almost all the protagonists of Paladino's work, lack pupils. But his is not the gaze of a blind man; rather it is the viewer looking at the painting who is unable to see, to meet and penetrate the divinity's enigmatic gaze. Paladino has depicted Baal at the centre of a grey background recalling the walls of a tem⁄ple or grotto where some niches hide ancient religious ob⁄jects like the oil lamp on the right. The image of the divine figure contains other faces and images and we can see his heart surrounded by a patch of white, which appears to be

MIMMO PALADINO, "BAAL", 1986

beating and thus gives the impression that the god Baal is semi-human.

One peculiarity of the picture is its shape. Round canvases were hardly used in the 20th century (with some exceptions among contemporary artists like Damien Hirst and Ugo Rondinone), so the shape looks like something from the past when circles and semicircles decorated the space created by arches and vaults in churches. The circular structure of "Baal" has therefore a spiritual reference. The edge of the canvas is marked with 12 dark shapes, like the hours on a clock face. But by being placed at uneven intervals, they distort our understanding of time and help make the sense of suspension in time and space even more tangible.

Paladino has created a universe of mysterious figures, ghosts and nocturnal creatures. They move within a space full of equally mysterious objects suspended in places where we can discern traces of just completed rites, as well as signs and symbols that are not only Christian but also alchemistic and magic. Paladino's origins ⁄ he was born and brought up in southern Italy ⁄ have often been cited as an important factor in helping create in his mind a strange mix of religiousness and popular cult, of the sacred and at the same time the mysterious.

Do we need to understand in full the individual references to appreciate the work? No ⁄ it's important to let ourselves be drawn into the fantastic and slightly ghostly world of the canvas. The artist himself says he wants to allow "absolute freedom of interpretation of the imaginative elements I propose; that's how the chance stratification of all the possibilities for deciphering generate a kind of duplication, reflection and thus an ambiguity which I believe is a constant concern in my work".

Non-figurative painting: an invitation to abstract vision
Sean Scully

Abstract art is the art of our times, according to Sean Scully. It allows us to think and reason without specific references that oppress the viewer, who is thus free to identify with the work. Abstract art is the spiritual art of our age. It could not be clearer that Sean Scully considers abstract painting to be absolutely pivotal to the development of art in the second half of the 20th century.

Scully is an extremely rigorous painter who is so precise and focused as to sometimes appear dour and uncooperative (according to some gallery owners). He is unwavering in his obsessive insistence on geometric abstraction. Everything is structure in Sean Scully and it is no coincidence that his works are often considered to have an architectural flavour. The stripes of colour are his hallmark and are to be found in all three media he uses: oils, pastels and watercolours.

Scully also follows a very precise order in the way he names his works. He only gives titles to oil paintings, which thus, as he says, "assume individual personalities, and that is why I sometimes give them names of people or places". His pastels and watercolours are only identifiable according to the date of execution.

The structural character and composition of Scully's works is accentuated by the fact that he constructs many of his works by joining or inlaying different canvases. He paints

Sean Scully, "Catherine", 1987

each one according to different principles regarding the size of the stripes and the layout of colour and even uses different sized and shaped paintbrushes to give the surface itself different streaks and textures. His is a continuous attempt, perfectly realised, to break down and reconstitute the harmony of a painting.

"Catherine" is part of a series of works named the "Catherine paintings" dedicated to Sean Scully's former wife. Every year since 1979, Scully has chosen a particularly significant work from his output the previous year and named it after his wife. The whole series, which is now in the collection of the Modern Art Museum of Fort Worth, Texas, represents a sort of mirror of the evolution of his art, an intimate retrospective.

"Catherine", like most of Scully's work, is a painting based on relationships or rather the lack of sense in relationships (both those between lines and colours and those between

people). What we see are three different parts or sections that are, in fact, three different canvases, two of which have been inlaid into the larger one. In this way, Scully is consciously seeking to introduce elements which break up the unity of the painting. The observer is thus inclined at first to concentrate on the individual elements rather than on the piece as a whole. This sense of rupturing the linear nature of the composition is accentuated both by the fact that in the little square, the lines are horizontal, whereas all the other lines run vertically, and by the fact that in the square on the right, the stripes are vertical as in the large background but are thinner. The apparent instability of the composition provides a sense of movement, of transformation, of a process that is underway. The artist is convinced that the concept of beauty can be reflected and displayed in strident juxtaposition and in the lack of harmony.

Beyond theories and explanations, Scully's paintings, which are genuine monuments to abstraction, pack an enormous visual punch. One of Italy's top critics and curators, Danilo Eccher (to whom Sean Scully owes many solo museum exhibitions) summed this up, saying of Scully's works that "one of art's greatest and most fascinating mysteries remains that which cannot be expressed, the disconcerting way that many works of art can't be pinned down, seeming in the moment they appear to be indescribable, often simple, silent in their magical visionariness".

Alchemist and sculptor: Tony Cragg transforms ugly and worthless things into gold

At first sight, you could think anything about the sculptures of Tony Cragg except that they are part of a naturalistic tradition of art in which the materials combine with the harmony of reality. But Tony Cragg rightly considers his works to be still lives of the 20th century.

His quest is to blur the boundaries of natural/artificial and beautiful/ugly in the conviction that the distinction is only a fiction dictated by prejudices and mental habits. Tony Cragg became famous for his use of synthetic materials (principally plastic, a synonym par excellence of industrial products) and urban non-organic refuse. For his sculptures, Cragg often picks up refuse (combs, plastic bottles, chair legs, empty bottles, etc.) from rubbish dumps and transforms them into works of art, as if by a process of alchemy which turns stones into gold and "ugly" and worthless things into things that are "beautiful" and precious.

The sculpture "Minster" is made from industrial discs in a variety of materials (rubber, iron, cement, cast iron, etc.), stacked up in decreasing order of size in order to form a series of spires. Their column-like shapes have an almost classical appeal given the synthesis between the heaviness and horizontal nature of the individual elements balanced by the spirituality emanating from the vertical nature of the structure. The shape of Tony Cragg's spires also automatically puts us in mind of chimneys

Tony Cragg, "Minster", 1987

on rooftops, the structure of Gothic churches or pylons and ra⁄
dio masts. Something familiar is born both out of the chosen
shape, which is always extremely simple, and the materials and
pieces he uses, giving all his works an air of déjà vu, a certain
undefinable ordinariness that is at the end of the day "natural".
Tony Cragg's minsters are definitely a monument to the evo⁄
lution of man and society. They seek neither to celebrate nor
to criticise, but simply to bear witness, for ourselves and for our
children and grandchildren, of the natural⁄industrial world
we live in.

Knitted protest: feminine and feminist
Rosemarie Trockel

German artist Rosemarie Trockel takes the Cartesian affir-
mation "I think, therefore I am" and puts it somewhere com-
pletely unexpected: in the stitches of a piece of knitting the size
of a large painting. Rosemarie Trockel hangs her so-called
"Wool Works" on the wall. She seeks to reuse a medium as-
sociated with women in a transforming and disconcerting
way, providing a critical and at the same time ironic reading
of the role of women in society.

"I think, therefore I am," says the woman who made this work
(whoever looks at the picture will have instinctively imagined
that the protagonist is a woman, even if no such reference has
been given; that proves how the use of wool is automatically
associated with women). She affirms it, not in a strident or
loud way, but by means of this neutral, impersonal and repeti-
tive object. In the absence of more appropriate and powerful
means which the artist believes are denied women in society,
knitting is the way they show they exist. It is a manifesto or a
notebook where, in the middle of a page, they can scrawl a self-
affirmation in uncertain, childish writing, stripped of philo-
sophical speculation but full of partly concealed anger. It is the
anger and desire to go beyond this first affirmation of principle
which the dark square in the bottom right seems to convey.
What emerges is a sense of uncertainty plus a dose of reproof
at the discriminatory attitudes shown towards women. The
viewer is also urged to reflect upon the fact that the words

Rosemarie Trockel, "Cogito, ergo sum", 1988

"I think, therefore I am" need continuous reaffirmation so that they may also apply to women.

Trockel has used many other traditionally feminine objects in her works, like electric hobs, irons and advertising images. But no other material or instrument has the same evocative strength, and also the same simplicity, as the "Wool Works". They have become her trademark and the most prized by collectors.

I have tracked Rosemarie Trockel's work for many years. I saw her early drawings in a show of works by contemporary German artists from the Deutsche Bank collection, organised by Museion, the Modern Art Museum in Bolzano, in northern Italy, in 1991. I immediately liked her small works on paper that looked very simple but were at the same time enigmatic and unsettling. I had never heard of the artist before and I asked Andreas Hapkemayer, then deputy director of the museum whom I had known for a few years, for information about her, before beginning my own research.

For a collector, finding the right piece is a particular pleasure. Going into a gallery and buying a painting hanging on the wall after falling in love with it at first sight takes away some of the satisfaction that comes from going from gallery to gallery, asking dealers, leafing through catalogues until you find the very piece you had spent months hunting for.

I was looking for a wool painting by Rosemarie Trockel that would be sufficiently small (most of her wool pictures are quite large) without losing force and intensity. Hapkemeyer gave me the name of a gallery (Monike Sprüth in Cologne) as a reference, but they had no small works available at the time. I got the same answer from another gallery. So I picked up the catalogue of the Basel art fair and I wrote to five or six galleries who had shown works by Trockel. One

gallery offered me a multiple, another some beautiful drawings (I bought one), and another - after having been asked for a small piece - offered me a wool work measuring two by three metres"! At the same time, at auctions, I had put in two offers for pieces that I found interesting, but both times I was outbid.

More than two years after my search began I finally got the news I had been waiting for in a fax from the Timothy Taylor Gallery in London: a private collector was selling a wool work measuring 40 by 40 centimetres, with a perfect provenance (Monika Sprüth gallery), at a price I could afford. A small jewel, finally within reach.

Today's sacred art is pantheistic
James Brown

Does sacred contemporary art exist? And if so, what does it look like? Perhaps talking about sacred art is misleading because it can call to mind images of saints and the atmosphere of a sacristy. It would be more appropriate to talk about art that makes spirituality its subject matter. In this sense, James Brown is an artist with a deeply-rooted sense of spirituality. Without knowledge of that, his works are hard to understand. His spirituality is not linked to any religion, even though Catholicism has influenced him greatly. It is a sort of lay spirituality which puts the capacity to evoke quasi-mystic feelings at the heart of his art.

James Brown has four brothers who, not coincidentally, all have the names of apostles. Educated at Jesuit schools, he assimilated an array of rituals, signs, symbols and concepts both from his family and from school that permeate his whole oeuvre, starting with the titles of some of the cycles of paintings he has composed: "Stabat Mater", "St Bartholomew", "St Gennaro", "Stella Maris" (a Latin name for the Virgin Mary), "The Fifteen Stations" (of the Cross), "The Five Glorious Mysteries", a series of sculptures called "Eleven Portraits of Buddha", as well as various paintings carrying the name of Christ. But nothing could be further from James Brown's work than a figurative representation of the images the titles evoke.

"Stabat Mater" is part of a vast cycle which takes its starting point from the initial words of a medieval religious poem

JAMES BROWN, "STABAT MATER NO. 50", 1988

written in honour of the Madonna often set to music over the course of the centuries. "Stabat Mater No. 50", is a small painting measuring barely 45 by 30 centimetres. We immediately note that it is divided into four equal parts by a horizontal and a vertical line. Brown often uses this quadrants method, and it derives from his use, as support, of untreated linen fabric which maps and street plans were once stuck to. What looks like a canvas folded into four is in fact the back of a map, yellowed with age and marked with folds. This is a highly effective visual trick enabling James Brown to take his cue from a grid, not a white canvas. The grid imposes a geometric design on the work, a sort of regular cadence on which to apply his brushstrokes.

Why does this work have a capacity to evoke a spiritual response in the viewer? The main feature is the tension between the precise squaring of the background on the one hand and the deliberately vague outlines of the oil painting - which in this case looks like a sort of double wedge - on the other.

The tension is further accentuated by the fact that all the colour is concentrated on the left of the work, like a weight on that side. But balancing it, on the right side, is a piece of collage, a piece of paper in the form of a shield bearing a number and a name. This is an artifice to ensure the viewer's gaze is not focused on the painted part of the picture. If we cover the piece of paper with a finger, we see that our eyes are drawn to the work in a much more unbalanced way, veering left. The element of collage confers stability on the whole composition. Though composed, to use an expression borrowed from theology, of a trinity of elements (the background grille, the colour red, the piece of paper), the work appears to have its own unity. It is a very well balanced composition, appearing not cold and rational but captivat-

ing and mysterious. The colour Brown has chosen ⁄ a shade of ochre or brick red ⁄ conveys a certain physical character and may recall the colour of blood, while the lines of the background form a cross.

James Brown, whose sensitivity and long stays in Paris and Naples make him seem more European than other contem⁄ porary American artists, is not interested in the representa⁄ tive aspect of religion but in the possibility of leading his pub⁄ lic towards a silent sense of meditation and transcendence.

A sensual, almost explosive beauty, barely contained by the edges of the canvas
Rainer Fetting

This painting by Rainer Fetting is so beautiful! So much is said about theories of art, about concepts and intellectual interaction with art, but when you're standing in front of a painting with great expressive force, you must, at least for a moment, abandon all rational thought and just enjoy the almost violent beauty of the piece.

It doesn't matter if the artist has also produced mediocre works and if his fame, and thus his prices, drastically declined in later decades. This great portrait of "Marc with Iris", which, at two metres high, shows the figure larger than in real life, certainly remains one of Fetting's most powerful works. Enzo Cucchi, mentioned before, believes an artist produces only a few very important works in the course of a whole career and for Rainer Fetting this is one of them.

Fetting applies colour in a rough and almost wild fashion (for this reason Fetting is linked with a group of German artists dubbed the "New Savages"). His painting style is as far as it is possible to imagine from the so-called "conceptual art" which also had many followers and moments of great intensity in Germany. On close inspection, the painting may also seem to evoke ⁄ perhaps to make fun of ⁄ another artistic movement from the second half of the 20th century:

Rainer Fetting, "Marc with Iris", 1989

the Abstract Expressionism of Jackson Pollock and Franz Kline which is characterised by strokes of colour and the dripping of paint. Fetting, too, lets the blue he uses for the background drip and he treats the whole background of the painting as if it were an abstract image (in Fetting's words, "it adds atmosphere to the painting"). But what really counts is the figure, the image, the portrait.

Fetting has often painted nudes which, far from being in any way vulgar, express the beauty of human beings. It is a very sensual, almost explosive beauty, barely contained by the upper and lower edges of the canvas. There is an attitude of fake relaxation about the person in the picture, who is on tiptoe and could run off any moment. The intensity of the colour, the spontaneity of the figure, the gaze turned on the viewer are all important elements of the piece. But the real extra touch in the composition comes from the iris that Marc is holding in his hand. The flower is held in an unnatural position and appears more like a dagger pointing at him than a decoration or symbol of tenderness. Thus the flower becomes a weapon against beauty, a weapon against which the naked body would have no defence if the figure were seized by a suicidal impulse.

The picture "Marc with Iris" was painted at the end of the 1980s, a decade that saw the revival of figurative painting. But the decade has come to an end and the 1990s will bring a new revolution that will once again relegate more traditional subject matters and techniques. Many artists, among them Rainer Fetting, will fade from the artistic limelight and the portrait of Marc, with this tender but almost threatening flower turned against the figure, is almost a premonition of the imminent end of an era.

The 1990s

After the euphoria of the 1980s, the following decade opens very differently. For a start, the art world is a casualty of economic crisis. Many galleries which opened on the wave of success and sales a few years earlier close down. Prices drop and the number of artists still able to achieve commercial success falls. Economic crisis triggers a crisis of values and, in the art world, this is accompanied and accentuated by the death, at the end of the 1980s and in the early 1990s, of some brilliant young artists: Jean-Michel Basquiat died of an overdose in 1988; Keith Haring and Felix Gonzalez-Torres died of AIDS in 1990 and 1996. The impact of AIDS, especially in the United States, in the first half of the decade is significant and helps spark renewed interest in social values which were set aside during the golden years of the 1980s.

Three other features shaped this decade. The first is the growing presence of women artists. By far the largest number of artists to emerge in the 1990s and to distinguish themselves by the originality and quality of their work were women.

When the "Italian Art in the XX Century" exhibition opened at London's Royal Academy in 1989, critics slammed the fact that among the dozens of artists on show there was only one woman: Carla Accardi. But curators Germano Celant and Norman Rosenthal would have had a hard job finding any other significant names then. Today, even a brief tour through Italian art in the 20th century could not fail to mention several women artists (Vanessa Beecroft, Eva Marisaldi, Liliana Moro, Grazia Toderi among others), who all came to prominence within the space of a few years. The 1990s were also characterised by a leap in the quantity of techniques and media available to artists. Photography and video became

commonplace. Though video had been used for several years, in this decade it stood out for delivering the greatest innovative impact). The vast majority of people today spend more hours sitting in front of a television or computer screen than reading newspapers and thumbing through magazines. Video, therefore, loses some of the gloss of tech^ nological novelty that it had at first and has become a completely nat^ ural instrument for the transmission of sensations and images.

Another characteristic of the 1990s is the fact that the works, which had already become bigger in size (we saw the case of Julian Schnabel), now become more complex, and technically feasible only with enormous feats of engineering and vast amounts of money. It was not easy to bring the tiger shark that Damien Hirst put in formalde^ hyde from Australia, nor to collect the 34 tons of ice that Anya Gallaccio left to melt slowly in an empty factory. Such works are not only inconceivable outside the extended spaces of a museum or oth^ er appropriate location, but are not even possible unless a private col^ lector (like Charles Saatchi who financed Hirst's shark), a com^ pany or a public institution picks up the tab. Public and private patrons, therefore, once again provide the cash and specialised institutions or organisations, like Artangel in Great Britain, are formed to bring large artistic projects to life.

Concept and sentiment, possession and loss: life passes in a ream of paper
Felix Gonzalez-Torres

As children, we have all faced the paradox of the box of chocolates. Take one and no one will notice. Take a second and everything still looks the same. And a third. But at some point, the box of chocolates is empty. There is thus a moment in which we move from the concept of "group" to "singles" which made up the whole before it became empty. But identifying the exact moment in which "lots of chocolates" turns into "a few chocolates" is no easy task.

Is it possible to apply the metaphor of the box of chocolates to abstract concepts such as art or personal feelings or life itself? Gonzalez-Torres says it is.

"Untitled (Loverboy)" is a sculpture presented as a stack of sheets of blue paper placed on the floor by a wall. The public is invited to pick up and take home the individual sheets that make up the pile. At the end of the day, the art gallery, collector or museum to whom the work belongs will top it up again with identical sheets to restore the artist's original specifications. The sculpture is presented as a composition, and only as such constitutes a work of art made up of individual pieces. When the pieces are removed, they lose meaning and value. The artist in this case works at the same time on two levels: one "conceptual", the other "sentimen-

tal". From a conceptual standpoint, Gonzalez-Torres' operation is a subtle form of revolution of the presumed preordained order of art. He overturns a number of conventions. To begin with, the untouchable nature of a work of art is turned on its head and viewers are not only invited to come into contact with the work (as is the case with Carl Andre's floor sculpture, which the public was invited to walk on), but are also authorised to take possession of part of the sculpture. Furthermore, the owner of the work, who usually gains the property rights of the work by buying it, in this case also becomes the person charged with the duty of reconstituting the work as it is progressively "eroded". His rights turn into a duty. But it is also important to grasp the more sentimental and romantic concept behind this stack of paper, just as in other works by Gonzalez-Torres comprising piles of sweets scattered on the floor. The progressive diminishment of the sculpture is a metaphor for the gradual day-by-day decline of Ross, the artist's lover, caused by AIDS. Ross died in 1991 (Gonzalez-Torres would die of the same illness five years later).

FELIX GONZALEZ-TORRES, "UNTITLED (LOVERBOY)", 1990

The blue card sheets of "Untitled (Loverboy)" recall the sky (Gonzalez-Torres describes the shade of this paper as "innocent blue") and their diminishment reminds us in an almost agonising way the slow but inexorable sensation of loss that an illness can produce by taking away every day a bit of the life of someone dear to us.

This process of identifying the human body with the sculpture is even more marked in the case of the piles of sweets, which usually match the weight of the portrayed person. They represent real portraits in a medium that is both sweet and happy but at the same time perishable and tinged with a certain melancholy. The sadness derives from the sense of progressive disappearance which every day forces us to confront the death of someone we love, like an empty fruit bowl with no apples left or a pile of sweets that have disappeared. Gonzalez-Torres' works must be continually restored by the owner to ensure that they continue to exist. But how do you guarantee the uniqueness of the work? Gonzalez-Torres himself affirmed that these pieces are indestructible in the sense that they can be duplicated to infinity; they will exist for ever because in reality they don't exist or rather it is not necessary that they exist at every moment.

This way of overturning normal artistic concepts is present in another work from 1991 that was conceived as an edition of 190 copies plus 10 artist's proofs. Such works in principle are destined to go to a vast number of collectors. But this particular work could only be sold as a single bloc piece. The owner, therefore, is in possession of 200 copies of the same work.

The importance of regulating his works for collections as well prompted Gonzalez-Torres to define in the certificates accompanying his work precisely where the work's prop-

erty rights lie, and the nature itself of the certificate of authenticity. The certificates which accompany the piles of sheets of paper/card, for example, contain precise indications: "If the exact type of card is not available, a similar card may be used. Part of the work resides in the fact that third persons may take away individual sheets of card from the pile. The owner has the right to reprint and substitute, at any moment, as many sheets of paper as is necessary to bring the work back to its ideal height. The construction of the work in more than one place at the same time is not harmful to the uniqueness of the work since the uniqueness is defined by the property rights."

Pharmaceutical paintings (don't exceed the recommended dose)
Damien Hirst

If I asked you who is the most famous living Italian artist, what would you say? I wouldn't know what to reply. Since Burri died in 1995, probably today I would say Mimmo Paladino. But if you asked an English person, they would almost certainly say that the most famous living British artist (not the most important from a critical standpoint, but the best-known to the public) is Damien Hirst, even though he is only just over 40. The other English artists who would probably be named are Lucien Freud, though he is much more a traditional classic artist than e contemporary one, and David Hockney, though many people consider him more American than European because of his type of painting (Pop Art) and the fact that he has lived for a long time in Los Angeles and New York.

Like Francis Bacon before him, Damien Hirst has made his obsession with the perishable nature of flesh and the body the driving force of his work. Bacon explored this preoccupation in a series of portraits, almost always of his friends or himself, in which the physical state of the contorted body expressed the suffering and internal anguish of the person painted ("When I look at myself in the mirror," Bacon once said, "I see death at work".) In Hirst's works, this preoccupation either takes the form of direct exhibition of animals - whole or in sections - preserved in formaldehyde inside glass tanks, or in the so-called "pharmaceutical paintings".

DAMIEN HIRST, "ACETIC ANHYDRIDE", 1991

Probably his most famous works, the ones for which Hirst will be remembered, just as the portrait of Marilyn Monroe immediately calls to mind Andy Warhol's Pop Art, are in the first category. "The Physical Impossibility of Death in the Mind of Someone Living" is a large tank in which an enormous tiger shark with its jaws wide open is immersed and suspended in formaldehyde, fixed in the moment at which it was about to attack its prey.

"Acetic Anhydride" belongs to the second group of works. The structure of the piece ⁄ identical in all the "pharmaceut⁄ ical paintings", which change only in the size of the canvas and the colour of the spots ⁄ shows a series of dots ordered in precise horizontal and vertical lines. All the paintings be⁄ longing to this series take their title from single chemical compounds, deuterated compounds or controlled sub⁄

stances used in pharmacology and present in drugs ("Anazolene Sodium", "Ammonium Biborate", "Bendroflumethiazide", "Adrenochrome Semicarbazone Sulfonate", etc.), and the work appears as an attempt to give artistic expression to the relationship between life, health and wellbeing on the one hand, and the medicines which can induce such states of health on the other.

"Art is like medicine," Hirst himself says. "It can heal." Drugs alleviate and improve our physical and mental states but at the same time they can create dependence and distress. In the same way, Hirst's pharmaceutical paintings at first sight convey a feeling of happiness and contentment but a second and longer look can induce the same sense of unease linked to the fact that we can't find a sense, an order or a connection between the dozens of colours on the canvas which are all deliberately, even if only subtly, different. In these works no colour is repeated twice; Hirst sought in this way to express the unexpected, the irrational and thus the true "horror" innate in any situation which escapes our classification and can overwhelm us at any time.

The relationship between the patient and medicine is also present in a series of wall sculptures, closely related to the pharmaceutical pictures, which appear as medicine cabinets crammed with pill boxes, medicines and syringes. What medicine means to man is summed up in the titles he gave to these strange assemblies: "God" from 1989, or "Nothing is a Problem for Me" from 1992.

At the heart of Hirst's entire oeuvre is the analysis of the relationship between life and death. When our daily life is taken up with this relationship, out come the ironies, lies and false expectations linked to contemporary man's pointless desire for immortality.

Hirst, who helped establish other British artists featured in the exhibition "Freeze" in London in 1998, which he curated as a 23-year-old student at Goldsmith's College, has many followers. Italian artist Maurizio Cattelan (who showed his work at the Venice Biennale in 1997 and 1999), while very different, has been compared to Hirst because he featured stuffed or preserved animals in some of his installations. One of the features distinguishing contemporary art from that of the past is the way a particular technique or original "discovery" becomes closely linked with a particular artist. The concept of "schools" has been lost and increasing emphasis is placed on an individual's own particular originality. As a result, there are few artists who would venture to use techniques now strictly linked to others (like Rosemarie Trockel and her wool pictures and Damien Hirst and his taxidermy).

The void attracts us;
it is our origin
Anish Kapoor

The subject of many of the sculptures of Anish Kapoor, who was born in India but grew up and trained in Britain, is nothingness, the void, the absence of space and matter. It almost seems a contradiction to imagine a sculpture – a word which immediately brings to mind the heaviness of an ob-ject and the physical nature of the materials used (marble, bronze, iron, etc.) – whose subject is the description of the void. But that is precisely the basis for the beauty and appeal of Kapoor's pieces.

"Untitled" from 1992 takes the form of a block of sandstone more than two metres high into which he has cut a wide rect-angular opening penetrating deep into the stone. The sur-faces of the carved-out part have then been painted such a dark blue (so-called Prussian blue) that they appear black at first sight and are only revealed to be blue when the view-er's eyes have gradually adjusted to it. We get a strange and yet fascinating feeling standing in front of the stone as we in-stinctively realise that the "sculpture" we are looking at is not made of stone, which has deliberately been left rough at the edges: the sculpture is the empty space at the centre which attracts our gaze. The stone, then, is like the frame of a paint-ing and its only function is to give the piece a spatial bound-ary. The void we are facing, and which we would like to touch – if that isn't a contradiction and if the security guards would let us put our hands or our head into the hole in the stone – inspires fear and respect at the same time. It is a kind

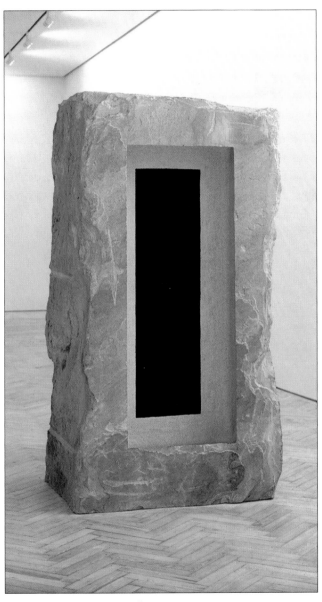

Anish Kapoor, "Untitled", 1992

of gap in the gloom and it is precisely this stark contrast be-
tween the sandstone frame and the indefinable nothingness
which is suspended within the stone that is an impressive
metaphor for the material and the spiritual, the conscious
and the unconscious, the finite and the infinite.

Another form often present in Kapoor's works is the womb.
Some works are explicitly about motherhood (one of his
sculptures, comprising a round bump protruding from a
wall is aptly titled "When I Am Pregnant") but even some
of his sculptures made of hollow stones such as "Untitled"
from 1992 refer to the same theme.

People have often linked Anish Kapoor's use of pure
colours and the spirituality that such shades can convey with
his Indian origins. But I don't think this deduction is ne-
cessarily accurate, both because his education and artistic
training all happened in Britain (he represented Britain at
the Venice Biennale in 1990) and because in Indian artistic
circles, Kapoor is not perceived as one of them, but as one
of many western artists who has occasionally been in-
fluenced by aspects of Indian life and spirituality (like
Wolfgang Laib or Francesco Clemente).

The irrational pull of Anish Kapoor's voids is proved by
their appeal to children, who are very attentive observers but
are completely unconditioned by artistic theory or concep-
tual notions. During the major exhibition which London's
Haywood Gallery dedicated to Kapoor in 1998, guided vis-
its for children aged between six and 12 were laid on. I think
the best way to get children interested in art is to put them in
front of a work with an aura of magic and mystery, works
which don't need explanations but which strike our imagin-
ation and remain imprinted on our minds like the pyramids
of Giza and the monoliths of Stonehenge.

Guided tours for children at the Anish Kapoor exhibition are just one way in which some countries, particularly Britain, are striving to remove that tone of seriousness and sacredness that often shrouds museums.

One day I went to the Tate Gallery in London with my children Federico and Alessandra, who at the time were five and four. It was a Sunday afternoon, a time dedicated to children thanks to an initiative called "Art Trolley". This was an actual trolley full of pencils, coloured papers for collages and tubes of glue that was wheeled happily through the museum's rooms. The assistants handed out various materials and the children had fun, lying on the floor copying famous paintings (Federico got to grips with a work by Joan Miró and Alessandra drew one of Giacometti's elongated figures). I, meanwhile, visited other rooms in the museum, and the children spent a wonderful afternoon in the company of other children in a place associated in their minds with pleasure and fun.

The British conviction - which I share - that museums should attract children to teach them a passion for art reminded me how I had been struck by the discovery that in the late 1930s, John Rothenstein, then director of the Sheffield Museum and later director of the Tate Gallery in London, organised an exhibition of drawings by Walt Disney to lure children into his museum.

Children are the most important beneficiaries of museums and it is fundamental to make them feel at ease in rooms that are normally austere. Familiarity, not discomfort, is what breeds respect for art.

Rachel Whiteread's monument is a hymn to the intimacy of daily life

It may look like coincidence but, as a result of a solid tradition handed down by excellent art schools, Britain has produced the most interesting and innovative sculptors in the last 40 years. After Richard Long, Tony Cragg and Anish Kapoor, this great British tradition continues with Rachel Whiteread.

Working on the same subject as many of the sculptures of Anish Kapoor, namely the void, Rachel Whiteread strips her quest of any poetic connotation to show in a direct and crude way the physical nature of something the naked eye does not perceive. She picks up on a procedure first used by American artist Bruce Nauman in a work called "A Cast of the Space Under My Chair", and takes it to its furthest extreme, turning reality inside out like a glove to give form to the air surrounding the objects and eliminating their physical presence, leaving only a cast to evoke them.

"House" is the exact cast of the inside of a late 19th-century English house from the outskirts of London, located in what was a working-class district later seized upon by lucrative property speculators. With a whole team of technicians and workers, financial and organisational assistance from an organisation called "Artangel" that specialises in large art projects, and sponsorship from a famous beer com-

pany, Rachel Whiteread worked for weeks and weeks (she began the planning phase in 1991) to give life to the void of a whole house.

While bronze sculptures adorning squares commemorate heroic triumphs, illustrious men on horseback or people who had won their place in history, Whiteread's "House" is a hymn to the intimacy of daily life and its precariousness. "House" has rightly been considered a grandiose and ephemeral monument to the memory of lost lives, the thou⁄ sands of anonymous people and the passage of urban com⁄ munities who disappeared without trace. And at the same time a memento mori dedicated to individuals and to soci⁄ ety itself.

Whiteread's monumental house, completed on 25 October 1993, was demolished on 12 January 1994. The work was deliberately not built to last and its temporary nature does not diminish the work's intensity. When it was finished, at⁄ tempts were made to make the installation permanent and some people were scandalised when bulldozers demolished

RACHEL WHITEREAD, "HOUSE", 1993

it. Even though I understand why people wanted to keep it standing, I believe that despite, or perhaps because of, its destruction, the piece is in fact complete. The artist herself said she never conceived "House" as a permanent monument.

The way Rachel Whiteread renders visible the invisible means her works have often been correlated with how blind people perceive objects. To feel the air and the void is a sensation far more immediate and intense for a blind person, for whom the distance between one object and another is a tangible reality. By giving form to invisible realities (whole rooms or small spaces in a house like the air under the bed or inside a wardrobe), the artist has produced a personal inventory of often unsettling places and objects which take us back to our childhood fears. In her sculptures, there are never any people, but there is a constant presence of inhabitants in the places she brings to life. In the same way, feelings, anxieties and fears ⁄ although not material ⁄ become perceptible as an integral part of our lives.

A slow-motion psychodrama between voyeurism and memory
Douglas Gordon

In 1996, to celebrate the 100th anniversary of the birth of cinema, the Hayward Gallery in London put on an exhibition called "Spellbound" to which both artists (including Douglas Gordon and Damien Hirst) and film directors (among them Ridley Scott, director of "Alien" and "Blade Runner", and Peter Greenaway, director of "The Draughtsman's Contract" and "Drawing by Numbers") were invited to show their work.

I went to see the exhibition. Inside, I found a dark, heavy curtain in front of me leading to a small cinema. On a screen, "Psycho", perhaps Hitchcock's most famous film, from 1960, was being projected. But there were two things that made the showing different and unique: it was completely devoid of sound (speech, music and sounds were off) and the speed of the projection had been slowed down (from a normal rate of 18 frames per second to less than two frames per second) so as to make the film last exactly 24 hours. Witnessing the very slow and silent projection of "24-Hour Psycho" is a very strange sensation. I spent nearly 10 minutes in the little room but I saw less than a minute of the actual film. My attention was completely distracted from what happens in the plot (which I already knew) and was focused on all those details which, though obviously part of the original film, I would never have noticed in normal circum-

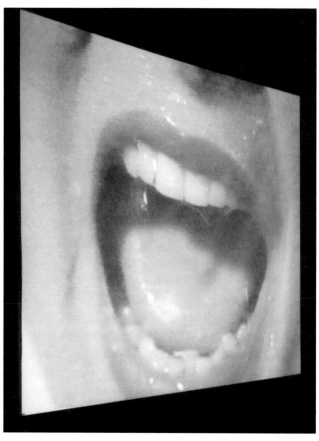

Douglas Gordon, "24-Hour Psycho", 1993

stances: the pleats in the clothes, the tuft of hair sticking up, the fastening of Janet Leigh's bra, what was in the sandwich that the main characters eat, and so on. But what does all that mean?

We have to take a step back and start out from two concepts that underlie all of Douglas Gordon's work and artistic investigation: voyeurism and memory.

Douglas Gordon studies our reactions, sometimes of at-traction and repulsion at the same time, when we are ex-posed to extreme behaviours. The psychopath in "Psycho" and the hysterical woman in his work from 1994 called "Hysterical", which uses a clip of archive footage from the late 19th century of a woman arguing and writhing in front of two men who are trying to restrain her - are examples. Another is a video made up of just one shot of two hands, one hairy and the other not, fighting each other (the work is titled "Divided Self": both hands are Douglas Gordon's). The artist is interested in our attitude and behaviour when we show a sort of vicious curiosity for scenes of violence or submission, scenes displaying one person's power over an-other. Therefore the work needs the participation of the viewer to exist. The spectator, with his or her reactions, be-comes an integral part of it.

Audience participation takes on a fundamental role in Douglas Gordon's pieces that have to do with memory, and in particular the process of how memories are inscribed in our minds. A group of pieces generally defined as "Wall Works" illustrate this. They consist of phrases written dir-ectly onto a wall (in this case too, like with Sol LeWitt and Gonzalez-Torres, the collector who buys the piece only be-comes owner of the certificate representing the right to repro-duce the writing, which can be written and removed at will).

One of these phrases, from 1993, says: "From the moment you read these words until you meet someone with green eyes." The mechanism at the centre of this work is the fact that the viewer, after reading this sentence written on the gallery wall, will involuntarily become part of a sequence of events that will only end when he or she really does meet a

friend, an acquaintance or even a stranger with green eyes. It's likely that then, by noticing their green eyes, he or she will remember the writing on the wall (whether it was an hour, a day or a week ago) and so the unconscious mechanism triggered by the visit to the art gallery will have ended.

Another example is a work from 1990 titled "List of Names" in which the artist himself is a guinea pig in his experiment. The work consists of a list of the names of all the people that Douglas Gordon can remember ever having met in his life up to the time he installed his work on the walls of the gallery. It's obvious that it is a work in progress and the list will differ, even if slightly, each time it is installed. It may seem at first sight difficult to classify such things as art compared to a painting or a sculpture whose forms or shapes, beyond aesthetic personal judgement, are still automatically included in our brain under the label of "artistic product". The importance of the works of Douglas Gordon lies precisely in their determination to venture into territories that are still largely unchartered (the mechanisms and functioning of the human mind subjected to external stimuli) using instruments of mass communication like cinema.

In May 1996 I bought a piece by Douglas Gordon from Galleria Bonomo in Rome. It is one of his "Wall Works" which says "I know what you are thinking" and refers to something he did in 1994. The work was displayed during his first solo show in Italy, in the Galleria Bonomo where Alessandra and Valentina Bonomo (now owners of two separate galleries) had already spotted Douglas Gordon's talent.

At the end of 1996, Douglas Gordon was announced as winner of the prestigious "Turner Prize", an award limited to artists who are British

or work in Britain (Tony Cragg, Damien Hirst and Rachel Whiteread are among winners) that is organised by London's Tate Gallery.

Pushed by the streak of vanity that collectors have regarding their pieces, I wrote to the Tate. I told them I had bought a work by the winner of the latest edition of the "Turner Prize" and I would be happy, if they wanted, to make it available to the museum for display. I received a letter from the director of the Tate Gallery, Nicholas Serota, thanking me for the information, congratulating me on my purchase and adding that the details of the Douglas Gordon work I owned had been added to their records in case they should have an appropriate occasion to show it.

I had also written a similar letter to the director of an Italian museum offering some works for display. I'm still waiting for a reply.

Scents of chocolate and soap: an unusual self-portrait
Janine Antoni

In 1992, an important group exhibition was held in Lau-
sanne which later moved to Turin, Athens and Hamburg.
It was called "Post Human" and brought together a like-
minded group of mainly very young artists who put the
human body at the centre of their artistic exploration. The
body was not, however, understood as a figurative represen-
tation or as an artistic instrument (as was the case with so-
called Body Art in the 1960s). Instead, it was a subject for
reflection on the perishable nature of the flesh, its eventual
deformation and its more intimate physiological functions.
Beside a profusion of art works that were at times deliberate-
ly uneasy on the eye (like Andres Serrano's photographs of
bodies in the morgue or sculptures of the deformed bodies
of children by the brothers Dinos & Jake Chapman),
Janine Antoni's works referred to the body and the natural
or artificially induced changes it undergoes, but with a greater
dose of irony, thus sparking curiosity rather than revulsion.
"Lick and Lather" is a work composed of a series of 14 busts
of the artist herself. Seven are made of chocolate and the
other seven of soap. The busts began as very realistic rendi-
tions of Antoni's features but were subjected to a constant,
slow treatment by the artist herself which gradually changed
their shapes: for several days, she licked the chocolate ones
and used the soap ones to wash her hands.

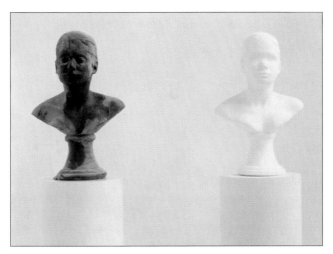

The artists of Body Art focused their work on the emotional involvement of the spectator as the work was being created through performance, some of which were particularly cruel (like when American artist Chris Burden got his assistant to break his arm in front of the terrified audience in an art gallery). Janine Antoni, on the other hand, conducts all her interaction with the artwork (licking the chocolate and soaping her hands or, in other works, blinking her eyelashes covered in paint onto a sheet of paper or chewing bacon fat and spitting it out to use it for modelling) in private in her studio, and presents only the product and not the process of her actions.

"Lick and Lather" is a powerful work where the sense of smell plays a very important role. The viewer is enveloped in a strange atmosphere where the smell of chocolate and soap ⁄ two scents which both recall childhood ⁄ become mingled and each penetrates the other. We are presented with a distinctly classical structure where the busts could be

19th-century sculptures that have weathered over time. But on closer inspection, we connect with what the artist was doing, trying to understand if, by remodelling her own image with her tongue or hands, she deliberately wanted to highlight the fictional changes of some parts of her face rather than others. (These actions are decidedly less extreme than the debatable plastic surgeries that French artist Orlan has been undergoing for many years, which have led to a radical and irreversible modification of her body and facial features).

The choice of soap and chocolate, both materials linked to pleasurable sensations (even if the chocolate one could also look like excrement), also creates a deliberate visual contrast between light and dark, giving the sensation of a representation of the two souls of the same person, fighting each other. "Lick and Lather" is a sculpture which also evokes the pleasures of the body, tactile sensations (hands sliding on soap, chocolate melting on the tongue) which would be hard to represent in an artistic endeavour that relied solely on sight.

The skeleton and the blood of a city that has never been seen
Guillermo Kuitca

GUILLERMO KUITCA, "TURIN", 1993–1995

Many artists have been inspired by maps or have used them in their work: Alighiero e Boetti and Jorge Macchi are examples from this book. But the artist whose name has become most associated with maps and has made the concept his trademark is Guillermo Kuitca, who started painting his unusual maps in 1987.

Maps contain a fundamental dichotomy: on the one side, the static nature of what is represented and on the other, the sense of movement and travel which they imply. The second apparent contradiction in Kuitca's maps is that, while being strictly "human" objects (that is non-natural, but created by man for man), they show no human figures, no images of men or women and no other reference to the individuals who make or use the map. Kuitca, who had decided in the mid 1980s no longer to include human figures in his works, only shows places that appear unavoidably deserted, even if they were built to be inhabited: maps, apartment plans, theatre halls, all of them empty.

"Turin" may at first look like a normal, almost didactic, representation of the central and outlying roads in the northern Italian city. But a more careful observer will spot an original and creepy detail: the streets of the city are marked not by lines but by human bones laid out in pairs to represent the streets. It is as if we were looking at a kind of macabre city of the dead, where the names of the streets indicate pieces of an endless cemetery. But that is not exactly true. In the map, Kuitca is attracted not just by the abstract nature of the network of streets (which reminds him of the flow of blood through the human body); he is fascinated by the power that names and topography of unknown places has on our imagination and what this unleashes in us. Kuitca has rarely visited the places shown on his painted maps (only once did he use his native city, Buenos Aires) and what interests him is mainly to trigger a non-rational mental process in the observer which, starting from the sonorous and almost tactile appeal of unknown names, creates an "imaginary reality" like that of a child. Kuitca's maps thus become like maps of Peter Pan's "Never-Never Land" or Alice's "Wonder-

land" which observers can imagine or even fall asleep on (some of Kuitca's maps are painted on mattresses not canvases!) and dream about the places they will never see and situations they will never experience. The bones of the streets of Turin are therefore an extra device, an additional detail, to evoke in the imagination of those who have never seen and maybe know the place's reputation for sorcery and spiritualism an almost spectral ghost city where the living and dead coexist, perhaps walking along the road side by side.

Gabriel Orozco
Skyscrapers and garbage: a commentary on the emptiness of supposed human grandeur

The outline of skyscrapers in what we presume to be an American city, just like we're used to seeing in films and in magazines, serves as the background to a miniature Manhattan made out of rubbish, waste and rubble rising out of a puddle recalling the waters of a river or a bay. Despite the grey of the leaden sky and the ordinariness of the materials used, the image has an air of poetry about it, triggered by the contrast and relationship between the imposing reality and an imaginary microcosm.

Gabriel Orozco is mainly a sculptor but some of his pieces are so ephemeral that, as in the case of "Island Within an Island", the only trace of them remaining is in photographs, often taken by the artist himself. Gabriel Orozco's sculptures typically seek to create a relationship between objects that are normally not associated with one another, but which are brought together by the artist. In "Island Within an Island", he creates a relationship between the cement skyscrapers and urban waste. On other occasions he has created unexpected links between rows of oranges and the window sills of a block of flats, or between a pile of sand and the table on which it is heaped.

The little island in "Island Within an Island" lends itself to a social interpretation, bringing to mind the way minorities are marginalised in American society and find it hard to integrate (Orozco is Mexican and lives in New York). At the same time, the photograph also inspires a feeling of tenderness.

"Island Within an Island" is a commentary on the emptiness of supposed human grandeur. This is a subject particularly dear to Orozco which he tackled in a controversial way at the Venice Biennale in 1993 (his controversies are, however, always accompanied with a smile). He put a small sculpture entitled "Empty Shoebox", consisting precisely of an empty shoebox, on the floor next to an enormous cubic sculpture made of steel weighing seven-and-a-half tons made by the American artist Richard Serra. Orozco's shoebox had such force that it made the steel sculpture look clumsy and pointless.

Gabriel Orozco's sculptures - and "Island Within an Island" is a typical example - also tackle the issue of the tran-

GABRIEL OROZCO, "ISLAND WITHIN AN ISLAND", 1994

sience and the obsolescence of objects in terms of the market logic that turns everything into "old" and worn out. Sky-scrapers made out of rubbish thus seem to predict a future of concrete buildings, destined to be substituted by even bigger blocks of flats that in turn will sooner or later be abandoned and left to go to ruin, in a cycle without end.

Food for art-starved people
Rirkrit Tiravanija

Giuseppe Arcimboldi's paintings are well known, not least because they have been widely used in advertising and cookery books. The 16th-century painter used shapes and images of different foods to compose the faces in his portraits, laying out fruit, vegetables and fish in an original and imaginative fashion so to appear on the canvas as noses, lips and eyes. Arcimboldi is just one of the many artists to have shown a particular rapport in his work with food and the act of eating. Images of foods and dishes are one of the most common subjects in figurative art.

In the 1960s, Swiss artist Daniel Spoerri made his leftovers the subject of his works. A table as it appeared at the end of a dinner between friends was transformed into a piece of art. Dirty dishes, cutlery, glasses, empty bottles, bread crusts, the ashtray full of cigarette butts: everything was stuck onto the tablecloth exactly as it had been left at the end of the meal and the table, minus its legs, was hung on the wall, providing a surface for this assembly of items. Thus a moment of communion and familiarity between people was frozen in time.

Tiravanija makes an even bigger leap, proposing something completely radical. He is not interested in painting food in a realistic rendition of a still life, nor is he interested in transmitting the memory of the moment when the food was eaten. He concentrates on the very act of eating as it takes place.

RIRKRIT TIRAVANIJA, "UNTITLED (FROM BARAJAS
TO PARACUELLOS DEL JARAMA, TO TORREJÓN DE ARDOZ,
TO COSLADA AND TO THE MUSEO REINA SOFIA)", 1994

His works consist of installations (a term which indicates the creation of a particular space that constitutes the work) in which he literally prepares and then hands out rice, noodles or tea (Tiravanija is Thai) to those present. Often this original scene is filmed with a video camera and later projected beside the remains of the meal.

The image of the work "Untitled" from 1994 refers to an installation with Tiravanija presented at a group exhibition that year in the Centro de Arte Reina Sofía in Madrid whose title *Cocido y Crudo* (Cooked and Raw) coincidentally evokes Tiravanija. The artist had put together camping stools and a little table on which he set out gas burners, cooking utensils and some notebooks and sheets of paper next to his rucksack and a bike he used. The video camera mounted on a pedestal showed the menu and the food that he had in fact eaten from the moment he landed at Barajas airport in Madrid to the moment he arrived at the museum where the exhibition took place (the stages of his journey are specified in the subtitle of the installation).

Tiravanija uses food as a way of bringing the largest possible number of people into contact with art in a bid to invert the notion prevalent within the cultural world of art as something elitist, which excludes non-experts. In his attempt to break through the barrier isolating the cultural product from its beneficiaries (in this case material ones, because the result of the artist's activity is eaten), Tiravanija brings into question the function of museums as places to preserve artworks. In his case, works of art are destined to be consumed (recalling in this way the sheets of coloured paper that the public was invited to pick up and take home in the work of Gonzalez-Torres). The contradiction lies in the fact that artists working with "actions" which are only temporary are

then obliged, in most cases, to document them with photo-graphs or, as in the case of Tiravanija, video. However, Tiravanija's art has a fundamental sincerity and his bid to start a process implying genuine audience participation, not as passive spectators but as a vital element of the work, is interesting. He believes a piece has to live to have meaning. Thus we need to bring down the glass barrier separating the viewer and the artwork, forcing the viewer to act in a way that social conventions usually discourage. To sit at the table and eat a meal prepared by Tiravanija is hard for a viewer entering an exhibition, just as it is difficult to take the first step and walk on a sculpture by Carl Andre.

Reconstructing a face to reconstruct a lost identity
Christine Borland

The small pretty face, the short boyish hairstyle, the permanently curious gaze that misses nothing. At first sight, Christine Borland looks like a novice scientist, launching into battle with an array of test tubes, samples, fragments to be analysed and lab results. I am convinced that had she lived in Darwin's time, she would have loved to join him exploring Tierra del Fuego and the Galapagos Islands. Indeed, Borland's work seems to have the characteristics of anthropological and social research The scientific nature of her works nevertheless conceals a particularly sensitive soul recording society's reactions to issues like death, the loss of identity and, in the case of her work titled "From Life", the loss of respect for the value of a single human life.

The artist took more than two years to complete "From Life", which is simply the cast of a head of a woman and some indications about her identity laconically written on a white sign: "Female; Asian. 5ft 2in Tall; Age 25; At least one advanced pregnancy".

The idea for the work came much earlier, when Borland found out that it is possible to mail-order a human skeleton for scientific purposes. The artist bought one and had a box of bones delivered to her house. With this grim material at her disposal, Christine Borland contacted police science ex-

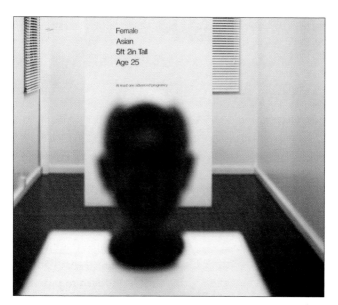

Female
Asian
5ft 2in Tall
Age 25

At least one advanced pregnancy

CHRISTINE BORLAND, "FROM LIFE", 1994-1996

perts, quizzed forensic scientists and followed the work of osteologists and surgeons with expertise in facial reconstruction. All she had to start with were the brief but significant facts reported on the white sign. Then, helped by experts who used techniques developed by Mikhail Gerasimov (the Russian palaeontologist who in the 1940s succeeded for the first time in the scientific reconstructing of faces from skulls), Borland reconstructed some facets of the face. By the end she had managed to define reasonably reliably what the person whose bones arrived at her house in the post, like goods ordered from a mail-order catalogue, actually looked like. A strange relationship between the artist and the young Asian woman must have developed over so many months of scientific cohabitation. I think an artist was needed to seize on and develop the sense of lack of humanity innate in the sale

of human bones that in all likelihood happens every day all over the world.

But is it art? Certainly the reconstructed face of the young Asian woman - especially now that we know the story - is not something to which we would want to give pride of place in our living rooms. But it is also true that Borland's work tells us a great deal about today's society, its lack of humanity and the lack of respect for our peers, and it forces us to reflect far more than a painting of a fruit bowl or a gentle mountain landscape.

The open diary
of a young English girl:
artists are still cursed
Tracey Emin

To understand and appreciate the majority of works of art
it is not necessary, or at least not fundamental, to know de-
tails of the artist's life (just think of the importance of many
ancient works: sometimes we don't even know the name of
their creators). But the case of Tracey Emin is different. Her
work is so intimately linked to her life that it appears impos-
sible to separate the two. Her life is faithfully reflected in her
works which thus represent fragments or stages in a sort of
therapy which enable her to overcome adversity and life's
difficulties. In this case too, art becomes a sort of medicine
for the soul (as it was for Joseph Beuys in the 1960s and for
Wolfgang Laib in the 1970s). It is a medicine for which the
artist feels both a physical and transcendental need: "I need
art like I need God," Emin says in one of her works consist-
ing of a large slogan on a wall.

Tracey Emin was abused as a very small girl and raped at
the age of 13; she later went through an abortion, attempted
suicide, saw her twin brother jailed and her uncle killed in
a car crash, had innumerable and not always positive sexual
experiences: these are stages in a difficult life comprehen-
sively documented, warts and all, in her work, which is per-
vaded at times by a feeling of desperate resignation and on
other occasions by an unusual sense of peace.

Drawings are an important part of Trace Emin's art. In her drawings, she often includes words or phrases which manifest the thoughts of the person shown, who is almost always a woman representing the artist herself. Her simple, almost banal phrases are the instrument to illustrate a life with no meaning and few prospects. But it is their ordinariness that makes them universal and "popular", like the chorus of a song.

The lines Tracey Emin draws delicately, spontaneously and often crudely, outline women with no particular stories to tell, wrapped up in a day-to-day world of violence and sex. Looking at her drawings, we are immediately projected into her private world, as if we were spying on the artist in a closed room through a keyhole. But the immediate intimacy, with its extremely crude details, into which we are hurled, to a certain degree repels us as fast as we were

TRACEY EMIN, "IF I COULD JUST GO BACK AND START AGAIN", 1995

drawn in. That is when we realise Emin has made us lean in for a moment and glimpse her world, which immediately recedes.

Just like the drawings of Egon Schiele, to which her art has been associated, Tracey Emin's works have for a moment lifted the curtain on a reality of desperation and loneliness that is alien to most of us. Afterwards, it's not easy to pretend that we saw or know nothing.

Needing to communicate and not being able to
Juan Muñoz

As in the works of Mimmo Paladino, silence is a central theme for Juan Muñoz. But if for Paladino silence helps create an atmosphere of mystery and magic, for Muñoz it is a painful human condition, a symptom of not being able to communicate, of internal suffering and solitude.

The bronze sculpture "After de Kooning" shows a figure, probably of a man, his body twisted. But his movement is limited by what looks like a straitjacket and a string tying the ends of his trousers, enclosing his feet. His features are barely discernible and his faraway look, as if lost in thought, makes the figure appear closed in itself, incommunicado, beyond our gaze and our attempt to make contact with him. The sense of strangeness is reinforced by the fact that the person is resting on a wooden pedestal which forms an integral part of the sculpture and serves to isolate him still further from external reality. The pedestal confers a feeling of uneasiness because he can neither free himself from the constrictions of his clothes nor get down from the base on which he appears to have been seated. It is not the first time that Muñoz has used architectural elements (fake balconies, floors, pedestals) to accentuate the almost theatrical characterisation of his figures and the situations they find themselves in. The size of the figure in the sculpture "After de Kooning", about a metre tall, may make us think of a child and this adds an extra note of sadness to the sense of void and inability to communicate enveloping the figure. He transmits a

Juan Muñoz, "After de Kooning", 1995

palpable feeling of unease coming from something we don't know: who tied him up? Why has he been abandoned on a pedestal? Whose attention is he trying to attract? The artist is very much interested in this grey area bordering on the inability to communicate or to take action. Communication is the most difficult task for the artist too. Muñoz himself said: "The impossibility of representing what you are trying to describe is the limit sculpture must contend with."

Instead of a child, Muñoz was perhaps portraying a dwarf. On other occasions the artist has used dwarves, mannequins, ventriloquists' dummies in his works. They are all figures with a special relationship with truth and reality: in the Middle Ages, dwarves in court games and ventriloquists through their dummies managed - because of their unnatural appearances - to express truths which would otherwise have been uncomfortable and dangerous to make public. Muñoz's figures would like to communicate something to us but they have become mute and weak, as if the truth required such an effort to express (like the figure who can't manage to get out of the straitjacket) that any attempt would be in vain. From this conflict between needing to communicate and not being able to comes the force of Muñoz's sculptures.

The title of the sculpture refers to Willem de Kooning, a naturalised American artist known for his obsessive attempt to depict feelings rather than the profiles of feminine figures. By this reference to one of the principal protagonists of 20th-century art, Muñoz also seeks to insert his work, which uses a traditional and ancient material like bronze, into a line of artistic development running through the great sculptures of the last centuries in a bid both to maintain and develop the tradition.

The unsuspected link between a crowd of people and a cut by Fontana
Vanessa Beecroft

I have always thought that Lucio Fontana, who went down in history for making cuts and holes in his canvases, would have greatly enjoyed Vanessa Beecroft's performances and installations. At first sight nothing could be further from Fontana's reflection on the nature of a painting expressed through his slashes than Beecroft's strange assembly of people. Why this bizarre comparison between the two artists?

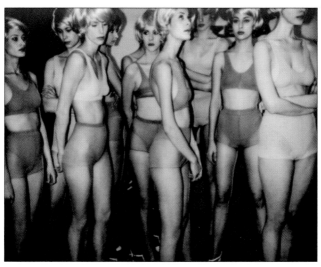

VANESSA BEECROFT, "UNTITLED" (DETAIL FROM A PERFORMANCE AT THE CAPC IN BORDEAUX), 1996

Because, more than the cuts which made him famous, Lucio Fontana enjoyed creating so-called "spatial environments", places where the entire space in the room or the gallery transformed itself into a work of art through the use of forms and light. In the same way Vanessa Beecroft creates her highly unusual "human environments", where a group of people, made to look similar by aesthetic devices, creates an air of tension similar to that produced by Fontana's lights and shadows.

For her performances, Beecroft usually recruits a group of women, makes them look alike through the use of often scant clothing, make-up and wigs, and places them in a space habitually dedicated to art (a private gallery or a room in a museum). The work thus consists of a group of people who perform no particular actions but rather who "exist" for a certain length of time in a particular place, like apparitions of an alien, incomprehensible world. But the artist is reflecting not on the future, but on her notion of the homogenisation of contemporary society in a provocative and at the same time extremely simple and linear way. We all increasingly tend to resemble one another. The irony of the process which makes us all the same is that far from making interpersonal relations easier, it annuls them, maybe because, once we're all the same, we have nothing more to say to each other.

Beecroft's performances are always documented by large photographs which freeze random moments of the installation. They are images which manage effectively to transmit the silence which generally accompanies the performance - something you wouldn't expect from a crowd of people. In the photograph shown here, from a performance at the Centre d'Art Contemporain in Bordeaux, all the women's

mouths are closed. Their arms, which are often crossed, accentuate the sense of lack of communication: each woman is wrapped up in herself. Once the performance is over, Beecroft's artwork will remain only as a photographic trace of an action which no longer exists and whose meaning has been lost.

Maybe that is the essence of our society: a crowd of similar people who don't communicate, playing an undefined role for a certain period of time.

Painting as an archeological dig
Callum Innes

Why does Callum Innes call his painting "exposure"? The term relates to the fact that Innes doesn't create a painting by adding colours and details but rather by removing them. He covers the whole surface of the canvas with a monochrome colour (in this case a very dark shade of grey called "Paynes grey") and only then begins the real creative process of dissolving whole areas of colour using turpentine. He works by eliminating the oil colours which cover the surface of the canvas to make the canvas emerge once more. Through the process of "covering and exposing" the canvas has undergone a transformation. It is no longer just a surface to be painted on, but has taken on autonomy and visual force. The canvas itself is part of the work. Some parts of the painting maintain signs of the process of dissolution of colour. In "Exposed Painting, Paynes Grey", this is visible in a vertical line linking the dark part of the painting with the background of the work. The apparent uncertainty in the way the line is executed, its waviness compared with the perfect square of the dark area above the exposed part serves to suggest the manual intervention of the artist. Callum Innes uses this means to convey an almost figurative element to balance the formal rigidity of geometric abstraction. This ensures that while Innes' works belong to the purest abstract tradition, they express a particular sensitivity and show more personality and warmth than most geometric compositions which make one of their chief traits the anonymity of execution.

Callum Innes is extremely rigorous and demanding. His technique of dissolving rather than painting recalls sculp⁄ture and the process of removing materials from a block of marble to bring out the figure it contains within. Once the action of "exposing" is done, there's no going back and if you're not satisfied with the result there is no turning back, just in the same way that with a sculpture you can't stick a piece of marble back on once you've chipped it off. This is one of the reasons why Innes creates a relatively limited num⁄ber of works. In fact he destroys two thirds of his "exposed' canvases because he doesn't find them sufficiently balanced. The technique used by Innes recalls the process of excavat⁄

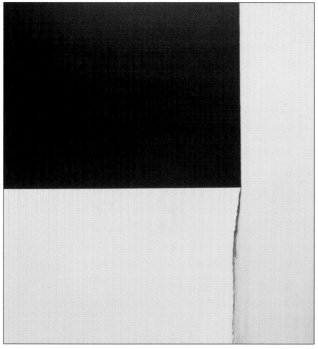

CALLUM INNES, "EXPOSED PAINTING, PAYNES GREY", 1996

ing and cleaning in an archaeological dig. In this way, the artist wants to reaffirm that even at the end of the 20th century, in a decade characterised by the use of new and unusual techniques ranging from Douglas Gordon's videos to Rirkrit Tiravanija's cooking, the principal basis of experimentation and artistic growth is still there, beneath the surface of a canvas.

Surprise: even something traditional can be innovating
Stephan Balkenhol

People can feel awkward looking at decidedly unusual pieces of contemporary art (like those by Rirkrit Tiravaija, Christine Borland and Douglas Gordon). But some critics and experts on contemporary art accustomed to everything "different" felt just as awkward when they saw Stephan Balkenhol's absolutely life-like and "normal" sculptures for the first time. It seemed inconceivable for a contemporary artist to represent a human figure using an ancient traditional technique such as carved wood, nowadays used by Tyrolean craftsmen creating figures for Christmas nativity scenes.

Despite the opposition of some critics who refused to take his work seriously, Balkenhol remained faithful to his basic idea and succeeded in imposing something he defined as his "own personal Pop Art".

His decision to continue the tradition of figurative sculpture also caused political controversy since figurative sculpture was traditionally associated with the celebration of personalities. In post-war Germany especially, which wanted to distance itself as much as possible from the rhetoric of the imposing neoclassical sculptures of the Nazi regime, figurative sculpture was a kind of taboo. Balkenhol made his work non-celebratory by sculpting completely anonymous people, often immortalising them in moments of apparent

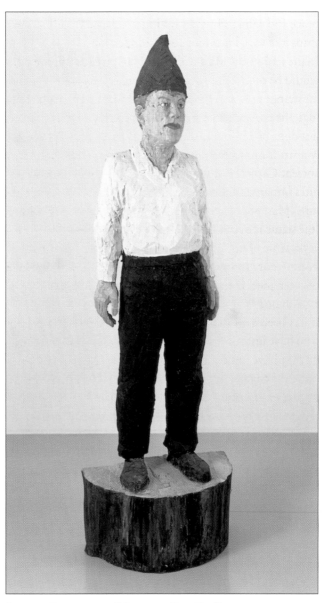

STEPHAN BALKENHOL, "MAN WITH RED HAT", 1996

peace and calm. Thus he continues a classical tradition but strips it of social meanings and implications.

In the sculpture "Man with Red Hat", we see a figure who would be dressed in a humble, ordinary way were it not for his strange red hat. His features give away no particular feelings, the way he is standing does not convey anything he has just done or is about to do. His arms are by his sides, slightly apart from his legs, in a similar position to the kouros of ancient Greece. But while the solidity of those stone sculptures imparts a sense of elegance and nobility, in the sculpture "Man with Red Hat", the wood, its colour and its size (the statue is over a metre tall, the size of a child) help convey a sense of uncertainty and almost shyness. The red hat inspires our curiosity but at the same time creates a balance between the abnormality of the hat and the character's calm expression.

It has been said that Balkenhol's figures could be people who have just come out of hospital, who have recently been ill: they have just recovered and have not yet plunged back into their chaotic day-to-day lives. They are figures who by staying on the threshold appear rather familiar, maybe because their sense of solitude is shared by so many of us.

20th-century Pegasus is exhausted and has no wings
Maurizio Cattelan

Abracadabra is a magic word beloved of children all over
the world and that is why my children, Federico and
Alessandra, their curiosity piqued, happily agreed to come
with me to see the exhibition "Abracadabra" organised by
the Tate Gallery (now Tate Britain) in London in 1999.
The most curious, and in its own way, magical piece as the
exhibition's title suggested, was on show just inside the en-
trance to the museum. Hanging in the centre of the great
dome arching over the entrance to the central hall usually re-
served for installations and sculptures, a real horse, preserved
by taxidermy and with a sad and vaguely troubled air, was
swinging from a leather sling around his belly. It was a work
by Maurizio Cattelan aptly titled "XX Century".
Beyond the initial surprise it caused, this work is the perfect
example of the heaviness, weariness and the sense of surren-
der and abandon of a century which at that time was draw-
ing to a close. The strap stopping the horse from falling al-
so prevents any movement. The lack of contact between the
animal's feet and the ground accentuate the sense of detach-
ment from reality, as if the 1900s, so full of historical events,
had been overtaken by the new century whose arrival was
imminent. Cattelan often uses ordinary objects and situa-
tions in situations that are completely out of context. At
times he also seems to play with his public, keeping people
in suspense between his seriousness and his jokes, like when,

at his first solo show, he put nothing on display and hung a sign on the gallery door saying "Back soon".

His tired horse is both a source of stupor (my children and I, like so many other spectators, wandered about under his belly for several minutes), pause for thought and also reflec⁄ tion, like an old friend who is about to leave us. We expect a pulley to hoist it up at any moment to stash it away in a warehouse or a ship. We almost wonder if we'll share its fate at the end of our lives: suspended for a moment between heaven and earth before disappearing forever.

Cattelan and Vanessa Beecroft are the most famous up⁄and⁄ coming Italian artists abroad. Their arrival on the inter⁄ national scene is good for Italian contemporary art, which had risked being confined to the great movements of Arte Povera and the Transavanguardia and remaining stuck in the 1970s and the 1980s. With Cattelan and Beecroft, Italian contemporary art has turned the page and has shown itself once again to be capable of surprising, of sparking interest and being worthy of consideration.

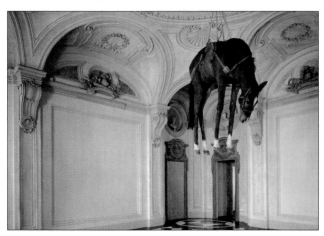

MAURIZIO CATTELAN, "XX CENTURY", 1997

Animated icons
and virtual divinities
to redeem us from
technological
"materialism"
Mariko Mori

From a strictly technical standpoint, video is one of the most impor-
tant novelties in the 1990s, comparable to photography or the inven-
tion of acrylic paints which, because they dry far faster than oil paints,
have allowed artists to work at speeds unthought-of a century ago and
thus boost their output.
But it would be wrong to call artists who use video in their works
video-artists. Video is just an additional medium and will be used by
a growing number of artists in exactly the same way as they use any
other technique today (oil painting, watercolour, collage, engraving,
photography, etc.). Video can generically be defined as a picture in
motion. Its technical qualities are not important; what matters is how
artists use it to express feelings and sensations in captivating and in-
novative ways.

Young, beautiful and rich, Mariko Mori worked as a model
and fashion designer before turning to art. Although she
has almost disappeared in recent years, her career in the 1990s
was meteoric and marked by a large number of shows in
very prestigious museums and public spaces (she exhibited

at the Venice Biennale in 1997 and the Fondazione Prada in Milan in 1999) and, by contrast, very few exhibitions in private galleries.

A characteristic of Mariko Mori's ascent, as well as that of other artists, is that museums, which once endorsed the success at the peak of an artist's career, are now increasingly interested in exhibiting very young artists. Nowadays no gallery or museum will consider artists who have not been successful by the age of 30. Mariko Mori for example, born in 1967, had shows in five museums (but only one in a private gallery!) between 1997 and 1998. The unexpected discovery of a great artist, unknown until the age of 50 or 60, is almost unthinkable today.

"Nirvana" is a video conceived, written, directed by and starring Mariko Mori. She made it with the help of a troupe of about 35 technicians using a highly advanced digital technique to give extremely realistic 3D effects. It is a mini-epic film and had costume designers, production coordinators, technicians, a producer for the digital images and a jewellery production house among others working on it.

"Nirvana" is a real visual experience. Before entering the little projection room, you have to put on special glasses to see the 3D effects. Then, once you sit down, you are immediately assailed by an incongruous but fascinating mixture of images and sounds where everything seems to be deliberately confusing, swaying between pop culture and kitsch. A feminine figure (Mariko Mori herself) moves and dances suspended in the air in the centre of the screen, while behind her a panorama in pastel colours is constantly changing from a forest into a sea and then from mountains to caves. Even time no longer seems to have any meaning in Mariko Mori's landscape, which is also inhabited by strange figures half-

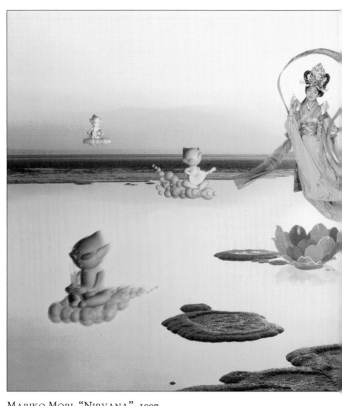

Mariko Mori, "Nirvana", 1997

way between sacred images and animated cartoons that, thanks to 3D technology, seem to come out of the screen and fill the room where the video is being shown. "Nirvana" (used by Buddhists to describe the state of pure happiness and illumination obtained through the extinction of any passion or sensation) is an explicit reference to transcendence and invites the viewer to share with the artist the physical and spiritual experience of illumination in the hope that the images of the video and the voice of Mariko Mori will manage, albeit for a few minutes, to take the spectator out of his or her mundane daily world of desires and pain.

The novelty of Mariko Mori's approach is to have tackled the issue of spirituality in a technological and televisual society through the use of video and the saturation of images. She uses late 20th-century technology in a strange but attractive fusion between art and spirit. Today, technology is the way to get close to spirituality and this idea, which may seem crazy, is not proposed by Mariko Mori as a hypothesis but is presented as fact. In a world where information and technology bombard us with images and news every day, it is art that can provide the link between the millions of details that our minds cannot manage to unite. Only art, according to Mariko Mori, can achieve the alchemy of transforming the world of science and technology into spirituality and religion.

Seize the moment
if you want to see the art
Anya Gallaccio

Chasing rainbows, as the title of this installation invites us to do, is obviously impossible. But we have probably never been as close to achieving it as when looking at Anya Gallaccio's work recreating a real rainbow inside the dark and closed space of a gallery.

The installation, which relies on the physical laws of light refraction, consists of a large rectangular sort of carpet (the one mounted in London's "Delfina" gallery measured about 20 by six metres) of what at first sight looks like sand but is actually made up of millions of miniscule fragments of glass, each of which acts like a microscopic prism.

The effect of the direct light on the carpet of glass from two spotlights, fixed above the two short ends of the rectangle, make a rainbow materialise for a few moments, arching from one side of the sandy rectangle to the other, as the viewer walks around the glass carpet.

The rainbow, which is clearly visible in the semi-darkness of the room, changes shape, disappears and recreates itself inside an imaginary triangle formed by the spectator, the source of light and the glass spread out on the floor. Shifting to a different observation point acts as a switch which turns on and off the fantastic apparition of the rainbow. The viewer only has to move a few steps to see the coloured arc appear or disappear again. Because it is so close, virtually within reach, and contained within the walls of a room, the rainbow both seems harnessed and yet out of reach.

Anya Gallaccio, "Chasing Rainbow", 1998

The main characteristic of Anya Gallaccio's works is their
limited duration. Since she avoids reproducing salient mo-
ments from her installations through video or photography,
it is difficult for them to be commercial. Her works, there-
fore, require the direct experience of the viewer. Her pieces
are often made with simple materials: the refraction of light
to produce rainbows, fruit (subject to decomposition), flow-
ers (which slowly wither) or, as in the case of an installation
from 1996 called "Intensity and Surfaces", an enormous
block of ice which slowly melts. What the public looking
at her work sees is a particular moment in the birth-growth-
death cycle of her works. Every movement in the brief life of
an installation will be different from what came before and
what is yet to come.

Anya Gallaccio's art has been defined as "multisensory" precisely because direct experience of one of her installations involves not only the eyes but also the sense of smell (as in the case of ripening fruits), touch (like when in the piece "Cover" from 1994, she covered a whole gallery in chocolate and invited the public to lick it), and more generally, a sense of mental and physical participation with what is being witnessed. The materials she uses are beyond the total control which artists often want to have. The process of decomposition, like the arrangement of tiny fragments of glass in "Chasing Rainbow", both mutate over time and defy our control. Gallaccio says she wants to foster a relationship of equality and not submission between the artist and the material: "Much of the history of art refers to the attempt by artists to impose their own will on the materials used. I am more interested in a collaboration between myself and the material [...] as if there were a relationship between us." And a sort of strange and particular relationship is born between whoever looks at a Gallacccio installation and the work in itself, as if that particular rainbow which is born and disappears within a few moments was created out of nothing just for us, who happen to be looking at it at that precise moment.

Art in the New Millennium

A Pakistani artist who moved to the United States (Shahzia Sikander), a Spaniard who lives in Mexico (Santiago Sierra), a Japanese woman who has lived for long periods in Germany (Yoshitomo Nara), an Argentine (Jorge Macchi), an Italian turned New Yorker (Luisa Rabbia) and some Europeans. This list alone shows how the new millennium opened with the most diverse geographical and therefore cultural outlook the contemporary art world has ever seen. Art has become more colourful, more varied, more complex. The new millennium appears like a Pandora's Box from which all sorts of styles and concepts seem to come out. It has never been harder to get one's bearings. It is not at all easy to find a link between a performance by Santiago Sierra and the recovery of the miniature technique by Shahzia Sikander, or between Julian Opie's use of the computer and the cold neo-conceptualism of Alexander Laner.

This array of styles and geographical origins is partly due to demand of the art market. The number of wealthy collectors has increased significantly both in the United States (which still accounts for about 80 percent of art transactions), and in Russia and China, thanks to the appearance of a new class of comfortably-off people. As a result, more and more artists have to be "discovered" since the market needs an increasing number of works in circulation. The big auction houses choose at least a dozen new unknown names every season. The trend in recent years has been to go for Chinese artists, whose works have achieved astonishing prices, and for a group of young German and Polish artists, the latest fashion of collector Charles Saatchi. Indian artists are also now entering the market.

The majority of them are not destined to last long. But beyond individual names, what is significant is that cultures are interacting.

It is clear that the new century has increased the power of auction houses. There is a new generation of collectors who prefer to buy from Christie's, Phillips and Sotheby's rather than from galleries because it makes them feel more certain in their investments. At an auction, as the bids fly, the buyer realises that at least two or three other people are willing to pay similar prices for the same piece. In this way the collector is reassured: the object of his desire is something other people covet too.

Large museums obviously also influence the art market, especially when it comes to photographic works in very limited editions. To give one example: German artist Thomas Ruff only prints five numbered copies plus two artist's proofs for each of his works. If the Museum of Modern Art in New York or the Tate Modern in London possess copies of a certain work by Ruff, that can only reassure the wealthy new collector about the quality and value of the work. It's much harder to trust your own instincts and go for a single piece that, by virtue of the fact it cannot be reproduced, will not be bought by anyone else.

But the pleasure of "old-style" collecting (chatting with trusted gallery owners, meeting artists, studying the works over and over again, checking the quality) will fortunately live on in the new millennium. It's not easy because it is a very time consuming passion. But the rewards generally make it absolutely and wonderfully worthwhile.

When society hides its own problems
Santiago Sierra

Irritation, awkwardness, embarrassment. It's impossible not feel such emotions when you are confronted by the sight of "Six Workers Who Can't Be Paid Legally Receive Money to Sit in Cardboard Boxes" by Spaniard Santiago Sierra (who lives in Mexico, a country of migrant workers par excellence). The piece is exactly what the title says: some illegal immigrants (who therefore can't get regular jobs and be paid legally) have been paid by the artist to sit inside cardboard boxes, in four hour shifts, while the public walks past. Sierra's piece is certainly powerful as a metaphor that harshly attacks the xenophobic speeches often coming from the same people who themselves employ illegal immigrants for domestic help or menial jobs.

Hiding their presence, shutting them up inside cardboard boxes evokes the atmosphere of the physical and mental claustrophobia of working illegally.

Is the fact that Sierra uses illegal workers in itself exploitation? Some may think so, but the power of his works would certainly be greatly reduced if both the working conditions themselves and the condition of psychological segregation were not represented by real people but by images painted on a canvas.

SANTIAGO SIERRA, "SIX WORKERS WHO CAN'T BE PAID LEGALLY
RECEIVE MONEY TO SIT IN CARDBOARD BOXES",
IMAGE FROM THE PERFORMANCE CONDUCTED ON SEVERAL
OCCASIONS BETWEEN 1999 AND 2000

*Another powerful example of Santiago Sierra's meditation on the
notion of segregation versus the idea of nationalism was on show in
2003 at the Venice Biennale where he was representing Spain. The
Spanish Pavilion was guarded and people wanting to enter were asked
to produce a passport or some other form of identification. It was an
international event, yet only Spanish people were allowed inside the
pavilion. It was a stark reminder, within such a relaxed atmosphere
crowded with wealthy tourists, of the difficulties that most of the
world's people face when trying to cross international borders.*

East and West, classic and contemporary: a synthesis in miniature
Shahzia Sikander

The Pakistani artist Shahzia Sikander reflects more than ever the new millennium's trend towards diversification in contemporary art.

Though she lives in New York, Sikander has kept strong social, cultural and even stylistic links with her homeland. Her most beautiful works are the miniatures which she executes with a technique (yes, technique, something so maligned in contemporary art!) that is hard to equal.

In her miniatures she is interested in revealing the links that exist between images and writing. In this piece, titled "Writing the Written", the most interesting part is not the centre of the sheet but the border on the right and at the bottom that frames the image. It shows a mixture of Arabic script and drawings of horses. Letters turn into animals and animals turn back into letters, without either taking precedence (as if representing reason and sentiment which are often mixed together). Sikander told me that in these works ("Writing the Written" is part of a series) the transfiguration of words reminded her of "reading by heart" verses of the Koran as a schoolgirl: her memory transformed the calligraphy into drawings of fantasy animals. The animals and the background of the miniature are clear, unlike the two human shapes in the centre of the paper, hidden inside concentric circles which may be nothing more than the chain

SHAHZIA SIKANDER, "WRITING THE WRITTEN", 2000

of thoughts darkening their minds. What is closest appears
more confused than what is far off. And reality is so often
like that: far clearer if you see it from afar.

There is a glimmer of poetry everywhere, even in pornography

Thomas Ruff

Thomas Ruff, probably the most versatile and creative of a new group of German artists using photography, has a magical gift. Like medieval alchemists, he manages to trans-form the humblest and most vile materials into gold. A few years ago he did it with a series of scientific images of starry skies originally taken by a research observatory in Chile: scientific prints which in his hands turned into fabulous images.

More recently, Thomas Ruff has taken pornographic mater-ials from hard-core sex sites on the Internet as his starting point. He trawled dozens of pornographic sites and down-loaded hundreds of images. Because of their poor quality and low resolution, human figures and details appeared grainy and insufficiently clear-cut when the pictures were enlarged. So he decided to edit and retouch them, making them even more out of focus, removing details he considered uninteresting, blurring the edges and generally brightening them and modifying the colours. In this way, he obtained a series of images that are undoubtedly strong but at the same time poetic and harmonious. The soft-focus technique makes these photographs seem dream-like and conveys a vague sense of déjà vu, almost like a lost memory that we are trying to recall. Some critics even have drawn a parallel be-tween these images and paintings of the Impressionists.

THOMAS RUFF, "NUDE ASD 04", 2001

The present work is a very beautiful image of a woman with a faraway look in her eyes and her hands cupping her face. She is partially naked, and that contrasts with the fact that she doesn't have a hair out of place. The position of her arms, which make it seem like she is leaning on a table, gives her a meditative and sad air. The work recalls one of Picasso's most famous works, "The Absynthe Drinker". Exactly 100 years separate the two women: Picasso's work dates from 1901 and Ruff's from 2001. But the sense of sadness and solitude are the same. Even if we know its pornographic origin and would struggle to admit it rationally, the picture is beautiful and captivating; we're not disturbed by it. It shows us that there can be a glimmer of poetry in any reality, even in pornography.

Naughty and tender, fragile and violent: it's tough to be a kid these days!
Yoshitomo Nara

Little girls (often looking very naughty) and frightened dogs are the protagonists of the works of Yoshitomo Nara, a Japanese artist who grew up watching Goldrake cartoons and reading Manga magazines.

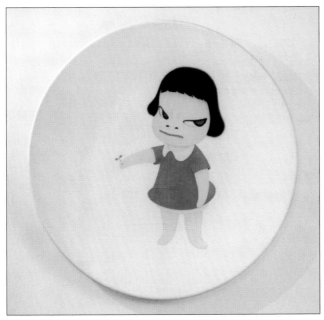

YOSHITOMO NARA, "SPROUT THE AMBASSADOR", 2001

This little girl is giving us a really dirty look and seems, very much against her will, to be offering us a little leaf as a sign of peace, while her gaze suggests she would far rather get stuck into a fight and thump us. Almost all her pieces show figures like this: angry little girls full of a sort of hate that inspires tenderness, scowling at the world of adults, who are guilty of unidentified crimes against them. Why does the girl bear such a grudge? Maybe the key to reading it is in a little painting by Nara in which there is a poster, like the ones stuck on walls or lamp posts, asking if anyone has seen a missing pet. It reads "Missing: my dog, my childhood" and offers a handsome reward to anyone who calls with information. Nara's naughty little girls are thus the artist's lost youth. Half-way between irony (heightened by the cartoon style of the figure) and seriousness, she tells us how tough it is to be a kid.

But then who knows. Maybe this is just conjecture. Maybe the girl is furious because her parents have cut her dark hair into this horrible fringe…

The myth of the monster: when beauty becomes grotesque
Marc Quinn

Marc Quinn's name may forever be linked to one of his first sculptures: the exact replica of his head made in 1991 out of his own blood that he patiently collected and froze. He did something similar 15 years later in 2006 when he moulded a replica of his new-born son's head out of his partner's placenta and umbilical cord. The same tendency, still bordering on the macabre though apparently less dark, is on display in the series entitled "Winter Garden". It is made up of photographs of flowers whose colours are so bright that they appear exaggerated, almost artificially touched up.

The title itself conveys the idea of quiet winter days gardening in a greenhouse. But the fact that flowers have such intense colours in the winter, even if they have been raised in hothouses, can only be the result of an operation worthy of Dr Jekyll's laboratory.

And that reality is this: the flowers, natural in their unnaturalness, were photographed while immersed in silicone kept liquid at low temperatures by means of refrigeration. The substance they were immersed in heightened the colours and made them seem so bright as to appear... fake. When nature is pushed beyond its limits, even if the result is beautiful, it cannot help but tend towards the grotesque.

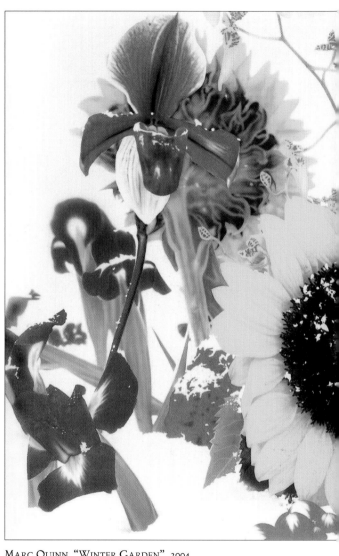

MARC QUINN, "WINTER GARDEN", 2004

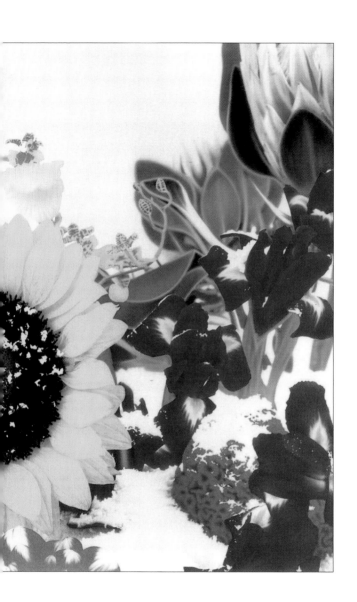

Memories on a postcard
Idris Khan

Idris Khan, "Every... William Turner Postcard from Tate Britain", 2004

Idris Khan (whose father is Pakistani and his mother Welsh, and who trained at London's Royal College of Art), uses photographs to try to gain some insight into how our minds work, especially the part of our brain that stores and replays memories. What Idris Khan, a rising star of the second generation of "Young British Artists" seeks to convey is the general impression, not the individual ideas, that a series of memories imprints on us. Khan is in search of a kind of archetype of memory.

The title of this piece from 2004 is self-explanatory: "Every... William Turner Postcard from Tate Britain". Khan has photographed and superimposed all the images of the works

of J. W. Turner which the Tate Britain ⁄ which owns the world's largest collection of that artist's works ⁄ has pro⁄duced in postcard⁄form. The result is an image with enor⁄mous visual impact conveying some typical characteris⁄tics of the English painter's work. You can make out, for example, the shape of the hull of a boat; the sky shows areas of light and shade accentuating its drama; here and there the sun seems to appear but it does not manage to break through the clouds or the fog. It is an abstract image but it has an intrinsic Turner "flavour".

In other works, Idris Khan applies the same process to more personal events and memories, like when he super⁄imposed dozens of photographs taken while on holiday for a whole summer.

In this way, he seeks to render the spirit of memories, that indefinite sensation that experience leaves within us, which defies categorisation and cannot be captured in a single image.

The magical essence of individuality
Julian Opie

British artist Julian Opie, who firstly made his name as a sculptor, later changed his style and is now the creator of highly distinctive portraits, as this beautiful work, "Anya with Veil", shows.

Opie does not paint but works on the computer, starting from a photograph of the person in the portrait. Bit by bit he removes all non-essential elements, the shading, the intermediate tones, the details. What remains are just a few lines but, surprisingly, they magically contain the essence of the individuality of the person depicted.

There is a very subtle but fundamental difference between the portraits of Julian Opie and the comic-strip images of Roy Lichtenstein or the drawings of Yoshitomo Nara. In Lichtenstein and Nara, the stylisation of the characters depersonalises the faces, making the people familiar while being absolutely imaginary. In Julian Opie, however, even though the people are represented with just a small number of clear lines, and look a bit like characters out of Tintin, they remain themselves. They are recognisable and they do not become any old faces but remain unmistakably individual.

Julian Opie, "Anya with Veil", 2005

Art as a box:
full or desolately empty?
Alexander Laner

Alexander Laner is a young German artist who must have
spent hours and hours as a child playing with cars and Lego
building bricks. Maybe we all did, but something of that
stuck in his mind after he decided to become an artist. As a

ALEXANDER LANER, "ACADEMY", 2006

finale for his art school graduation he dismantled, repaired and then put back together (in a classical hall brightly lit by powerful spotlights), an old model of the most typical of German cars, a Mercedes.

Then one day he had the idea of building a model of the Academy of Fine Arts in Munich where he studied, using several dozen coloured containers. For safety reasons, the construction was very short-lived (it was taken down after just six hours), but evidence of it remains in this large-format photograph.

The image suggests many metaphors on the art world, start-ing from the commercialisation and the commoditisation of art. It could refer to the fact that the containers are individ-ual units which can be connected as if to indicate a difficul-ty in dialogue between the various disciplines taught. We could also wonder whether the containers are full (of mater-ials, of works of art, of ideas) or desolately empty. Letting our imagination run a bit further, we could also note a ref-erence to China and its ever more pressing desire to be part of the elite of countries that count in the art world (on at least four containers in the photograph the words "China Shipping" are visible).

But maybe the strongest idea it conveys is that the sense of wholeness is achieved with things that, on their own, would be nothing more than metal boxes. Only by stacking small, insignificant blocks one on top of the other do we get a wider sense, a vision of the whole, an idea of unity of the history of art destined to travel round the world as if it were a coloured container.

The imaginary world
of a mind explorer
Jorge Macchi

Argentine artist Jorge Macchi certainly likes playing with maps. In his works we find imaginary maps of the Buenos Aires metro, road maps where all the buildings have been removed and cities made only of cemeteries.

His large work "Lilliput" is an accidental map of the world. The artist cut out all the countries in the world, scattered them randomly on a big white sheet and stuck them into the precise place they fell. Many countries ended up upside

Jorge Macchi, "Lilliput", 2007

Jorge Macchi, "Lilliput" (detail), 2007

down, thus being harder to spot. Others appear casually dropped like leaves bobbing in a puddle. It is not the result of an uncoordinated break-up of continents but rather the result of an unexpected "big bang". But the randomness of the geographical distribution is balanced by the millimetric precision of the scale of distances between the various cities printed in the bottom left-hand corner. And the term millimetre is particularly apt, since the numbers indicate the precise number of millimetres that separate various cities on the map. But if, for example, the 882 millimetres on the scale of distances is what really divides Chicago from Kabul, then that would mean that what looks like a map is in reality not a map but a life-sized place. That is why the work is called "Lilliput" like the legendary island in Jonathan Swift's *Gulliver's Travels*. Because it is not a world to scale, it is simply a very small world. This implies that only the limits of our sight and the extremely reduced dimensions of what now does not appear like a map but like a sort of aquarium

prevent us from distinguishing within each nation the inhabitants, cars, aeroplanes and indeed any form of life too microscopic to be seen with the naked eye. Peering closer at the glass protecting the work we cast a brief shadow over the surface, darkening four or five countries. Perhaps this gesture of ours is mistaken by the inhabitants of this miniature world for an enormous cloud or even an eclipse which darkens part of the earth's surface for a few seconds.

When a bare tree is the only friend left
Luisa Rabbia

"A Tree to Walk With" is a melancholy sculpture by the Italian artist Luisa Rabbia consisting of a shopping trolley with an enormous, bare tree in it. At first sight, the trolley makes us think that the tree was bought at a supermarket, but it could also remind us of homeless people in the United States so often seen on the street, carrying their whole life with them, generally stacked up in a stolen supermarket trolley. And it may be no coincidence that the artist lives in the United States. In this piece, the shopping is replaced by a single item, this tree that is so bare, yet still alive, as shown by the roots which have grown and spread around the metal container in which it is planted.

Commenting on the work, Rabbia told me: "The tree in 'A Tree to Walk With' sits in the supermarket trolley which, for homeless people, is more like a house and becomes a space where they collect anything they think may turn out useful. It is a portable suitcase-house. The tree symbolises a precarious equilibrium (physical/psychological), which needs a push and four wheels to go on its way."

The trolley's colour is no accident. It is a particularly intense blue recalling the shade IKB (International Klein Blue) chosen as the perfect colour by artist Yves Klein to represent spirituality and the sense of supernatural. But very little of the supernatural is left in this representation. Here the sculpture speaks of precariousness, disillusionment, defeat: real-

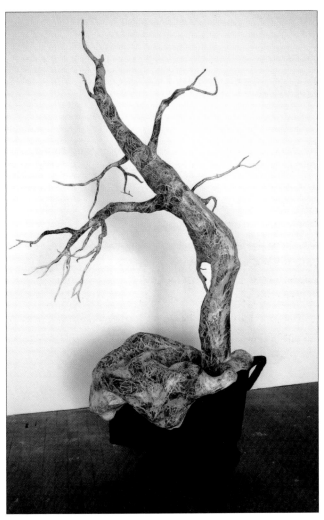

Luisa Rabbia, "A Tree to Walk With", 2007

ities people have suffered before hitting the point of living on the streets, with no family and no friends. But maybe there is a friend now: it is the sad and lonesome tree which, however bent, lends a protective air, like an older brother, a companion for adventures and misadventures who will not abandon us, in good times or bad.

It is interesting to note that even Luisa Rabbia's sculptures are related to the act of drawing (in this case, the blue pencil used for the tree). It has rightly been said of her works that they are "deeply rooted in drawing, which she sees as a platform that unites rational construct with the imagination. The dynamic tension that exists in drawing between the figure and its background, the being and the becoming, has influenced much of Rabbia's work with paper, papier mâché, porcelain and animation".

Ready! Aim! Fire!
Lara Favaretto

On various occasions Lara Favaretto presented a piece called "Firing Squad". The last display ⁄ the largest version to date ⁄ was presented at the 16th Sydney Biennale in the summer of 2008. This time the piece was made up of 35 ran⁄ domly placed upright nitrogen canisters.

Each canister is connected to a timing device which makes it emit a small jet of gas at regular intervals (but each canis⁄

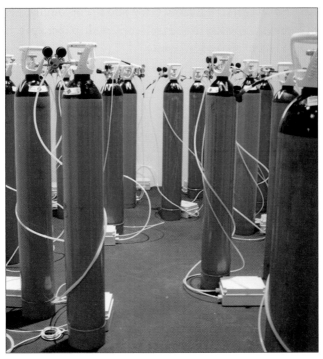

LARA FAVARETTO, "FIRING SQUAD", 2003⁄2008

ter is set to a different time, so the gas jets never come at the same time). The little nitrogen blast briefly inflates a paper whistle, like the ones children use at parties. But the artist has removed the sound device from the whistle, therefore the paper inflates but without making any noise.

At first sight, the installation is disturbing. But the disturbance disappears with each puff of air and each mute unfurling of the paper tube. The heaviness of the canisters is balanced by the lightness of the action set off by the jet of gas. Since the piece is called "Firing Squad", we may be inclined to think that someone has been sentenced to death and is about to be executed. But the chosen weapon is just a paper tube. So the sentence is nothing more than a hollow gesture. In reality, no one has been tried or sentenced. The work is just a kind of representation of the futility of effort. This futility is accentuated by the fact that the whistle makes no sound. Sometimes enormous efforts, or ones which appear enormous to us, produce miniscule results that make it seem like, in the end, unconsciously, the joke is on us.

Martin Creed **doesn't want to say anything and therein lies his importance**

Let's try to mix three very diverse elements: one⁄third cold American Minimalism (art consisting of few elements stripped to the bone); one⁄third the personality of the Italian artist Piero Manzoni (who said that anything an artist did was art, and consequently created the famous cans of... "artist's shit", now sold for more than £50,000 each); and one⁄third the playful, funny and irreverent spirit of some artists mentioned in this book (such as Alighiero e Boetti or Maurizio Cattelan). What would be the result? The English artist Martin Creed.

Martin Creed creates pieces that are so banal and tauto⁄logical that they seem irreverent but at the same time abso⁄lutely fascinating in their simplicity.

His works are all progressively numbered. This piece is en⁄titled "Work No. 898 (simple drawing)" and is nothing more than a simple scribble with a pen on an A4 sheet of white paper. But even a simple scribble can provide food for thought about art.

The decision to include the simplest works, like this scrib⁄ble, and more complex ones (like installations and video) in a single numbered series shows a very clear desire not to establish a hierarchy of importance depending on the media used. An oil on canvas is traditionally considered a more

MARTIN CREED, "WORK NO. 898 (SIMPLE DRAWING)", 2008

important (and therefore more expensive) work than a watercolour or a pastel drawing, and both of these are in turn considered of a "higher" rank than a sketch. But what really counts in a work of art is the presence of a spark, a little bit of inexplicable magic. And it is not guaranteed that this will be more likely in an oil painting than in a simple drawing. I will never tire of repeating that it is far more intelligent to buy a beautiful drawing than a mediocre oil painting.

Another consideration sparked by Martin Creed with this work is that art is absolutely tautological. It is as if he has wiped out any attempt by the viewer to find any significance, to infer social, cultural or political references in what they are looking at. Martin Creed tells us, with an ironic smile, that what we see is what we get. A scribble is a scribble. It is an artistic attitude highly reminiscent of a large work by Alighiero e Boetti from 1969 made up of a metal structure which served as a frame and a grid for an enormous window. The work is aptly titled "Nothing to See, Nothing to Hide".

Martin Creed does not want to say anything and, paradox-
ically, therein lies his importance. If you like it, good. If you
don't, the artist won't mind.

That should be a golden rule in contemporary art and it is
no coincidence that this beautiful little work by Martin
Creed closes this volume. Let yourselves be guided by the
simple pleasure of viewing, don't seek meanings where there
are none, look at as many works of art as possible and in the
end, trust your instincts. And don't feel embarrassed if you
like a mark on a canvas but you can't say why. The motive
may simply be that it is beautiful. It means nothing, but it is
beautiful. That is the secret of art.

The Works

The numbers indicate the pages with the illustration of the work.

23.
FELIX GONZALEZ-TORRES
"Untitled", 1988,
photostat, 28 x 35 cm.

26.
GEORG BASELITZ
"Birch" (Birke), 1970,
oil on canvas, 199 x 144 cm.
Courtesy Christie's, London.

31.
JANNIS KOUNELLIS
"Untitled", 1971,
blowtorches, room-sized.
Courtesy the artist.

34-35.
RICHARD LONG
"Three Circles of Stones", 1972,
stones, diameter of the external
circle approximately 13 m.

41.
REBECCA HORN
"Mask of Pencils"
(Bleistiftmaske), 1972,
video still,
Courtesy the artist.

44.
SOL LEWITT
"Wall Drawing # 161", 1973,
pastel drawing with certificate,
244 x 244 cm.

48-49.
ROBERT RYMAN
"Untitled (Study for Brussels)",
1974, polymer paint on vinyl
mounted on fibreglass,
10 panels 54 x 54 cm each.

52.
GIUSEPPE PENONE
"Four-Metre Tree"
(Albero di quattro metri), 1974,
wood, 400 x 25 x 12 cm.

55.
GERHARD RICHTER
"1024 Colours", 1974,
lacquer on canvas, 96 x 96 cm
Courtesy Christie's, London.

58.
GIULIO PAOLINI
"Mimesis" (Mimesi), 1975,
plaster casts, 210 cm high.
Courtesy the artist.

61.
CARL ANDRE
"Thirty-Ninth Copper
Cardinal" (Trentanovesimo
numero cardinale di rame),
1975, 39 copper plates
0.5 x 50 x 50 cm each;
0.5 x 150 x 150 cm overall.
Courtesy Christie's, New York.

64/65.
MARIO MERZ
"Fill/In Leaves"
(Foglie tappabuchi), 1976,
mixed media on unstarched
canvas, 150 x 390 cm.

68.
JENNY HOLZER
selection from "Truisms" series,
1977/1979,
neon sign, 6 x 12 m.

72.
WOLFGANG LAIB
"Milkstone", 1978,
greek marble and milk,
36 x 32 x 5 cm.
Courtesy Christie's, London.

76.
CINDY SHERMAN,
"Untitled Film Still # 48",
1979, black/and/white
photograph, 18 x 24 cm.

82.
DAVID SALLE
"Unexpectedly, I Missed
My Cousin Jasper", 1980,
acrylic on two jointed canvases,
122 x 193 cm.
Courtesy Gagosian Gallery,
New York.

87.
FRANCESCO CLEMENTE
from the series "The 24 Indian
Miniatures" (Le ventiquattro
miniature indiane), 1980/1981,
gouache on antique handmade
paper, 22 x 15 cm.

91.
ENZO CUCCHI
"Holy Bread"
(Pane santo), 1981,
pencil on paper, 39 x 30 cm.

95.
SANDRO CHIA
"The Scandalous Face"
(Il volto scandaloso), 1981,
oil on canvas, 160 x 130 cm.

99.
ANSELM KIEFER
"The Master Singers"
(Die Meistersinger), 1982,
oil, acrylic and straw on canvas,
210 x 280 cm.
Courtesy Gagosian Gallery,
New York.

102.
GIOVANNI ANSELMO
"Greys Lighten Towards
Overseas" (Grigi che si
alleggeriscono verso oltremare),
1982, stone, steel wire and acrylic
paint, size variable.
Courtesy Sotheby's, London.

104.
JEAN-MICHEL BASQUIAT
"Portrait of the Artist
as a Young Derelict", 1982,
acrylic and oil on wood,
203 x 280 cm.

107.
KEITH HARING
"Untitled", 1983,
vinyl paint on tarpaulin,
396 x 396 cm.
Courtesy Christie's, London.

111.
GIULIO PAOLINI
"Young Man Looking
at Lorenzo Lotto" (Giovane
che guarda Lorenzo Lotto),
1967, photographic print
on canvas, 30 x 24 cm.
Courtesy Christian Stein
Gallery, Milan.

113.
NICOLA DE MARIA
"Universe Without Bombs"
(Universo senza bombe), 1983,
acrylic on paper, 81 x 96 cm.

117.
MIQUEL BARCELÓ
"Painter with a Blue Paintbrush"
(Le peintre avec pinceau bleu),
1983, mixed media on canvas,
284 x 198 cm.

120.
JULIAN SCHNABEL
"Portrait of Jacqueline", 1984,
oil, plates and bond on wood,
154 x 122 cm.

126.
RICHARD TUTTLE
"Two or More IX", 1984,
iron wire, plastic, paper, canvas,
wood and ink on paper,
129 x 82 x 8 cm.
Private collection, Joseph
Hellman Gallery, New York.

129.
ALIGHIERO E BOETTI
"Map" (Mappa), 1984,
tapestry, 150 x 200 cm.

132.
SIGMAR POLKE
"Untitled", 1985,
mixed media on printed fabric,
180 x 150 cm.
Courtesy Christie's, London.

136.
CHRISTIAN BOLTANSKI
"Candles" from the series
"Lessons of Darkness", 1986,
copper figurines, aluminium
brackets and candles,
size variable.

138.
JULIÃO SARMENTO
"David and Devil", 1986,
mixed media on canvas,
295 x 380 cm.
Courtesy Galerie Bernd Klüser,
Munich

142.
MIMMO PALADINO
"Baal", 1986,
mixed media on canvas
with wooden frame,
diameter 260 cm.
Courtesy Galleria d'Arte
Moderna, Bologna.

145.
SEAN SCULLY
"Catherine", 1987,
oil on canvas, 244 x 305 cm.

148.
TONY CRAGG
"Minster", 1987,
rubber, stone, wood and metal,
height of the tallest piece
305 x 58 cm.

150.
ROSEMARIE TROCKEL
"Cogito, ergo sum", 1988,
wool, 220 x 150 cm.
Courtesy Galerie Monika
Sprüth, Cologne.

154.
JAMES BROWN
"Stabat Mater No. 50", 1988,
oil and collage on canvas,
46 x 30 cm.
Courtesy Farsetti Arte, Prato.

158.
RAINER FETTING
"Marc with Iris"
(Marc mit Iris), 1989,
oil on canvas, 200 x 160 cm.
Courtesy the artist.

163.
FELIX GONZALEZ-TORRES
"Untitled (Loverboy)", 1990,
blue paper (endless copies),
ideal size 19 x 74 x 58 cm.

167.
DAMIEN HIRST
"Acetic Anhydride", 1991,
household gloss paint
on canvas, 169 x 200 cm.
Courtesy Christie's, London.

171.
ANISH KAPOOR
"Untitled", 1992,
sandstone and pigment,
230 x 122 x 103 cm.
Courtesy Fondazione
Prada, Milan.
Photographer A. Maranzano.

175.
RACHEL WHITEREAD
"House", 1993,
cement and plaster,
about 10 m high, later destroyed.
Courtesy Anthony d'Offay
Gallery, London.

178.
DOUGLAS GORDON
"24-Hour Psycho", 1993,
video projection, size variable.

183.
JANINE ANTONI
"Lick and Lather", 1993,
chocolate and soap, two busts,
61 x 38 x 33 cm each.
Courtesy Christie's, London.

185.
GUILLERMO KUITCA
"Turin" (Torino), 1993-1995,
oil on canvas, 188 x 208 cm.
Courtesy Gian Enzo Sperone,
New York.

189.
GABRIEL OROZCO
"Island Within an Island",
1994, colour photograph
31 x 45 cm.
Courtesy Monica de Cardenas,
Milan.

192-193.
RIRKRIT TIRAVANIJA
"Untitled (From Barajas
to Paracuellos del Jarama,
to Torrejón de Ardoz,
to Coslada and to the Museo
Reina Sofia)", 1994,
mixed media, room-sized.
Courtesy Emi Fontana, Milan.

197.
CHRISTINE BORLAND
"From Life", 1994-1996,
mixed media, room-sized.

200.
TRACEY EMIN
"If I Could Just Go Back
and Start Again", 1995,
monoprint on paper,
65 x 81 cm.

203.
JUAN MUÑOZ
"After de Kooning", 1995,
bronze, 99 x 42 x 58 cm.

205.
VANESSA BEECROFT
"Untitled" (detail
from a performance
at the CAPC in Bordeaux), 1996,
photograph, 74 x 100 cm.
Courtesy Sotheby's, London.

209.
CALLUM INNES
"Exposed Painting,
Paynes Grey", 1996,
oil on canvas, 170 x 162 cm.
Courtesy Christie's, London.

212.
STEPHAN BALKENHOL
"Man with Red Hat", 1996,
wood and paint,
128 x 50 x 28 cm.
Courtesy Sotheby's, London.

215.
MAURIZIO CATTELAN
"XX Century" (Novecento),
1997, stuffed horse and leather,
200 x 270 x 69 cm.

218-219.
MARIKO MORI
"Nirvana", 1997, video.
Courtesy Deitch Projects,
New York.

222.
ANYA GALLACCIO
"Chasing Rainbow", 1998,
glass and lamps, room-sized.

227.
SANTIAGO SIERRA
"Six Workers Who Can't Be
Paid Legally Receive Money
to Sit in Cardboard Boxes",
image from the performance
conducted on several occasions
between 1999 and 2000.

229.
SHAHZIA SIKANDER
"Writing the Written", 2000,
vegetable colour, dry pigment,
watercolours and tea
on wasli paper, 24 x 16 cm.
Private collection.

231.
THOMAS RUFF
"Nude asd 04", 2001,
chromogenic colour print
mounted with Diasec Face,
124 x 92 cm.

233.
YOSHITOMO NARA
"Sprout the Ambassador",
2001, acrylic on cotton laid
over a plaster base reinforced
with fibreglass, diameter 180 cm,
depth 25 cm.
Courtesy Sotheby's, London.

236/237.
MARC QUINN
"Winter Garden", 2004,
pigment print, 84 x 124 cm.
Courtesy Galleria Alessandra
Bonomo, Rome.

238.
IDRIS KHAN
"Every... William Turner
Postcard from Tate Britain",
2004, Lamda digital print
mounted on aluminium,
edition of 5 with 2 artist's proofs
98 x 136 cm.

241.
JULIAN OPIE
"Anya with Veil", 2005,
vinyl on wooden stretcher,
90 x 66 cm.
Private collection, Bari.

242/243.
ALEXANDER LANER
"Academy" (Akademie), 2006,
photograph, 120 x 202 cm,
Courtesy Galerie Klüser,
Munich.

245 and 246.
JORGE MACCHI
"Lilliput", 2007,
paper collage and ink on paper,
150 x 180 cm.
Courtesy Galeria Benzacar,
Buenos Aires.

249.
LUISA RABBIA
"A Tree to Walk With", 2007,
blue pencil and acrylic on mixed
material, 75 x 100 x 212 cm.
Courtesy the artist.

251.
LARA FAVARETTO
"Firing Squad" (Plotone),
2003/2008, air tanks, pressure
regulators, distributors, timers,
electrovalves, plastic cables and
whistles, dimensions variable.
Courtesy the artist.

254.
MARTIN CREED
"Work No. 898
(simple drawing)", 2008,
pen on paper, 14.9 x 21 cm.
Courtesy Galleria Lorcan
O'Neill, Rome.

Conclusions

All art has always been contemporary. Any artist from any period was inescapably a contemporary when he created his works and inevitably came into conflict with traditional taste. Piero della Francesca's frescoes, like Paul Gauguin's Tahitian paintings, were, at the time they were created, no less innovative, different and shocking for their public than Andy Warhol's portraits in the 1960s or Baselitz's inverted paintings in the 1970s. Various works commissioned from Caravaggio were rejected because they were judged obscene, like the first version of his "St Matthew" (obscene just because the saint was wearing no shoes). Caravaggio painted a second version of that work which was more in tune with the aesthetic canons of the time but which, today, we consider far less intense and successful than the first.

This does not mean that all the artists cited in this volume will be remembered as greats of the 20th and 21st centuries. There would be too many. Time will make a cruel selection as it has always done. Just think of the hundreds of Renaissance artists who were famous in their day and whose names we can barely remember today! But I'd be prepared to bet on some of the artists cited here: two hundred years from now Anselm Kiefer and Tony Cragg will still be well-known names.

At the beginning of the 21st century we are seeing an increasing mixing of roles that were once rigidly separated. Artist, critics, gallery owners, collectors, museum directors, auction house experts: they all want more protagonism. English artist Damien Hirst first came to prominence as the curator

of the show "Freeze" in 1988 and then as an artist. Hirst also opened a fashionable bar-restaurant in London called "The Pharmacy" that was completely decorated with medical paraphernalia, like some of his works (after a few years, Hirst himself dismantled the restaurant and sold every bit, from ashtrays to the toilet doors, which he had duly signed, at Sotheby's). Sotheby's itself formed a joint-venture with the André Emmerich art gallery in New York to organise exhibitions and sales of works. Artist Maurizio Cattelan has been appointed curator of a Berlin Biennial. Julian Schnabel is now also a successful movie director and even won a prize at Cannes and obtained an Academy Awards nomination for best director in 2008 for his feature film "The Diving Bell and the Butterfly".

In today's art world the impact of technology is also growing, not so much as a technique but for its social implications. Artists will see information networks as a new medium at their disposal. Some artists will be interested in studying the possibilities linked to the exchange of information and the connections between people through the Internet. A pioneering work in this direction is that of the English artist Adam Chodzko who uses personal ads to make or break up non-existent relationships between people.

The Internet is an excellent vehicle for transmitting information and images and as such will be increasingly used for publicity purposes both by galleries and by individual artists (as the site www.sandrochia.com demonstrates). It will become easier to buy multiples and editions at low prices online,

even directly from the artist (see www.martincreed.com). The site www.artnet.com has launched a system of online auc-tions, but collectors will still, for many years to come, con-tinue going to their trusted galleries or directly to artists and will savour the moment in which a work is placed in front of them with all its physical presence. The passionate rela-tionship between the collector and the work will be hard to change and anyone buying a work will not welcome intrud-ers between his or her gaze and the canvas at that magical moment in which a rapport of pleasure and mutual respect is established.

Some countries which have contributed in such a signifi-cant way to the history of contemporary art in the 1970s and 1980s (Germany, Italy, USA) and in the 1990s (Britain) will have to face the fact that their roles could start being eroded. Artists and curators from Asian countries (China, Korea, India), Africa (South Africa and Nigeria) and Latin America (Argentina and Brazil) will emerge with increasing frequency. Art will become globalised: artists from all over the world using every possible kind of media will emerge and disappear like shooting-stars as the art moves faster and faster.

But luckily we can continue to enjoy a simple flower painted apparently so hesitantly by a poet artist like Nicola De Maria.

Bibliographical Note

This volume deliberately avoids detailed biographical notes. It seemed to me out-of-place and contrary to the spirit of simplicity and clarity which motivated this book to include a long list of volumes and catalogues that are often impossible to find in normal bookshops. I suggest that people seeking to further their knowledge of contemporary art should above all go to museums and galleries and buy the exhibition catalogues. Maybe a few months later, they will leaf through them again, calmly. When visiting private galleries, do not be afraid to ask for information, details, prices, explanations and, if available, buy the catalogue.

There are a number of specialist magazines dedicated to contemporary art, which are an excellent way of keeping up to date. Among the best are *Artforum* (New York), *Parkett* (Zurich) and *The Art Newspaper* (London).

There are hundreds of Internet sites devoted to contemporary art. One of the most interesting and exhaustive is www.artnet.com, which gives access to the websites of more than 2000 galleries worldwide. Artnet's database, for which it charges, provides details of over 3.6 million works of art sold at auction.

It is also interesting to look at the catalogues from the contemporary art auctions at Christie's, Phillips and Sotheby's (they are put online about two weeks before the auction date on the auction houses' websites). For the most important auctions of the year, in London and New York in May and November respectively, Christie's, Phillips and Sotheby's divide the sales, and catalogues, into a first part, represent-

ing more expensive works, and a second part. A large num‐ ber of the works of art included in the catalogues covering the first part of these auctions are accompanied by a clear in‐ depth presentation of the works on sale which provides de‐ tailed information not only about the pieces on sale but about the artists in general.

For more information on the general subject of contem‐ porary art, I would, however, highlight some books that have been published recently: *Capire l'arte contemporanea* (Understanding Contemporary Art) by Angela Vettese (Allemandi, Turin 1996, revised 8th reprint in 2008); *Icons of Art: the 20th century* (Prestel, Munich‐New York 1997); *Art Since 1960* by Michael Archer (Thames & Hudson, London 1997); *Art at the Turn of the Millennium* edited by Burhard Riemschneider and Uta Grosenick (Taschen, Colone 1999); *Art Now* edited by Burhard Riemschneider and Uta Grosenick (Taschen, Cologne 2002); *Collecting Contemporary Art* edited by Adam Lindemann (Taschen, Cologne 2006); *Owning Art* by Louisa Buck and Judith Greer (Cultureshock Media Ltd‐Thames & Hudson, London 2006).

Artist Information

CARL ANDRE
Born in Quincy, Massachusetts
(United States) in 1935.
Main private galleries:
Paula Cooper (New York)
Konrad Fischer Gallery
(Düsseldorf)
Recent exhibitions in public spaces:
Kunsthalle (Basle, 2005)

GIOVANNI ANSELMO
Born in Borgofranco di Ivrea
(Italy) in 1934.
Main private galleries:
Marian Goodman (New York)
Kewenig Galerie (Cologne)
Sperone Westwater (New York)
Recent exhibitions in public spaces:
Centro d'Arte Contemporanea
(Geneva, 1993)
Centro Galego de Arte
Contemporaneo (Santiago
de Compostela, 1995)

JANINE ANTONI
Born in Freeport (Bahamas)
in 1964.
Main private galleries:
Sandra Gering (New York)
Luhring Augustine
(New York)

Recent exhibitions in public spaces:
Centre for Contemporary Arts
(Glasgow, 1995)
Irish Museum of Modern Art
(Dublin, 1995)
Aldrich Contemporary Art
Museum (Ridgefield, United
States, 2001)

STEPHAN BALKENHOL
Born in Fritzlar (Germany)
in 1957.
Main private galleries:
Valentina Bonomo (Rome)
Mai 36 (Zurich)
Stephen Friedman (London)
Recent exhibitions in public spaces:
Hirshhorn Museum
(Washington, 1995)
Montreal Museum of Fine Arts
(Montreal, 1996)
Galleria Civica d'Arte
Contemporanea
(Trento, Italy, 1999)
Staatliche Kunsthalle
(Baden Baden, 2006)

MIQUEL BARCELÓ
Born in Felanitx (Spain)
in 1957.
Main private galleries:
Galerie Bischofberger (Zurich)
Timothy Taylor (London)

Recent exhibitions in public spaces:
Galerie Nationale du Jeu
 de Paume (Paris, 1996)
Centre Pompidou (Paris, 1996)
Museum voor Moderne Kunste
 (Ostend, 1997)
Museu d'Art Contemporani
 (Barcelona, 1998)
Musée Mander (Riom, 1998)
Centro de Arte Reina Sofía
 (Madrid, 1990)
Fondation Maeght
 (Saint-Paul, 2002)

GEORG BASELITZ
Born in Deutchbaselitz
 (Germany) in 1938.
Main private galleries:
Michael Werner (Cologne)
Recent exhibition sin public spaces:
National Galeri Staatliche
 Museum (Berlin, 1995-1996)
Carnegie Museum
 (Pittsburg, 1998)
Stedelijk Museum
 (Amsterdam 1999)
Musée Rath (Geneva, 1999)
Deutches Guggenheim
 (Berlin, 1999)
Musée d'Art de d'Histoire
 (Geneva, 2000)
Kunsthalle (Hamburg, 2000)

Albertina Museum
 (Vienna, 2003)
Louisiana Museum
 (Humlebaek, 2006)

JEAN-MICHEL BASQUIAT
Born in New York (United
 States) in 1960, died in 1988.
Main private galleries:
Galerie Bischofberger (Zurich)
Mary Boone Gallery (New York)
Tony Shafrazi (New York)
Recent exhibitions in public spaces:
Whitney Museum of American
 Art (New York, 1992)
Serpentine Gallery
 (London, 1995)
Museo d'Arte Moderna
 (Lugano, 2005)

VANESSA BEECROFT
Born in Genoa (Italy) in 1969.
Main private galleries:
Deitch Projects (New York)
Massimo Minini (Brescia)
Lia Rumma (Naples)
Recent exhibitions in public spaces:
Guggenheim Museum
 (New York, 1998)
Museum of Contemporary Art
 (Sydney, 1999)
Moderna Museet
 (Stockholm, 2004)
Nationalgalerie (Berlin, 2005)

ALIGHIERO E BOETTI
Born in Turin (Italy) in 1940,
 died in 1994.
Main private galleries:
Alesandra Bonomo (Rome)
Marilena Bonomo (Bari)
Massimo Minini (Brescia)
Gagosian Gallery (London,
 New York, Rome)
Recent exhibitions in public spaces:
Galleria Nazionale d'Arte
 Moderna (Rome, 1996⁄1997)
Fundación PROA
 (Buenos Aires, 2004)

CHRISTIAN BOLTANSKI
Born in Paris (France) in 1944.
Main private galleries:
Bernd Klüser (Munich)
Recent exhibitions in public spaces:
Musée d'Art Moderne
 de la Ville (Paris, 1998)
Arken Museum
 (Copenhagen, 1998)
Museum of Fine Arts
 (Boston, 2000)
MACRO (Rome, 2006)

CHRISTINE BORLAND
Born in Darvel (Scotland)
 in 1965.
Main private galleries:
Lisson Gallery (London)
Toni Tàpies (Barcelona)

Recent exhibitions in public spaces:
Tramway (Glasgow, 1994)
Kunstwerke (Berlin, 1996)
Museum für Gegenwartskunst
 (Zurich, 1999)
Museu de Serralves
 (Porto, 1999)
Contemporary Art Museum
 (Houston, 2002)

JAMES BROWN
Born in Los Angeles, California
 (United States) in 1951.
Main private galleries:
Marilena Bonomo (Bari)
Rebecca Ibel Gallery
 (Columbus)
Lipanjepuntin (Trieste)
Studio d'Arte Raffaelli (Trento)
Recent exhibitions in public spaces:
Galleria Civica d'Arte
 Contemporanea
 (Trento, 1995)
Musée d'Arts Décoratifs
 (Paris, 1999)
Museum of Art (Oaxaca, 2004)

MAURIZIO CATTELAN
Born in Padua (Italy) in 1960.
Main private galleries:
Massimo de Carlo (Milan)
Jim Kempner Fine Art
 (New York)
Massimo Minini (Brescia)

Recent exhibitions in public spaces:
Castello di Rivoli (Turin, 1997)
Museum of Modern Art
 (New York, 1998)
Kunsthalle (Basel, 1999)
Museo Migros (Zurich, 2000)

SANDRO CHIA
Born in Florence (Italy) in 1946.
Main private galleries:
Galerie Bischofberger (Zurich)
Contini (Venice)
Thaddaeus Ropac (Salzburg)
Tony Shafrazi (New York)
Recent exhibitions in public spaces:
Accademia di Francia Villa
 Medici (Rome, 1995)
Palazzo Reale di Arengario
 (Milan, 1997)
Museo Archeologico Nazionale
 (Florence, 2000)
Galleria Civica (Trento, 2000)
Museo Archeologico Nazionale
 (Florence, 2002)

FRANCESCO CLEMENTE
Born in Naples (Italy) in 1952.
Main private galleries:
Galerie Bischofberger (Zurich)
Lorcan O'Neill (Rome)
Recent exhibitions in public spaces:
Metropolitan Museum
 (New York, 1998)

Villa delle Rose (Bologna, 1999)
Guggenheim (Bilbao, 2000)

TONY CRAGG
Born in Liverpool
 (Great Britain) in 1949.
Main private galleries:
Bernd Klüser (Munich)
Lisson Gallery (London)
Recent exhibitions in public spaces:
Whitechapel Art Gallery
 (London, 1997)
Sara Hilden Art Museum
 (Tampere, 1999)
Von der Heydt Museum
 (Wuppertal, 1999)
MUHKA (Antwerp, 2000)
Tate Gallery (Liverpool, 2000)
Centro Cultural Recoleta
 (Buenos Aires, 2005)

MARTIN CREED
Born in Wakefield (Great
 Britain) in 1968.
Main private galleries:
Hauser & Wirth
 (London and Zurich)
Galleria Lorcan O'Neill (Rome)
Recent exhibitions in public spaces:
Fondazione Nicola Trussardi
 (Milan, 2006)
The Douglas Hyde Gallery
 (Dublin, 2007)

Ikon Gallery (Birmingham, 2008)
Tate Britain (London, 2008)

ENZO CUCCHI

Born in Morro d'Alba (Italy)
in 1949.
Main private galleries:
Galerie Bischofberger (Zürich)
Bernd Klüser (Munich)
Recent exhibitions in public spaces:
Museo di Capodimonte
(Naples, 1996)
Centro Cultural Recoleta
(Buenos Aires, 1997)
GAMEC (Bergamo, 2007)
Castello Colonna
(Genazzano, 2002)

NICOLA DE MARIA

Born in Foglianise (Italy)
in 1954.
Main private galleries:
Marilena Bonomo (Bari)
Cardi (Milan),
Lelong (New York, Paris,
Zurich)
Giorgio Persano (Turin)
Recent exhibitions in public spaces:
Liechtensteinische Staatliche
Kunstsammlung (Vaduz,
1998)
MACRO (Rome, 2004)

TRACEY EMIN

Born in London (Great Britain)
in 1963.
Main private galleries:
Jay Jopling (London)
Lehmann Maupin (New York)
Lorcan O'Neill (Rome)
Recent exhibitions in public spaces:
South London Gallery
(London, 1997)

LARA FAVARETTO

Born in Treviso (Italy) in 1973.
Main private galleries:
Klosterfelde (Berlin)
Franco Noero (Turin)
Recent exhibitions in public spaces:
GAMEC Galleria d'Arte
Moderna e Contemporanea
di Bergamo (Bergamo, 2001)
SI Swiss Institute
(New York, 2003)

RAINER FETTING

Born in Wilhelmshaven
(Germany) in 1949.
Main private galleries:
Raab Gallery (London)
Recent exhibitions in public spaces:
Von der Heydt Museum
(Wuppertal, 1998)
Neuer Berliner Kunstverein
(Berlin, 1999)

ANYA GALLACCIO

Born in Glasgow
(Great Britain) in 1963.
Main private galleries in public spaces:
Thomas Dane Gallery
(London)
Lehmann Maupin (New York)
Recent exhibitions in public spaces:
Serpentine Gallery
(London, 1997)
Palazzo delle Papesse
(Siena, 2005)

FELIX GONZALEZ-TORRES

Born in Guaimaro (Cuba)
in 1957, died in 1996.
Main private galleries:
Andrea Rosen Gallery
(New York)
Recent exhibitions in public spaces:
Guggenheim Museum
(New York, 1995)
Sprengel-Museum (Hanover,
1997)
Kunstmuseum
(San Gallo, 1997)
Museum Moderner Kunst
(Vienna, 1998)
Serpentine Gallery
(London, 2000)
Douglas Hyde Gallery
(Dublin, 2000)

DOUGLAS GORDON

Born in Glasgow
(Great Britain) in 1966.
Main private galleries:
Gagosian Gallery
(London, New York, Rome)
Yvon Lambert
(New York, Paris)
Lisson Gallery (London)
Recent exhibitions in public spaces:
Museum für Gegenwartskunst
(Zurich, 1996-1997)
Kunstverein (Hanover, 1998)
Kunstverein (Cologne, 1999)
Centro Cultural de Belém
(Lisbon, 1999)
Powerplant Art Gallery
(Toronto, 2000)
Museu de Serralves
(Porto, 2000)
Moderna Museet (Stockholm,
2000)
Winner of Tate Gallery's
Turner Prize in 1996
Fundació Joan Miró
(Barcelona, 2006)

KEITH HARING

Born in Kutztown,
Pennsylvania (United States)
in 1958, died in 1990.
Main private galleries:
Tony Shafrazi (New York)

Recent exhibitions in public spaces:
Whitney Museum
(New York, 1997)
Art Gallery of Ontario
(Toronto, 1998)
Museum of Modern Art
(San Francisco, 1998)
Musée des Beaux-Arts
(Montreal, 1998)
Ludwig Forum
(Aquisgrana, 2000)
Palazzo Lanfranchi (Pisa, 2000)

DAMIEN HIRST
Born in Bristol (Great Britain)
in 1965.
Main private galleries:
Gagosian Gallery
(London, New York, Rome)
Jay Joplin (London)
Sotheby's Auction House
(London)
Recent exhibitions in public spaces:
Dallas Museum of Art
(Dallas, 1996)
Museum of Contemporary Art
(Chicago, 1999)
Tate Gallery (London, 1999)
Winner of Tate Gallery's
Turner Prize in 1995
Museo Archeologico Nazionale
(Naples, 2004)

JENNY HOLZER
Born in Gallipolis, Ohio
(United States) in 1950.
Main private galleries:
Cheim & Read (New York)
Barbara Gladstone Gallery
(New York)
Recent exhibitions in public spaces:
National Gallery of Australia
(Canberra, 1998)
ICA (London, 2005)

REBECCA HORN
Born in Michelstadt (Germany)
in 1944.
Main private galleries:
Marian Goodman Gallery
(New York)
Recent exhibitions in public spaces:
Guggenheim Museum
(New York, 1993)
Serpentine Gallery and Tate
Gallery (London, 1994)
Hayward Gallery
(London, 2005)

CALLUM INNES
Born in Edinburgh
(Great Britain) in 1962.
Main private galleries:
Frith Street Gallery (London)
Recent exhibitions in public spaces:
Irish Museum of Modern Art
(Dublin, 1999)

ANISH KAPOOR
Born in Mumbai (India)
in 1954.
Main private galleries:
Lisson Gallery (London)
Massimo Minini (Brescia)
Recent exhibitions in public spaces:
Fondazione Prada
(Milan, 1995)
Hayward Gallery
(London, 1998)
CAPC (Bordeaux, 1998)
Winner of Venice Biennale
prize and Tate Gallery's
Turner Prize in 1991
Museo Archeologico Nazionale
(Naples, 2003)
Centro Cultural Banco do
Brasil (Rio de Janeiro, 2006)

IDRIS KHAN
Born in Birmingham
(Great Britain) in 1978.
Main private galleries:
Yvon Lambert Gallery
(New York, Paris)
Victoria Miro Gallery
(London)
Thomas Shulte Galerie (Berlin)

ANSELM KIEFER
Born in Donaueschinghen
(Germany), in 1945.
Main private galleries:
Gagosian Gallery
(London, New York, Rome)
Lorcan O'Neill (Rome)
Sonnabend Gallery
(New York)
White Cube (London)
Recent exhibitions in public spaces:
Centro de Arte Reina Sofía
(Madrid, 1998)
Metropolitan Museum
(New York, 1999)
Galleria d'Arte Moderna
(Bologna, 1999)
Art Museum (Seattle, 2000)
Hangar Bicocca (Milan, 2004)
Aldrich Contemporary Art
Museum (Ridgefield, 2006)

JANNIS KOUNELLIS
Born in Pireo (Greece) in 1936.
Main private galleries:
Valentina Bonomo (Rome)
Lelong (New York, Paris,
Zurich)
Recent exhibitions in public spaces:
Palazzo Fabroni (Pistoia, 1994)
MADRE (Naples, 2006)
Fondazione Arnaldo Pomodoro
(Milan, 2006⁄2007)

GUILLERMO KUITCA
Born in Buenos Aires
(Argentina) in 1961.
Main private galleries:
Hauser & Wirth (London)
Thaddaeus Ropac (Paris
and Salzburg)
Sperone Westwater (New York)
Recent exhibitions in public spaces:
Whitechapel Gallery
(London, 1995)
Museo Alejandro Otero
(Caracas, 1997)
MALBA (Buenos Aires, 2003)

WOLFGANG LAIB
Born in Metzinger (Germany)
in 1950.
Main private galleries:
Galerie Buchmann (Basel)
Sperone Westwater (New York)
Recent exhibitions in public spaces:
Musée d'Art Contemporain
(Nîmes, 1999)
Sara Hilden Art Museum
(Tampere, 2000)
Hirshhorn Museum
(Washington, 2000)
Sprengel Museum
(Hanover, 2000)
MACRO (Rome, 2005)

ALEXANDER LANER
Born in Munich (Germany)
in 1974.
Main private galleries:
Galerie Klüser (Munich)

SOL LEWITT
Born in Hartford, Connecticut
(United States) in 1928,
died in 2007.
Main private galleries:
Alessandra Bonomo (Rome)
Marilena Bonomo (Bari)
Valentina Bonomo (Rome)
Paula Cooper (New York)
Pace Wildenstein (New York)
Recent exhibitions in public spaces:
Museum of Modern Art
(New York, 1996)
Museum of Contemporary Art
(Chicago, 2000)
Palazzo delle Esposizioni
(Rome, 2000)
Museum of Modern Art
(San Francisco, 2000)
Fondazione Merz (Turin, 2006)

RICHARD LONG
Born in Bristol (Great Britain)
in 1945.
Main private galleries:
Haunch of Venison (London)

Recent exhibitions in public spaces:
Kunstverein (Hanover, 1999)
Winner of Tate Gallery's
　Turner Prize in 1990
Hessisches Landesmuseum
　(Darmstadt, 2002)
Milwaukee Art Museum
　(Milwaukee, 2002)

JORGE MACCHI
Born in Buenos Aires
　(Argentina) in 1963.
Main private galleries:
Galeria Benzacar (Buenos Aires)
Galleria Continua
　(San Gimignano)
Distrito Cuatro (Madrid)
Galerie Peter Kilchmann (Zurich)
Recent exhibitions in public spaces:
　6ª Bienal do Mercosul
　(Porto Alegre, 2007)
Centro Gallego de Arte
　Contemporaneo (Santiago
　de Compostela, 2008)

MARIO MERZ
Born in Milan (Italy) in 1925,
　died in 2003.
Main private galleries:
Barbara Gladstone (New York)
Konrad Fischer Gallery
　(Dusseldorf)
Giorgio Persano (Turin)

Recent exhibitions in public spaces:
Galleria Civica d'Arte
　Contemporanea
　(Trento, 1995)
Museu de Serralves (Porto, 1999)
Musée d'Art Moderne et d'Art
　Contemporain (Nice, 2000)
Fundación PROA
　(Buenos Aires, 2002)
Fondazione Merz (Turin, 2006)

MARIKO MORI
Born in Tokyo (Japan) in 1967.
Main private galleries:
Deitch Projects (New York)
Gallery Koyanagi (Tokyo)
Emmanuel Perrotin (Paris)
Recent exhibitions in public spaces:
Los Angeles County Museum
　of Art (Los Angeles, 1998)
The Andy Warhol Museum
　(Pittsburgh, 1998)
Serpentine Gallery
　(London, 1998)
Museum of Contemporary Art
　(Chicago, 1998)
Kunstmuseum
　(Wolfsburg, 1999)
Fondazione Prada (Milan, 1999)
Centre Pompidou (Paris, 2000)

JUAN MUÑOZ
Born in Madrid (Spain) in 1953,
died in 2001.
Main private galleries:
Galerie Ghislaine Hussenot
(Paris)
Recent exhibitions in public spaces:
Irish Museum of Modern Art
(Dublin, 1994)
DIA Center for the Arts
(New York, 1996-1997)
Louisiana Museum
(Humlebaek, 2000)

YOSHITOMO NARA
Born in Hirosaki (Japan) in 1959.
Main private galleries:
Stephen Friedman (London)
Galerie Michael Zink
(Berlin, Munich)
Recent exhibitions in public spaces:
Institute of Contemporary Art
(Philadelphia, 2004)
Centro de Arte Contemporaneo
de Málaga (Málaga, 2007)

JULIAN OPIE
Born in London (Great Britain)
in 1958.
Main private galleries:
Valentina Bonomo (Rome)
Alan Cristea Gallery (London)
Lisson Gallery (London)

Recent exhibitions in public spaces:
Museum of Contemporary Art
(Chicago, 2004)
Institute of Contemporary Art
(Boston, 2005)

GABRIEL OROZCO
Born in Veracruz (Mexico)
in 1962.
Main private galleries:
Galerie Chantal Crousel (Paris)
Marian Goodman Gallery
(New York)
White Cube (London)
Recent exhibitions in public spaces:
Kunsthalle (Zurich, 1996)
Institute of Contemporary Art
(London, 1996)
Portikus (Frankfurt, 1999)
Museum of Contemporary Art
(Los Angeles, 2000)

MIMMO PALADINO
Born in Paduli (Italy) in 1948.
Main private galleries:
Valentina Bonomo (Rome)
Alan Cristea (London)
Waddington (London)
Recent exhibitions in public spaces:
South London Gallery
(London, 1999)
Palazzo Reale (Milan, 2000)

Winnipeg Art Gallery
(Winnipeg, 2000)
Museo di Capodimonte
(Naples, 2005/2006)
Museo dell'Ara Pacis
(Rome, 2008)

GIULIO PAOLINI
Born in Genoa (Italy) in 1940.
Main private galleries:
Marilena Bonomo (Bari)
Yvon Lambert
(New York, Paris)
Lisson Gallery (London)
Galerie Annemarie Verna
(Zurich)
Recent exhibitions in public spaces:
Galleria Civica (Turin, 1999)
Villa Medici (Rome, 1999)
Fundación La Caixa
(Madrid, 2000)

GIUSEPPE PENONE
Born in Garessio (Italy) in 1947.
Main private galleries:
Galerie Guy Bärtschi (Geneva)
Konrad Fischer Gallery
(Düsseldorf)
Marian Goodman (New York)
Recent exhibitions in public spaces:
Musée d'Art Contemporain
(Nîmes, 1997)

De Pont Foundation for
Contemporary Art
(Tilnurg, 1997/1998)
Galleria Civica d'Arte
Contemporanea
(Trento, 1998)
Douglas Hyde Gallery
(Dublin, 1999)
Centre Pompidou (Paris, 2004)

SIGMAR POLKE
Born in Oels (then Poland,
now Germany) in 1941.
Main private galleries:
Konrad Fischer (Düsseldorf)
Michael Werner (Cologne)
Recent exhibitions in public spaces:
Kunst und Ausstellungshalle
(Bonn, 1997)
Hamburger Banhof
(Berlin, 1998)
Museum of Modern Art
(New York, 1999)
Ludwig Museum
(Budapest, 1999)
Kunstverein (Stuttgart, 2000)
Fundació Joan Miró
(Barcelona, 2000)
Kunsthaus Zurich
(Zurich, 2005)

MARC QUINN
Born in London (Great Britain)
 in 1964.
Main private galleries:
Alessandra Bonomo (Rome)
White Cube (London)
Recent exhibitions in public spaces:
Fondazione Prada (Milan, 2000)
Irish Museum of Modern Art
 (Dublin, 2004)
Groningen Museum
 (Groningen, 2006)
MACRO (Rome, 2006)

LUISA RABBIA
Born in Turin (Italy) in 1970.
Main private galleries:
Massimo Audiello Gallery
 (New York)
Galleria Giorgio Persano (Turin)
Recent exhibitions in public spaces:
Fondazione Palazzo Bricherasio
 (Turin, 2003)
Isabella Stewart Gardner
 Museum (Boston, 2008)
Fondazione Merz
 (Turin, scheduled 2009)

GERHARD RICHTER
Born in Dresden (Germany)
 in 1932.
Main private galleries:
Jean Bernier (Athens)

Barbara Mathes Gallery
 (New York)
Recent exhibitions in public spaces:
Getty Center
 (Los Angeles, 1999)
Museo d'Arte Contemporanea
 (Barcelona, 1999)
Kunstmuseum
 (Winterthur, 1999)
Staatliche Kunstammlungen
 (Dresden, 2000)
MOMA (New York, 2002)
Whitechapel Gallery
 (London, 2003)

THOMAS RUFF
Born in Harmersbach
 (Germany) in 1958.
Main private galleries:
Ben Brown Fine Arts (London)
David Zwirner Gallery
 (New York)
Recent exhibitions in public spaces:
Museo Rufino Tamayo
 (Mexico City, 2002)
Irish Museum of Modern Art
 (Dublin, 2002)

ROBERT RYMAN
Born in Nashville, Tennessee
 (United States) in 1930.
Main private galleries:
Peter Blum (New York)
Paula Cooper (New York)

Konrad Fischer Gallery
(Düsseldorf)
Pace Wildenstein (New York)
Recent exhibitions in public spaces:
Museum of Modern Art
(New York, 1995)

DAVID SALLE
Born in Norman, Oklahoma
(United States) in 1952.
Main private galleries:
Galerie Bischofberger (Zurich)
Mary Boone (New York)
Recent exhibitions in public spaces:
Stedelijk Museum
(Amsterdam, 1990)
Castello di Rivoli (Turin, 1999)
Guggenheim Museum
(Bilbao, 2000)

JULIÃO SARMENTO
Born in Lisbon (Portugal)
in 1948.
Main private galleries:
Sean Kelly (New York)
Bernd Klüser (Munich)
Recent exhibitions in public spaces:
Stedelijk Van Abbemuseum
(Eindhoven, 1996)
Hirshhorn Museum
(Washington, 1998)
Fundacíon Calouste
Gulbenkian (Lisbon, 2000)

Palácio Nacional de Queluz
(Queluz, 2005)

JULIAN SCHNABEL
Born in New York (United
States) in 1951.
Main private galleries:
Galerie Bischofberger (Zurich)
McClain Gallery (Houston)
Thaddaeus Ropac (Salzburg)
Timothy Taylor (London)
Recent exhibitions in public spaces:
South London Gallery
(London, 1999)
Palazzo Venezia (Rome, 2007)

SEAN SCULLY
Born in Dublin (Ireland)
in 1945.
Main private galleries:
Galerie Lelong (New York,
Paris, Zurich)
Timothy Taylor (London)
Recent exhibitions in public spaces:
Galleria d'Arte Moderna
(Bologna, 1996)
Staatliche Graphische
Sammlung (Munich, 1996)
Irish Museum of Modern Art
(Dublin, 1996)
South London Gallery
(London, 1999)

Metropolitan Museum
(New York, 2000)
Staatliche Museum
(Kassel, 2005)
Phillips Collection
(Washington, 2005)

CINDY SHERMAN
Born in Glen Ridge, New Jersey
(United States) in 1954.
Main private galleries:
Gagosian Gallery
(London, New York, Rome)
Metro Pictures (New York)
Recent exhibitions in public spaces:
Ludwig Museum
(Cologne, 1998)
Museum of Contemporary Art
(Los Angeles, 1998)
Museum of Contemporary Art
(Chicago, 1998)
National Gallery of Australia
(Canberra, 1998)
Barbican Art Gallery
(London, 1998)
Museum of Contemporary Art
(Sydney, 1999)
Art Gallery of Ontario
(Toronto, 1999)

SANTIAGO SIERRA
Born in Madrid (Spain) in 1966.
Main private galleries:
Galeria Helda de Alvear
(Madrid)
Galerie Peter Kilchmann
(Zurich)
Recent exhibitions in public spaces:
Forum Kultur und Wirtschaft
(Düsseldorf, 2004)
Centro de Arte Contemporáneo
(Málaga, 2006)

SHAHZIA SIKANDER
Born in Lahore (Pakistan)
in 1969.
Main private galleries:
Valentina Bonomo (Rome)
Sikkema Jenkins (New York)
Recent exhibitions in public spaces:
Aldrich Contemporary Art
Museum (Ridgefield, 2004)

RIRKRIT TIRAVANIJA
Born in Buenos Aires
(Argentina) in 1961.
Main private galleries:
1301PE (Los Angeles)
Chantal Crousel (Paris)
Recent exhibitions in public spaces:
Boijmans-Beuningen
(Rotterdam, 1999)

Wexner Center
(Columbus, 1999)
Serpentine Gallery
(London, 2005)

ROSEMARIE TROCKEL
Born in Schwerte (Germany)
in 1952.
Main private galleries:
Barbara Gladstone (New York)
Monika Sprüth Philomene
Magers (Cologne, Munich,
London)
Recent exhibitions in public spaces:
Centro d'Art Contemporain
(Geneva, 1998)
Kunsthalle (Hamburg, 1998)
Whitechapel Art Gallery
(London, 1998)
Musée d'Art Moderne
de la Ville (Paris, 1999)
Staatgalerie Stüttgart
(Stüttgart, 1999)
Centre Pompidou (Paris, 2000)
De Pont Stichting
(Tilburg, 2000)
Sammlung Goetz
(Munich, 2002)
Museum Ludwig
(Cologne, 2005)

RICHARD TUTTLE
Born in Rahway, New Jersey
(United States), in 1941.
Main private galleries:
Alessandra Bonomo (Rome)
Marilena Bonomo (Bari)
Sperone Westwater (New York)
Galerie Annemarie Verna
(Zurich)
Recent exhibitions in public spaces:
Ludwig Forum
(Aquisgrana, 1998)
Modern Art Museum
(Fort Worth, 1998)
Kunsthaus (Zug, 1998)
MOMA (San Francisco, 2005)
Whitney Museum
(New York, 2006)

RACHEL WHITEREAD
Born in London (Great Britain)
in 1963.
Main private galleries:
Gagosian Gallery
(London, New York, Rome)
Recent exhibitions in public spaces:
MADRE (Naples, 2007)

© 2008 UMBERTO ALLEMANDI & C.

EDITORIAL COORDINATION LINA OCARINO

PROOFREADING HARRIET GRAHAM

DESKTOP PUBLISHING
ELISABETTA PADUANO AND CARLO NEPOTE

PHOTOLITHOGRAPHY FOTOMEC, TURIN

PRINTED IN SEPTEMBER 2008
BY CAST, MONCALIERI (TURIN)